Advanced 3D Photorealism Techniques

Bill Fleming

Wiley Computer Publishing

John Wiley & Sons, Inc.

NEW YORK · CHICHESTER · WEINHEIM · BRISBANE · SINGAPORE · TORONTO

Publisher: Robert Ipsen

Editor: Cary Sullivan

Assistant Editor: Kathryn A. Malm

Managing Editor: Brian Snapp

Electronic Products, Associate Editor: Mike Sosa

Text Design & Composition: North Market Street Graphics

Library of Congress Cataloging-in-Publication Data:

Fleming, Bill, 1969–
 Advanced 3D photorealism techniques / Bill Fleming.
 p. cm.
 ISBN 0-471-34403-6 (pbk./CD-ROM : alk. paper)
 1. Computer graphics. 2. Photo-realism. 3. Three-dimensional
display systems. I. Title.
 T385.F59214 1999
 006.6'96—dc21 99-21928
 CIP

Printed in the United States of America.

10 9 8 7 6 5 4 3 2

CONTENTS

Introduction **vii**

 Book and Technology Overview viii

 How This Book Is Organized ix

 Who Should Read This Book xii

 Tools You Will Need xiv

 What's on the Companion CD-ROM xv

 Getting Started xv

Part One The Principles of Photorealism **1**

Chapter 1 An Introduction to Photorealism **3**

 Clutter and Chaos 5

 Personality and Expectations 7

 Believability 10

 Surface Texture 12

 Specularity 14

 Dirt, Dust, and Rot 15

 Flaws, Tears, and Cracks 17

 Rounded Edges 19

 Object Material Depth 21

 Radiosity 22

 Wrap Up 24

Part Two Modeling Techniques **25**

Chapter 2 Image Map Modeling **27**

 The Image Map Modeling Process 29

 Exercise: Editing the Source Image 33

 Exercise: Modeling the Window 42

 Exercise: Modeling the Glass 48

 Exercise: Modeling the Security Bars 51

 Exercise: Surfacing the Window 53

Image Map Modeling with Depth 60
Exercise: Modeling the Bricks 61

Organic Image Map Modeling 69
Exercise: Modeling the Leaf 71
Exercise: Modeling the Stalk 77
Exercise: Surfacing the Leaf 83

Wrap Up 86

Chapter 3 Adding Depth with Seamless, Tileable Models 87

Creating Seamless Tileable Models 87
Exercise: Editing the Cobblestones Source Image 90
Exercise: Modeling the Cobblestones 90
Exercise: Surfacing the Cobblestone Tile 98

Custom Shapes from Seamless, Tileable Models 104
Exercise: Creating a Custom Model from a Seamless
Tileable Model 105

Creating Complex Tileable Models 113
Exercise: Creating a Tileable Room 114

Wrap Up 123

Chapter 4 Creating Tileable Ground Covers 125

Creating a Field of Clover 129
Exercise: Creating a Bed of Clover 130
Exercise: Automatically Cloning the Clover Clusters 137
Exercise: Manually Creating the Clover Patch 140

Staging Natural Tileable Models 143
Exercise: Placing Objects in Ground Covers 147

Wrap Up 157

Chapter 5 Displacement Map Effects 159

Adding Chaos to Ground Covers 160
Exercise: Creating a Tileable Grass Object 160
Exercise: Adding Chaos to the Grass with Displacement Maps 166
Exercise: Creating Major Chaos with a Displacement Map 170

Custom Contours with image Map Displacement 171
Exercise: Creating a Depression in the Grass 173

Displacement Map Animation 176
Exercise: Animating Grass with Fractal-Noise Displacement 177

Wrap Up 179

Part Three Surfacing Complex Objects **181**

Chapter 6 Creating Detailed Image Maps **183**

Creating Rust, Oxidation, and Corrosion 184
 Exercise: Painting Rust 184
 Exercise: Creating Rusty Patches 198

Creating Botany Image Maps 203
 Details of a Healthy Leaf 204
 Details of an Unhealthy Leaf 205
 Exercise: Creating an Unhealthy Leaf Image Map 206

Wrap Up 221

Chapter 7 Morph Target Surfacing **223**

Using Morph Target Surfacing 227
 Exercise: Editing the Goblin Tree for Morph
 Target Surfacing 228
 Exercise: Surfacing the Goblin Tree 236
 Exercise: Morphing Target Surfacing 240

Using Morph Target Surfacing on Simple Objects 242
 Exercise: Using Bones to Create the Surfacing Morph Target 243

Saving Resources with Morph Target Surfacing 247
 Exercise: Morph Target Surfacing of Leaves 251

Wrap Up 257

Part Four Creating Industrial Environments **259**

Chapter 8 Designing City Streets **261**

Creating City Street Elements 274
 Exercise: Modeling a Chain-Link Fence 274
 Exercise: Creating the Fence Poles 282

City Street Surfacing Tricks 293
 Exercise: Creating Alpha-Mapped Dirt 293
 Exercise: Using Alpha Dirt Maps over Tiled Color Maps 297

Wrap Up 303

Part Five Creating Natural Environments **305**

Chapter 9 Designing a Natural Scene **307**

Creating Natural Elements 316
 Exercise: Creating a Goblin Toilet Monument 316
 Exercise: Adding Fringe Grass to the Toilet Rim 343

Wrap Up 347

Chapter 10	**Exploring Ponds and Puddles**	**349**
	Creating Surface Chaos	351
	Exercise: Creating a Murky Water Surface	351
	Creating Underwater Detail	356
	Exercise: Creating Underwater Detail	357
	Creating Water Depth	360
	Exercise: Creating Cloudy Water Depth	361
	Exercise: Adding Grass to the Pond	363
	Wrap Up	365
Appendix A	**CD-ROM Image Map Libraries**	**367**
Appendix B	**What's on the CD-ROM?**	**369**
	Software Requirements	370
	User Assistance and Information	370
Index		**371**

Welcome back to reality! I'm pleased to bring you the next installment of 3D photorealism. The first book, *3D Photorealism Toolkit* (Wiley, 1998), covered the "when" and "where" of 3D photorealism. This book covers the "how." If you haven't already read the *3D Photorealism Toolkit*, I suggest you pick up a copy. That book provides a solid foundation of photorealism principles. While these principles will be covered again in this book, they will be slanted toward outdoor settings, which are very different from the indoor variety. If you are seeking the complete photorealism package, it is a good idea to read both books.

So, what's this book about? *Advanced 3D Photorealism Techniques* is about getting your hands dirty with some actual production work. In the pages to come, you'll work through a number of insightful modeling and surfacing tutorials. Another distinction between this book and the *3D Photorealism Toolkit* is that you'll be spending a great deal more time outdoors. The first book detailed how to create a variety of man-made objects and environments. Now you're going to strip down and get natural. Well, not totally natural, but you will be taking a look at how to re-create the chaos Mother Nature has provided in the wondrous wilderness that surrounds us.

Nothing is more challenging and rewarding than creating outdoor settings. Nature is both chaotic and organized at the same time. The key to success in 3D photorealism is to be able to identify where and when the chaos should be used and, of course, how it can be accomplished. The process of creating photorealistic outdoor environments isn't terribly difficult, but it does require creative thinking. In a world that's nonlinear, you need to be flexible in your approach. That means using creative techniques to model and surface your objects. In this book I cover a variety of simple and easy-to-implement methods that will give you the tools you need to blow minds with your natural environments.

Naturally (no pun intended), you'll also examine some of the man-made chaos that is around us every day when we walk down the street. This is important, because it provides the complete outdoor experience. There is a point where Mother Nature and man come together in our world, and you

need to examine the differences between these two environments so you can blend them properly. It's almost impossible to go anywhere and find a place where man's presence isn't evident. Even if it's nothing more than a rusty pull-tab from a soda can, you still need to explore how Mother Nature and mankind co-exist.

Book and Technology Overview

New technology that expands the capabilities of 3D products is steadily being developed. Even the most basic 3D programs possess many of the essential tools needed for creating photorealistic 3D images. While the capabilities of 3D programs will continue to grow, the principles of 3D photorealism will always remain constant. This book covers countless universal techniques for creating photorealistic 3D images. These techniques are not unique to any specific program; they can be used with any 3D program on the market—well, most of them, anyway. There will be some differences in the extent of the features between the low-cost amateur programs and the more expensive professional programs, but the techniques used for 3D photorealism remain the same.

If you use any of the following programs you should read this book:

- SoftImage
- Alias
- LightWave
- 3D Studio MAX
- 3D Studio
- Strata Studio Pro
- ElectricImage
- Ray Dream
- trueSpace
- Extreme 3D
- Animation Master
- Houdini
- Imagine
- Pixels3D
- Cinema 4D
- POV-RAY

How This Book Is Organized

This book is divided into six parts that take you logically through the process of developing photorealistic images. Each part is a complete concept, allowing you to reach closure at the end. You don't have to read one part to understand another. If you are only interested in the principles of photorealistic modeling you can read Part Two: Modeling Techniques and skip the other parts of the book, although I do recommend you read the entire book if you are interested in the complete process of developing photorealistic 3D images.

Part One: The Principles of Photorealism

This part revisits the ten principles of 3D photorealism discussed in the *3D Photorealism Toolkit*. Of course, this time I'll be gearing the exploration toward natural environments, rather than the man-made examples in the *3D Photorealism Toolkit*.

Chapter 1: An Introduction to Photorealism. Here is where you lay the foundation for a photorealistic 3D image. Chapter 1 identifies the ten principles of 3D photorealism and how they relate to outdoor settings. You will examine several photorealistic 3D images and learn to identify the elements that make them appear realistic. It's all about taking the time to experience the chaos of reality. By the end of this chapter you will be looking at real-world objects in an entirely different way than you ever have before.

Part Two: Modeling Techniques

Modeling is the backbone of 3D photorealism. While having a solid image map is certainly helpful, it can't hide the flaws of a poorly created model. The key to photorealism is to build a solid foundation with detailed models. In this part, you'll explore some ingenious techniques for rapidly developing completely photorealistic models.

Chapter 2: Image Map Modeling. Creating detailed photorealistic models can be a real challenge. That's where image map modeling steps in to make things easier. Image map modeling is a reverse-engineering process in which you model the object from the image map, rather than modeling the object first and then creating an image map to match. Let's face it, photographs can provide an abundance of details that would take you quite a while to re-create in a painting program. Why go through all that effort when you can use the photograph as your actual image map? This chapter has several tutorials involving the little-used yet very powerful image map modeling technique.

Chapter 3: Adding Depth with Seamless, Tileable Models. One of the most challenging aspects of natural scenes is ground cover. It's visible in nearly every natural setting yet absent in all but a few 3D images. While a variety of image maps that represent ground cover are available, they lack depth and therefore appear very unrealistic. You can't have a character running through ground cover when it's flat beneath their feet. This is where tileable image maps come into play.

Tileable image maps are a creative method for replicating the 3D ground covers of real natural environments. They also come in handy for creating repeated details in industrial environments. In this chapter, you'll explore techniques for creating both industrial and natural tileable models that will make your scenes come to life with extraordinary depth.

Chapter 4: Creating Tileable Ground Covers. Probably one of the most fascinating elements created in 3D images is the natural structure. Natural structures are man-made buildings or elements that are built using natural materials such as rocks, adobe, bricks, and boards. It's amazing how inspiring a rickety, old shed in the middle of a wheat field can be. There is something about the natural structure that fascinates us.

This chapter covers several techniques for creating a number of natural structures, which can greatly enhance your natural settings.

Chapter 5: Displacement Map Effects. Natural environments are nothing but chaos. The last thing you want to see is repeating details in an outdoor setting. Mother Nature has a way of making every element unique. Like the old saying goes, no two snowflakes are alike. Therefore, to accurately re-create outdoor settings you need to incorporate chaos. That's where the displacement map comes in. Nothing is better for adding chaos than a displacement map. This chapter takes a look at how displacement maps can be used to add irregularities that tend to repeat, such as ground covers, to your natural models.

Part Three: Surfacing Complex Objects

Surfacing organic objects can be a real nightmare. New techniques, such as implicit UV mapping, allow you to create a single image map to wrap around a model. However, these techniques come with problems, particularly that of creating a seamless map when your mesh template is all over the place. There are some simple and universal techniques for surfacing organic objects that will save you time and headaches, and this part explores several of those techniques.

Chapter 6: Creating Detailed Image Maps. The earmarks of a photorealistic surface are chaos. Just take a look at human skin, and you'll quickly see that it's more than a single tone. In fact, it changes tone radically across even the

smallest region. This is the chaos of reality. The same chaos applies to natural and industrial surfaces. If you are to mimic the chaos of real surfaces, you need to start incorporating these details into your surfacing regime.

This chapter covers several very simple techniques for adding this surface chaos to your image maps.

Chapter 7: Morph Target Surfacing. Morph target surfacing is a real lifesaver when it comes to creating realistic environments. Have you ever tried to surface a tree, where the branches have the surface grain flowing along their length as real trees do? Well, then I'm sure you've realized just how frustrating this can be. Fortunately, there is a simple and effective solution: morph target surfacing.

You can use morph targets to position the original object so it can be surfaced effectively, and then use the morph target to position it naturally. In this chapter you'll work through a number of tutorials on morph target surfacing, which will introduce you to one of the easiest methods for surfacing even the most complex objects without creating endless headaches.

Part Four: Creating Industrial Environments

One of the most popular 3D settings is the industrial environment, or man-made worlds. It's only logical that we would re-create the world around us. Of course, there are a number of things to consider when creating industrial environments. This part explores the concepts and practices of creating 3D industrial worlds.

Chapter 8: Designing City Streets. What's the human fascination with dark alleys and grungy streets? Well, they're just plain cool. They have so much personality and chaos. City streets are a smorgasbord of visual inspiration. Let's face it, a heaping pile of junk is captivating. It gives our eyes so much to focus upon. Who doesn't enjoy a junkyard? I, for one, can't get enough of them. To me, rust is simply a beautiful array of colors and textures.

This chapter explores all the finer points of creating city streets, including the placement of details and the types of chaos to apply.

Part Five: Creating Natural Environments

You rarely see natural settings in 3D images, probably because they appear very daunting and challenging to create. While it's true they require more effort than an industrial environment, they really aren't more complicated. They just have a different way of representing the details. Natural settings still have to comply with the ten principles of 3D photorealism—they just do it in their own unique way. This part studies how natural environments are devel-

oped and outlines several techniques for quickly and accurately re-creating the complexities of the natural world.

Chapter 9: Designing a Natural Scene. Designing natural scenes can be quite a task since there is such a wealth of chaos in the wild. In this chapter you'll be exploring some very simple guidelines for creating natural environments. These guidelines will provide you with a formula for insuring your success every time you embark upon creating natural worlds.

Chapter 10: Exploring Ponds and Puddles. Water effects are one of the most complicated tasks to undertake in the 3D realm. They are particularly challenging because they tend to require volumetric effects, which most programs don't do, and those that do take quite a while to render them. Fortunately, there are some very simple and effective techniques for simulating the complexities of water surfaces without the big render time or a need for special tools. These techniques can be done with every 3D program and only take a few minutes to perform.

This chapter covers several aspects of water effects, such as creating cloudy water, creating water depth, surface chaos, and underwater chaos.

Appendixes

The two appendixes cover resources for modeling source material and a complete reference of the bonus items on the companion CD-ROM. Appendix B, What's on the CD-ROM? should be your first stop in this book, so you can get a feel for the location of the support files you'll need in the coming tutorials.

Appendix A: Image Map Libraries. Image map modeling requires good source material. It can be very difficult to find high-quality color images of objects you wish to model. Appendix A contains a comprehensive listing of resources for image maps on CD-ROM.

Appendix B: What's on the CD-ROM? In Appendix B you'll find a reference of the support materials on the companion CD-ROM. In addition to support materials, you'll find free photorealistic models and image map modeling templates that will make your photorealism work a bit easier.

Who Should Read This Book

This book is for 3D artists who want to take their images to the next level. If you are truly dedicated to making photorealistic 3D images, you should read this book. Most of the 3D books I've read seem to throw the word *photorealism* around like the multimedia industry once did with the word *interactive*. It's one thing to call an image photorealistic, it's another thing to take the time to

really make the image realistic. I have a simple definition for *photorealism*: If it looks like a photograph, it's photorealistic—no more, no less. A 3D pond isn't photorealistic unless it has the cloudiness of small particle debris under the surface of the water. A leaf isn't photorealistic unless the edges show some signs of having been eaten by insects, of the dryness of aging. And, of course, nothing is photorealistic if it's perfect. If you want to create 3D images with unprecedented levels of photorealistic detail, then this book is for you.

If you fall into any of the following categories you should read this book:

Seeking a career in 3D. If you are seeking a career in 3D graphics, this book is a must. While there are literally thousands of 3D artists seeking work, only a handful are capable of generating photorealistic 3D images. A proficiency in creating photorealistic images puts you at the top of the stack of resumes in the major studios. You should read the book cover to cover because it will give you a distinct advantage in the job market.

Multimedia/games. If you are in the multimedia or game industry you are well acquainted with 3D graphics. 3D effects have permeated every aspect of your industry. Where it was once acceptable to use 2D or low-quality 3D graphics, photorealistic effects are now mandatory. Competition is fierce, forcing you to keep improving the quality of your 3D graphics. In this book you'll discover hundreds of techniques for wowing your customers and clients with photorealistic 3D effects.

Film/broadcast. No industry is more particular about the quality of 3D work than yours. Every form of visual media is being saturated with 3D graphics—whether it's needed or not. From virtual sets to animated stunt characters, 3D effects have become a part of nearly every film and broadcast production. Traditional special effects are being replaced with digital effects. This book provides you with the knowledge to create photorealistic sets and props for your next project or production.

Print media. Computer graphics have taken your industry by storm. More 3D graphics are popping up in print media every day. Your industry is probably the most challenging when it comes to photorealistic 3D. Unlike the film industry, where most things move by you too fast to really get a good look, your work lies there motionless, so even the smallest flaw can stand out like a beacon. This book shows you countless techniques for creating eye-popping photorealistic images that will keep your viewers glued to the page.

3D modelers. You are the foundation of every 3D image. It all starts with modeling. If you want to know the secrets of making photorealistic models, you should dive right into Part Two. You'll discover dozens of proven techniques for adding photorealistic detail to your models.

3D texture artists. There is no more important element of photorealistic 3D than the textures. You are saddled with the responsibility of creating the eye candy. It's up to you to create realistic textures that make the model photorealistic. You've mastered the painting technique, but now you want to learn the elements that make a texture realistic. You should skip ahead to Part Three, where you'll learn how to add subtle nuances to your textures to make them undeniably realistic.

3D staging and lighting technicians. You're sitting there with a pile of 3D models that have beautiful textures, and now it's up to you to package them in a photorealistic environment. Part Four will show you how to mimic the chaos of reality in your scenes. You'll learn techniques for making your scene look natural, not staged. You'll also learn techniques for lighting every situation you'll encounter.

Hobbyists. You've been experimenting with 3D and you really want to do something spectacular. Let's face it, you want to show the world what you're capable of doing. You want to leave them dumbfounded when they look at your 3D images. Well, you're only 300 pages away from doing just that! Remember this: Photorealistic 3D is more attention to detail than artistic talent. Let everyone else be artistic—you'll be photorealistic.

Whether you are an amateur or a professional, you will benefit from reading this book. In short, if you are a 3D artist who's interested in creating photorealistic images, read this book!

Tools You Will Need

You will, of course, need a 3D program to take advantage of the information this book has to offer. Any 3D program is fine, the principles and techniques discussed here are not limited to any one program. I do recommended that you purchase SoftImage, Alias, LightWave, or 3D Studio MAX if you are interested in exploring all the resources described in this book. The lower-priced programs typically lack a few of the surfacing and lighting features that make photorealistic 3D images possible. You can still create great-looking photorealistic images with the lower-priced programs, but the quality just won't be as high as the professional programs.

To grasp the concepts in this book, you also will require a working knowledge of the modeling, surfacing, staging, and lighting aspects of your 3D program. The main focus of this book is to illustrate the principles and techniques of 3D photorealism. It doesn't cover product-specific examples. If you are just beginning to explore 3D, you should become more acquainted with your program before beginning to read this book.

You will also need a painting program, such as Photoshop. This is an important tool when creating the different types of image maps. Some Photoshop techniques will be described in Part Three, but the same techniques can be applied with Fractal Design Painter and Corel's Photopaint.

The last item you need is patience. You have to be dedicated to creating photorealistic 3D images. It doesn't happen overnight. It takes practice and experimentation, but in time it will become second nature. You won't even have to think about doing it.

What's on the Companion CD-ROM

The companion CD-ROM contains a variety of support materials for creating photorealistic 3D images. The support materials for the examples discussed in this book are provided in common formats such as 3DS files and JPG images that can be used by any program on any platform. The bonus models are available in several common formats and the bonus image maps are in a high-quality JPG format.

Getting Started

Creating realistic outdoor environments can be both exciting and challenging. Fortunately, you have many techniques and principles at your fingertips that will help to eliminate the challenge of creating realistic environments. Well, it won't *remove* the design challenge of re-creating reality, but it will eliminate the tiresome headaches of production work. In fact, after reading this book, you'll find 3D photorealism to be one of the easiest endeavors you've undertaken. Okay, I know that sounds a bit oversimplified, but you will definitely find many techniques in this book that will cut your development times in half, if not a third, and you can't beat that.

What are you waiting for? Dive in!

The Principles of Photorealism

I'm sure a great number of you are already familiar with the principles of photorealism from the *3D Photorealism Toolkit*. In case you aren't, this chapter takes another look at them and how they apply to natural settings, rather than the industrial settings examined in the *3D Photorealism Toolkit*. If you have already reviewed the industrial version of these principles, I suggest you take a moment to read the forthcoming natural variation since it explores an entirely different aspect of the world around us.

Creating photorealistic worlds requires a keen eye for detail. Nothing is more important than detail when you are attempting to re-create realities in 3D. The trademark flaw of most 3D images is lack of detail. The principles of 3D photorealism are all about details. Each one focuses on a specific detail of the object or environment. Together, they serve as a guide to help you insure your image meets the basic criteria for photorealism. It's not as hard as it may seem. Creating photorealistic images is more about patience than anything else. When we become impatient we skimp on details, and our environments lose that sharpness of reality. I know it's tough to be patient. I tend to be very impatient, so I keep the ten principles of photorealism posted next to my computer to remind me—or rather, to haunt me—so I don't become so impatient that my work suffers. Patience is the backbone of 3D photorealism, and we must try our best to stay focused on the details and not the clock.

Okay, that's enough chatter. Let's dive into Chapter 1, "An Introduction to Photorealism" and take a look at how the ten principles of photorealism apply to a natural environment.

COLOR FIGURES ON THE CD-ROM

Before you begin the chapter, all of the figures shown in this book are mirrored, in color, on the companion CD-ROM. I recommend you check out the CD-ROM and view the images while you read the book. There will be details in the figures that you can't see as clearly in the printed image.

An Introduction to Photorealism

What makes an image photorealistic? There are countless factors, but we'd grow old trying to cover all of them, so I've broken them down into a set of general guidelines that I call the ten principles of 3D photorealism. These principles will help you insure the images you create are photorealistic. They apply to both industrial environments and natural settings. Of course, the nature and extent of the principles do change from industrial to natural since there aren't that many rusted plants in the real world. Let's take a moment to examine the ten principles of 3D photorealism:

1. Clutter and chaos
2. Personality and expectations
3. Believability
4. Surface texture
5. Specularity
6. Aging—dirt, dust, and rot
7. Flaws, tears, and cracks
8. Rounded edges
9. Object material depth
10. Radiosity

To insure you have achieved photorealism, you simply need to look at your image and compare it with the ten principles of 3D photorealism. While your

image doesn't necessarily need to conform to all ten at the same time, it should at least adhere to seven of them.

There you have it. Ten simple principles to use as guidelines in your photo-realistic 3D endeavors. What are they all about? I was hoping you would ask. This chapter briefly outlines each of the principles to give you a basic understanding of their application. Each principle will be explored in greater depth in the coming chapters.

Let's take a moment to examine each of these principles by seeing how they were applied to an image located in a natural setting. Before getting started, we should gather a little background about the image. It's important to understand the background so you can understand how and why the principles of 3D photorealism were applied to the image. Take a look at Figure 1.1.

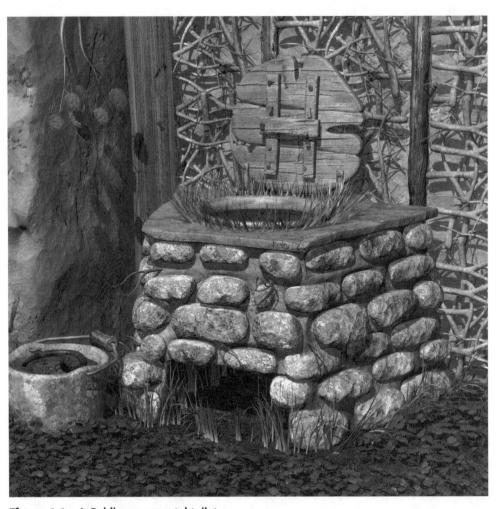

Figure 1.1 A Goblin ornamental toilet.

This image shows a Goblin ornamental toilet. Yes, Goblins view toilets as works of art. Actually, they have no idea what toilets do. They just like the way they look. Who would have imagined that the toilet was pioneered 60 million years ago by the Goblins? It was news to me. Most Goblins have ornamental toilets in their backyards. They usually reflect the personality of the Goblin. This particular toilet belongs to Crouch, the Goblin equivalent of Indiana Jones. Crouch is an adventurer, so his toilet is quite large, and it resembles the great temples of Island of Yoran. Crouch is the only Goblin who has actually seen the temples, so all the other Goblins think he's been hitting the fungus juice (a.k.a. Goblin moonshine).

Okay, so what are Goblins? They are a race of creatures that lived 60 million years ago in the Tertiary period on a small island in Lake Victoria, located in modern-day Tanzania, Africa. The typical Goblin is only 6 to 8 inches tall, so they are perfect for our study of natural environments since we need to be very close to the environment to actually see the Goblins. One of the most fascinating areas of 3D graphics is the small world of nature, meaning the close-up view of nature.

Now that we have a basic understanding of the story behind the scene, let's take a look at how the principles of 3D photorealism were applied to the image in Figure 1.1.

Clutter and Chaos

There is much more to photorealism than applying real image textures to objects. The way you stage a scene defines the realism. For example, a clearing in the grass that is a perfectly defined circle looks too planned. Even if the textures are amazingly real, the scene will end up looking like it was planned rather than a product of nature. It just won't look natural unless the proper chaos is added to the clearing. In reality, the clearing would have a nonuniform shape, with parts where the border was clearly defined and others where the grass crept into the clearing. It is important to add chaos and clutter to your natural 3D scenes to paint a little reality in the picture.

Clutter is the most obvious trait of reality. A common problem in natural 3D images is the lack of clutter. They are just too sterile, with everything neatly arranged. If you look out the window, you'll see that reality is chaotic. Yes, there is order, but it occurs on a grand scale, meaning the forests are located in places of rainfall and the deserts where there is little water. If you take a closer look at these regions, you'll soon see they are fraught with chaos. Rocks aren't neatly aligned, nor are they rotated to be parallel with the ground. Things are off kilter, indicating the presence of animals foraging for food. Trees have fallen from storms. Branches are broken where larger animals have walked

through the brush. Puddles and bogs remain from past rains. You get the idea. Nature is chaos on a small scale.

Chaos doesn't mean that everything is completely disorganized, but it does mean that no two elements are the same. It also means that everything in the scene cannot be aligned perfectly. You can create order by placing the larger stones on the top of the hill and the smaller ones at the bottom. This order makes sense because we expect the larger stones to break into smaller pieces as they roll down the hill. What you can't do is neatly organize the stones by their size, nor can you make them all the same size. There is no uniformity in reality, yet for some reason, 3D-rendered scenes often defy reality by neatly arranging everything. We tend to get too organized when we develop 3D environments because the whole process is so technical, which seems to beckon organization. It's easy to get caught up in the rigidity of 3D engineering. You need to break loose of the engineering binds of 3D and experience the creative side.

When you are designing your 3D worlds, make it a habit to place things out of alignment. Don't get carried away—you just want to add enough chaos so the scene doesn't appear planned. You'll see it makes a big difference in the photo-realism of the scene.

Now that we have a handle on the principle of chaos and clutter, let's see how it applies to the goblin toilet scene. Take another look at Figure 1.1, and you'll soon see a balance of clutter and chaos. Notice how there is a variety of clutter on the ground. There is a clover ground cover with an underlying layer of moss and small pebbles. This helps to break up the monotony of the dirt. Far too many 3D images feature a simple, repeating dirt surface with nothing to add chaos.

Another element of chaos and clutter is the grass that's growing around the base of the toilet. In fact, there are two types of grass to add more chaos. It's highly unlikely that the weeds and grass will be limited to a single classification. In reality, a variety of species would be present.

Now take a look at the rocks that are embedded in the clay. Notice how they are all different shapes and sizes. They are aligned chaotically, yet are still somewhat organized so they appear manufactured. Of course, you can't ignore the completely chaotic weave of twigs embedded in the wall behind the toilet. This is a great detail that adds tremendous depth and chaos to the scene. The clay wall by itself certainly would have been interesting, but the addition of the twigs helps to make it appear both manufactured and naturally chaotic at the same time.

All of these elements are essential for the scene to appear realistic. While they could be replaced with a variety of other details, the chaos they produce is key to the success of the image. This brings us to the next principle of 3D photore-alism: personality and expectations.

Personality and Expectations

What does personality have to do with 3D photorealism? Everything. It's important to express the creators of the environment, whether they are people, creatures, or elements of nature. In this world, there are few sanctuaries that people or creatures haven't altered. Because of this, nearly every natural 3D scene has some element of their intervention. Every creature, whether human, mammal, insect, or goblin, has a distinct personality that it reflects in its environment. Each has a particular way of doing things. It may be sloppy, as is the case with Goblins, neat like the insects, or completely chaotic like the average human.

In any case, every kind of creature definitely has a preference for the way to structure its environment. You need to dedicate some time to exploring the theoretical creators of your scene before you begin construction. The personality you imbue in your scene is the endearing element that hooks the viewer. Even though a character may not be featured in the scene, it was most definitely created by someone or something. You can't forget the elements of nature when you develop natural settings.

While the creators of the environment may not be cognitive creatures with a personality, they certainly have an impact on the personality of the scene. A rain forest has certain features that we have come to expect. These features comprise the personality created by the elements. For example, tall towering trees with heavy growth at the top create the canopy common to the rain forests along the equator. This canopy is an aspect of the rain forest's personality. If you are creating an equatorial rain forest, you'll need to include this canopy as part of the scene's personality. Then, on a smaller scale, you'll need to incorporate other elements such as the chaos created by the tree-dwelling animals or the erosion created by the insatiable appetites of insects.

In short, you need to understand the personality of the scene's creators before you can develop a photorealistic natural environment.

Expectation

When exploring the personality of your scene's creators, it's important to consider the viewer's expectations. Expectation is a large part of photorealism. We have come to stereotype nearly everyone and everything. While stereotypes may not always be flattering, they do provide us with good guidelines for developing photorealistic scenes. Stereotypes don't limit your creativity; instead, they provide you with simple guidelines for insuring your work will be photorealistic.

For example, we assume that grass will grow around any permanent structure in nature, such as buildings, trees, and rocks. A natural scene lacking this grass will appear unrealistic because we expect to see it. In fact, let's take a look at the natural personality of our Goblin toilet image. Figure 1.2 shows a close-up of the toilet base.

Here's a great example of grass growing around a permanent object. The toilet is surrounded by grass, with a good amount growing underneath it. In fact, the toilet opening on the top is also bordered by grass. This is an element we expect to see in something that has been sitting in one spot for a long time. The clover ground cover is also an expected element. We don't necessarily expect to see clover, but we do expect to see some form of ground cover in a relatively humid environment. How do we know it's humid? The clay structure is the giveaway. For clay to be present, there must be a relatively good deal of humidity. Therefore, we would expect to see ground cover.

Of course, not all of the personality in the environment comes from nature. Some of it may belong to a character or creature. In these cases you need to show a blending of natural personality and character personality, which can be seen in Figure 1.3.

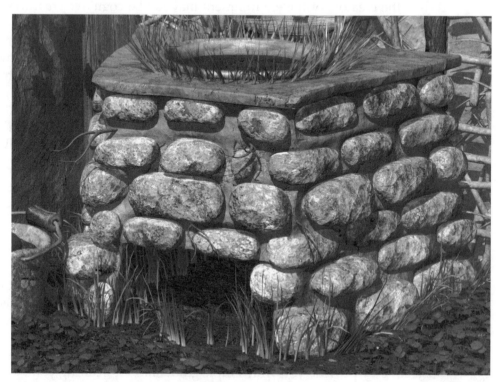

Figure 1.2 The natural personality of the Goblin toilet scene.

What are the elements that express Crouch's personality? The first would be the construction of the actual toilet. Crouch is an adventurer, so his toilet is quite large and resembles the great temples of Island of Yoran. This is a very distinct expression of the character's personality, since he is the only Goblin who has actually seen the temples of Yoran. Another expression of his personality is the bucket full of worms. He's a friend and partner with Drale the Bug King, so he often has insects wandering around his home. This is a detail that reflects Crouch's personality.

You can see how the scene is starting to make sense based on the personality of both the environment and of Crouch. It's very important to get inside the head of the characters responsible for the development and maintenance of the scene you are creating. It's also a lot of fun.

Work with the Viewer's Expectations

While all viewers of your images may not be experts on natural environments, they do have certain expectations. For example, we expect a natural environment to be very chaotic, with weeds and grass covering portions of it. If there

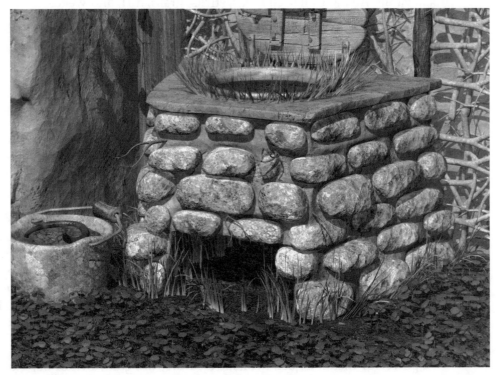

Figure 1.3 Identifying the character's personality.

are trees with leaves, we expect to see some of the leaves on the ground where they have fallen off the tree. If it's a damp environment, we expect to see ground cover and moss; if it's a dry environment we expect tumbleweeds. If the environment is a pine forest we expect to see pine needles covering the ground. If it's a tropical environment we probably expect to see dead palm leaves on the ground.

As you can see, you don't need to be an expert to have expectations, but you do need to conform to the viewers' expectations if you want them to consider your images realistic. It's all part of making the scene believable—which just happens to be the next principle of 3D photorealism.

Believability

What is the key to believability? Probably the most important aspect of believability is object recognition. The objects, including surfaces, must be recognizable to be believable. They must be familiar, so that the viewer will have something to solidify the realism of the image. Actually, the concept of believability is very simple since nearly everything in a natural environment is believable. We have all seen rocks, sticks, grass, dirt, and weeds.

There is very little you can add to a natural environment that isn't believable. You do need to focus on the modeling and surfacing. No matter how common the object may be, it needs to be modeled and surfaced properly so the viewer will believe it is realistic. To get a better idea of the concept, let's take another look at Figure 1.1.

What makes this scene believable? Nearly everything in the scene is believable. First and foremost, the scene is composed of common natural elements such as grass, clover, sticks, and rocks. All of these are real-world objects we see nearly every day (that is, unless we live downtown in a big city; then nature would be a cement sidewalk and metal grates).

One of the most believable objects in the scene is the worm in the bucket. This object would be classified as an *anchor object*. Anchor objects are those objects that are immediately recognized as real objects. They are called "anchors" because they give credibility to the rest of the objects in the scene. They are so realistic that they make up for the possible lack of realism in other objects. Of course, if you make all of the other objects equally as believable, you have a home run on your hands.

The worm is an immediately recognizable object and a creature, which makes it a powerful anchor object. Realistic creatures are great anchor objects for natural settings. Insects are a particularly good choice since we see them all the

time in reality but rarely see them in 3D images. They are also one of the easier creatures to create since they have an exoskeleton, meaning you don't need bones to pose them and they can be modeled in segments. In addition to being easier to model, insects are also easier to surface. While they may have more chaotic surfaces than most creatures, they don't have fur, which makes them a great deal easier to make believable.

As a rule of thumb, it's not a bad idea to drop a few insects into your environments to anchor their believability. In fact, let's take a look at how the worm works its magic in another image. Take a look at Figure 1.4, which shows Drale the Bug King and his latest find.

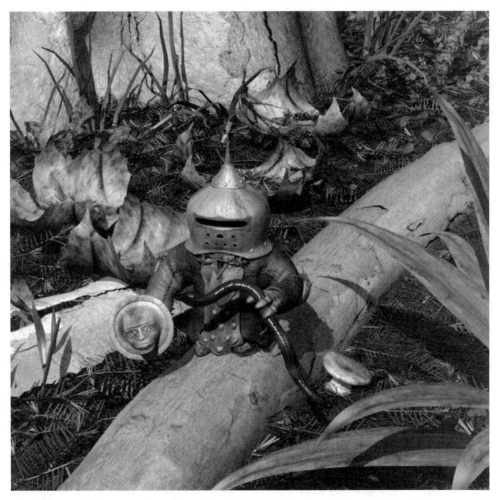

Figure 1.4 The power of anchor objects.

Notice how the eyes are almost immediately drawn to the worm, which looks very realistic. The worm is the photorealistic anchor for the image. While the object anchor is crucial to the scene's believability, it doesn't need to be the main focus of the scene. The worm in Figure 1.4 isn't the main element of the image. The actual focus of the image is Drale the Bug King. The worm is a logical part of the story but not the main element. While there may be a number of object anchors in a scene, the worm is actually the only object anchor in this image. You'll find that a single anchor object will likely do the job, though it doesn't hurt to have a few just in case.

Of course, nearly everything in the image is recognizable, from the pine needles to the mushroom. While these are familiar objects, they aren't necessarily anchor objects because they don't have a strong impact on the scene's photorealism. They are supporting cast members, and the worm is one of the stars. Anchor objects are defined as photorealistic objects that draw the viewer's eyes. *Familiar objects* are also photorealism anchors, but they aren't as prominent in the image. They are included to reinforce the credibility of the image. Your eyes aren't drawn to these elements immediately, but as they drift around the image, these objects will help to reinforce the realism of the image.

Make an effort to include both anchor objects and familiar objects in the construction of all your natural environments. Of course, the surfacing of the object is responsible for a great deal of its credibility. The next three principles of 3D photorealism explore the surfacing guidelines, so let's keep going.

Surface Texture

All real-world objects have surface texture. Don't confuse the term *texture* with the reference commonly used in the 3D industry. Texture does not mean the coloration of the object. In fact, the proper definition of texture is the physical surface you can feel, the roughness or smoothness of the object surface. All objects have some form of surface texture, even the smooth ones.

A common problem with surfacing of 3D objects is that they are almost always too smooth. Frequently you will see perfectly smooth leaves and wood, which are just plain unnatural. Keep in mind that just because you can't feel a texture it doesn't mean it's not there. The texture may be too subtle to feel, but it will definitely show up in the object's specularity—particularly if the object is animated. You will be able to see subtle glints of light on the surface, particularly if the object is slightly wet.

Nearly every object in the natural world is porous, particularly if it is alive. To make these objects realistic you need to show the pores. The same applies to wood grain. In fact, wood grain is very important because it's much more

obvious in the wilderness. Remember, the wood in nature hasn't been sanded down to be smooth to the touch. It's very rough and porous. To make natural wood appear realistic you need to add a heavy texture to the surface. Let's take a look at the surface textures in the Goblin toilet image, shown in Figure 1.5.

Notice the rough texture of the toilet lid wood. This is an example of an unrefined wood surface. These boards are very crude and therefore rather rough. Now take a look at the wood poles behind the toilet. These are simple branches that still have bark, so they are also rough to the touch. Okay, so the wood is the most obvious textured surface. Now let's look at something less obvious, like the clay on the toilet. Notice how the clay is both rough and smooth at the same time. There are patches of roughness and areas where it's relatively smooth. This is an excellent use of texture. Natural objects don't have the same surface texture over their entire surface. The texture can vary widely, unlike most man-made objects, which tend to have a consistent texture.

If you look closely, you'll also see a crumpled texture covering the whole surface of the clay. This is a key detail. The toilet is obviously crafted, and primitively at that, so we need to show signs of its having been manufactured. The

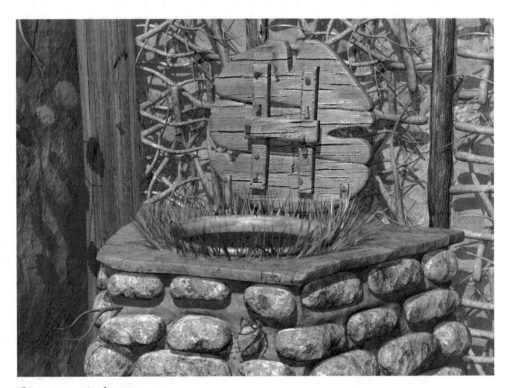

Figure 1.5 Surface texture.

crumpled lines represent the strokes made by the trowel that was used to pack and smooth the clay.

I could go on all day about the surface texture in this image, but you get the idea. The key is to always apply surface texture to natural objects and to make an effort to keep it from being uniform. If you adhere to those two guidelines, you'll end up with some very realistic surfaces.

Since specularity is the key to visualizing surface texture, we should next take a look at the fifth principle of 3D photorealism.

Specularity

Simply put, specularity is the reflection of the light source on the object's surface. It's a bright spot that the human eye uses to determine the surface's shininess and hardness. Specularity is a very important aspect of photorealistic 3D images. It's necessary to add specularity to mimic the real-world attributes of the surface. Without specularity, the object would appear dull, soft, and flat. While this can be good for man-made objects, it doesn't do much for natural objects, which tend to show more life, meaning they have moisture. When specularity is applied, it adds specular highlights to the tops of the surface bumps. This does two things: It gives the surface bump a 3D feel, and it provides a visual reference for hardness. This is the most important element of natural 3D images. The tiny specular highlights on the bumps bring the surface to life.

Let's face it, a smooth, dull worm would be less than realistic. Ditto for leaves, bark, and even rocks. Yes rocks. While they aren't typically wet, they do have tiny crystals that reflect light, which is particularly evident in granite. Objects don't need to be alive to be specular.

Let's take a look at how specularity impacts the photorealism in the Goblin toilet image. Take another look at Figure 1.5. Notice the glint of light across the surface of the toilet lid. The wood has a very low specularity, but it is also soft so the specularity spreads across the surface. This is a key detail since the specularity helps to define the hardness of the object. The diffused specularity of the toilet lid tells us that it's very soft, which is normal for rotten wood. If Crouch were to actually sit on the lid he'd fall into the toilet. It's a good thing they don't actually use the toilets.

Now take a look at the metal toilet seat rim. Notice how there are specular highlights on the gray portions but very few on the rusted portions. Owing to its crystalline nature, rust can be very specular, but this rust is powdered due to the unrefined ores in the metal, so it doesn't reflect much light at all. If any-

thing, it "absorbs" light. It's important to consider the background of the object you are surfacing when you add specularity so you don't end up over-doing it.

Of course, the environmental conditions also have a large influence on specu-larity. In a humid environment such as this, the objects will all be slightly spec-ular since there is moisture in the air. If this were a desert shot there would be little specularity except on those objects that stored moisture such as plants. As you can see, it's important to identify the environmental conditions of the scene to properly apply specularity.

Now that you have a handle on specularity, let's take a look at the sixth prin-ciple of 3D photorealism: dirt, dust, and rot.

Dirt, Dust, and Rot

Dirt, dust, and rot are very important aspects of an object's surface, and they are commonly referred to as *aging*. There are few clean surfaces in reality, par-ticularly in nature. Just look around your yard, and you'll find that almost everything is covered in dust or dirt or is rotting. Yes, rotting. While your yard may not be a compost pile (I hope it isn't, anyway), there are still many objects that will show aging in the form of rotting. Take a close look at the leaves on your plants. They are likely to be brown on the edges. If you have a vegetable garden or fruit trees, you know that vegetables and fruit that lay on the ground rot. It's Mother Nature's way of fertilizing soil so the plants will grow better next season.

Aging is a large part of any natural scene, and it is much more important than seen in man-made environments since nature is constantly replenishing itself on an annual cycle, while mankind prefers to make things last forever—that's the goal, anyway. For natural environments to look realistic, they need to show an abundance of aging. In a field of flowers, for example, there must be a large number of flowers that have wilted. A field of perfect blooms would look painfully unnatural. In a forest, there should be moss on trees, which shows aging. Moss and mushrooms are fungi, and therefore indications of rot.

There is literally no end to the number of ways you can age a natural environ-ment. For example, during the fall, you'll need to have dead leaves laying on the ground and barren tree branches. During the summer, the foliage should be brown since it's past the rainy season of spring and well into the hot months that literally bake foliage. Aging in a natural setting has a great deal to do with seasons and climate. Things tend to rot much faster in a humid environment. You don't get much rotting in a desert, where it's dry and hot.

Let's take another look at the Goblin toilet (Figure 1.6) and see where the aging was added.

Start with the toilet clay. Notice how it's covered in pits and cracks. It also has a number of depressions where the clay has dried up and fallen off. If the clay had a consistent texture, it would look brand new and definitely out of place in this setting where we have grass growing everywhere, telling us that the toilet has been around a while.

Since we're looking at the clay, we might as well examine the rocks next. Notice how they are a variety of colors. This represents all types of fungus on the surface, which is a sign that the rocks have been here a while and that the environment is humid. All too often we see perfect rock surfaces in 3D images. That can happen in desert regions, but in tropical areas the rocks tend to be covered in all sorts of cool stuff like fungus and moss. Adding these elements to your surfaces will really make them come to life.

Of course, we can't ignore the rust on the toilet seat rim. The Goblins use unrefined metals that tend to rust very quickly, particularly in a humid environment such as this one.

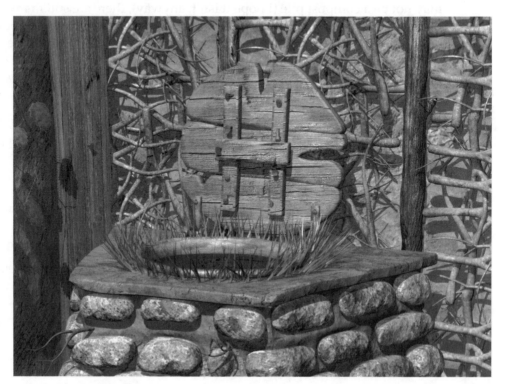

Figure 1.6 Identifying the aging.

Now there is one last element of natural aging that we have already discussed a number of times. This would be the grass that grows around the base of the toilet and the toilet seat. This is a unique form of aging that applies only to the natural world, but it is very cool. It lets us know that the objects have been there a while. If we wanted to make them appear as if they have been there even longer, we can place dead blades of grass lying on the ground beneath the new growth. Adding the botanical aging can be a great deal of fun. It also adds tremendous depth to the image.

Another form of botanical aging is the presence of roots sticking out of the mud on the toilet. It looks like something new is growing inside the toilet and the roots have made their way to the exterior. This helps to break up the surface of the toilet and shows once again that the toilet has been here a while. As you can see, aging is a critical aspect of natural environments. Without it, they wouldn't appear realistic.

Another element of aging that we haven't covered is flaws, tears, and cracks. As you have probably guessed, that's the topic of the next principle of 3D photorealism.

Flaws, Tears, and Cracks

Nothing makes an object look more artificial than a flawless surface, particularly when it is a natural object. No object in the natural world has perfect surfaces. All of nature's surfaces are full of flaws. Many of them are tiny, such as pores in the surface, while others are more obvious such as rips, tears, and cracks. No matter how perfect something appears to be, there will always be a flaw.

Applying flaws to your objects requires that you first explore the nature of the scene. You must consider several questions before you can properly surface the objects in your scene. Let's take a moment to examine those questions:

What is the object? The type of object determines the aging you should apply. For example, wood and leaves tend to rot because they are soft objects that absorb moisture and are highly organic, meaning they can decompose. Decomposition is the most severe form of aging. On the other hand, rocks suffer from chips and cracks because they are very hard. They can't decompose because they aren't organic. Rocks are simply minerals so they are limited in the types of aging that can be applied. Of course, you can always apply moss or fungus to their surface, but that's more an issue for Principle 6: dust, dirt, and rot. Once you know what type of object you have, you need to consider the environment.

What is the environment? This is a question 3D artists rarely consider when applying surfacing to their objects. It's important to take into consideration

the environment when surfacing an object. As we discussed earlier, wood typically doesn't rot in the desert, but it will crack very easily due to the moisture being drawn out. On the other hand, if the environment is moist, like a forest, the wood is likely to decompose, and quite rapidly. Take a rock in the desert, for example. It's likely to be cracked from the heat making it brittle, while the same rock in a tropical environment would most likely be covered in fungus and moss and have very few cracks. The same rock in a hilly terrain would likely be chipped and possibly broken in smaller pieces due to rolling down a hillside. As you can see, the environment has a great deal to do with the type of aging that should be applied.

Where is the object located? The placement of objects will determine the magnitude of flaws. For example, a log that's sitting in the middle of the dry, hot desert will be very dry and cracked, while the same piece of wood under a rock overhang in the same desert will likely have some moisture and will be less cracked. You need to carefully consider the placement of the object if you are to surface it properly. A rock near the water is more likely to have fungus than one on the top of a hill that is far from the water. Plants in arid climates are apt to be dry and cracked, while those in tropical climates will be moist but will also have damage from bugs eating them. Object placement is critical in the aging process.

Now it's time for a little fun. Let's ask these questions about an object in the Goblin toilet image. Take a look at Figure 1.7, a close-up of the toilet seat.

Notice how the wood is cracked. This is because the seat is exposed to the direct sunlight for most of the day. Yes, it's a humid environment, but since the wood isn't touching a source of moisture, such as the dirt or mud, it gathers humidity during the evening hours and then quickly dries out during the morning hours. This rapid change in humidity causes the wood to crack. If the same object were placed in the shade, it would be rotten from holding a great deal of humidity. The placement of the toilet lid determines the type and extent of aging.

Now take a look at the dark wood pole on the right side of the image. This wood shows aging with a cracked surface, but it's not nearly as bad as the toilet seat because it's embedded in the ground, which is a constant supplier of moisture. The exterior is cracked from sun exposure but not very deeply because the interior of the wood is moist.

As you can see, it takes some planning to determine the proper use of aging. It requires a bit of work, but it's time is well spent when you consider the final result is a truly striking photorealistic image. Just don't get carried away with aging items. If you apply too much aging, the items will tend to look unrealistic. Just apply enough to break up the surface. Nobody will buy into an object

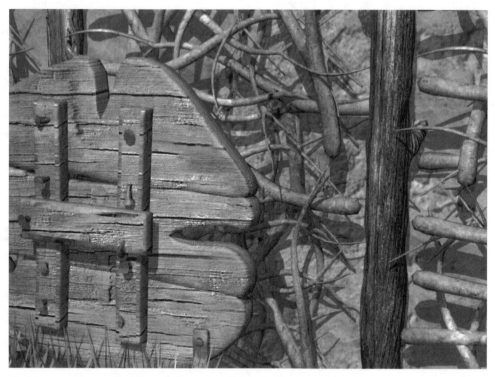

Figure 1.7 Flaws, dents, and dings are signs of aging.

that is completely mutilated...unless it's a completely rotten piece of fruit, which would be a very cool 3D object. I'll have to try that.

Now that we've covered all the staging and surfacing principles, it's time to take a look at the modeling principles.

Rounded Edges

What is the one feature that is missing in nearly every natural 3D object? Rounded edges. Very rarely will you see rounded edges on 3D models. Nearly every natural object has a rounded edge. Mother Nature likes her creations to be relatively smooth so the world doesn't become a gauntlet of razor blades. While leaves may appear to have hard edges, they are actually relatively smooth when examined closely. Of course, they are also usually flexible, so the edge gives when you make contact with it.

While it's important to make your natural objects with rounded edges, it is more important that your creature-made elements have rounded edges. Even in the primitive sense, we are still wise enough to round the edges of the

objects we encounter or handle. When you are creating objects that are made from natural elements, you'll need to round the edges. A rounded edge isn't quite the same thing as a beveled edge. A bevel is a uniform edge effect, while rounding is a nonuniform effect. Simply put, rounding isn't a linear effect. It can change shape and size over the surface of the object. When rounding the edge of a clay pot you typically don't make the rounded portion the exact same width all the way around. These objects aren't machined so they are not exact. This is important to consider. Natural construction with linear, exact edge smoothing is going to appear out of place. The smoothing needs to be as chaotic as the material being used.

Let's take a look at how rounded edges were used in the Goblin toilet image. Take a close look at Figure 1.8, and you'll see rounded edges on the toilet clay.

Notice how even the hard plate on the top of the toilet had subtle rounded edges. You'll also notice that while the edge's smoothing appears rather constant, it does vary a bit. This is a flat object that has been worked quite a bit, so it's likely to have cleaner edge smoothing, unlike the rest of the toilet. At the base of the toilet you'll notice that the rounded edges are rather chaotic. They are well rounded but uneven. This makes sense because the clay base was basically thrown together with little precision, whereas the top was precisely formed.

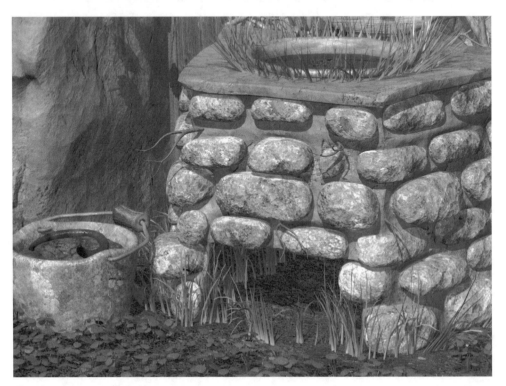

Figure 1.8 Rounded edges.

Now if you look to the left of the image, you'll see the end of a wall, which has rounded edges. Notice how the edge is both very chaotic as well as rounded. This is a good example of applying the proper rounding to an edge. The end where the wall terminates is not a critical feature of the construction. It doesn't need to seam-up with another structure, so it doesn't require any real precision or attention to detail. When you are creating natural structures you should keep in mind where the elements are going to be used. Civilized man is the only creature that takes the time to clean up portions of the structure that are of little relevance. Okay, so the Egyptians also did it, but then they were pretty sophisticated and had a real eye for detail. When building an all-natural structure, you should make sure that the edges are rounded but not perfect. Even the Egyptians' stone blocks had nonuniformly rounded edges.

Let's explore the other modeling principle: object material depth.

Object Material Depth

One of my major complaints about 3D objects is their lack of material depth. They seem to lack physical depth of the material. I've seen far too many objects where their material was thin as paper. While that's fine for paper, it's not good for other objects, such as leaves. Even though leaves are thin, they still have a material thickness that needs to be represented for them to appear realistic. It seems that the leaves in most 3D programs are always paper thin, which is why they appear to be polygon leaves rather than moisture-filled realities. There needs to be some level of thickness for the leaves to hold water.

Another problem with material thickness is seen in ground covers. It's a different form of material thickness, in which the ground cover shows complex details but no height. This is a very serious problem since we can see the details are flat. We often see 3D images in which complex details have been added by simply placing a detailed image map on a simple object. That will probably work from a distance, but it's not very effective when we want to zoom in on the environment. Physical object depth is a necessity when it comes to creating photorealism. In fact, let's take a look at how object depth added tremendous credibility to the Goblin toilet image (Figure 1.9).

Notice how the clover ground cover is a physical mesh, showing great depth and detail. It even casts shadows on the dirt below. It is a very significant element of the scene. It lends tremendous credibility to the image since as viewers we are absolute suckers for depth. We are immediately fooled into thinking the image is real because a 3D image couldn't possibly have that kind of depth and detail. This is yet another example of how depth solidifies the photorealism of a 3D image.

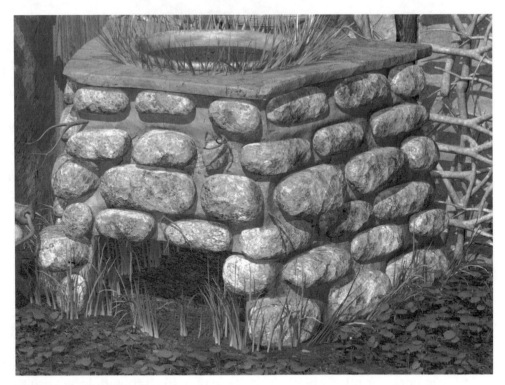

Figure 1.9 Object depth.

Another great example of object depth is the woven twigs on the wall. They offer a great deal of depth while making the image more interesting to look at. While both the clover and twigs look complicated to create, they actually aren't that difficult. The key is to create tileable models, which we will discuss in Chapter 3, "Adding Depth with Seamless, Tileable Models." It's a simple technique that will take your 3D images well beyond the viewer's expectations.

That does it for the modeling principles. Now let's consider the final principle of 3D photorealism: radiosity.

Radiosity

Radiosity is the most critical of the ten principles of 3D photorealism. What is radiosity? I'm glad you asked. Simply put, *radiosity* is the indirect light that is distributed between objects. Most real-world objects reflect light, particularly those that are highly specular or reflective such as water.

Of course, outdoor lighting is far different from indoor lighting, where most of the illumination in any room comes from the light reflected off objects. In outdoor shots most of the light comes from the source, which is the sun. There is

reflected light but not to the extent we see indoors. There isn't much in the way of enamel paints and metals in the wilderness, so the amount of reflected light is dramatically reduced. Of course, there are still a number of objects and surfaces that do reflect light in nature, such as water, rocks, ice, mud, or any wet or crystalline object. Have you ever noticed that everything is completely illuminated on the water or in snow-covered environments? That's because the light is being reflected by the wet specular surfaces. You'll find that things are much brighter after it rains because moisture is covering everything, making all objects reflect light.

When you light natural environments, you'll need to consider the role radiosity plays in the scene. In fact, it may not be a factor at all. It really depends on the environment. Let's take a look at how radiosity was applied to the Goblin toilet image in Figure 1.10.

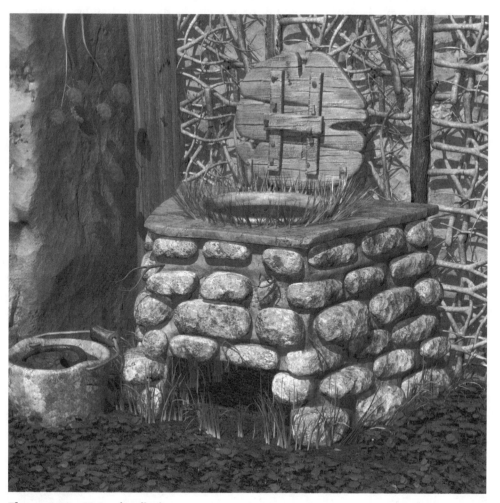

Figure 1.10 Natural radiosity.

You can tell by the direction of the shadows that the sun is behind you and off to the left, yet the back of the toilet is illuminated. This is because the specular clay and rocks are reflecting light into the seam between the toilet and wall. This is a fine example of where natural radiosity should be used. Of course, you can also see that the shadows on the front of the toilet are less defined than the one on the back. That is because they are being hit with stronger light and the radiosity of the rocks and mud is more prominent. In the back there is less light to reflect. There is also a deep shadow under the toilet because there isn't much to reflect the light up into the toilet but dirt, which doesn't reflect light. It's important to consider the reflected light in your images to insure they look realistic. Poor lighting will kill the photorealism of the image.

Now that you understand the concept of radiosity, you can see why it's so important for photorealism. Unfortunately, nearly every natural 3D scene suffers from a lack of reflected light, which has more to do with the program than the artist. Few programs have radiosity. Radiosity is the most complex lighting formula to create. Not to mention that it also adds considerably to your render times. The good news is that many of the developers of popular 3D programs are working on radiosity solutions. So what do you do until radiosity is a feature in your 3D program? You fake it.

Radiosity can be easily faked by using point lights to fill the light gaps. You simply find the areas in your image that lack light and place point lights in them. Of course, the intensity of the point lights and their range are all variables with which you'll need to experiment.

Wrap Up

Well, there you have it, the ten principles of 3D photorealism as they apply to natural environments. See, it wasn't that bad, but it was definitely different than the industrial principles of photorealism. It's important that you fully understand how the principles apply to both industrial and natural environments before you begin to develop your images.

And now the fun begins. You've seen how these principles were applied to the Goblin toilet scene to make it photorealistic. Now it's time to take a look at how you can apply the same principle to your own images. In the coming chapters we'll be using these principles as we work through the modeling and surfacing tutorials. There's a lot to cover, so let's get started!

Modeling Techniques

M odeling detailed, photorealistic objects can be challenging. In fact, it can be downright aggravating. The problem lies in creating enough detail to make the object convincing to the viewer. The common practice today is to apply complex, photographic image maps to simple models. While this works well for real-time games and animation, it doesn't hold up under close inspection. What do you do when you want to fly your camera through a complex environment or zoom in close to see the small details?

A simple model with image maps won't work because you can easily see there is no depth. While a bump map works well for distance shots, it becomes painfully obvious there is no depth when you zoom in close to the wall, which undermines its credibility and all the work you've put into the scene. Depth is the key to photorealism. It's the definition of 3D. If you want a scene to be believable, the objects and surfaces must have depth. Yes, this does require more effort, but it doesn't have to be painful if you know the proper techniques. In fact, it can be a lot of fun.

This part of the book focuses on providing simple and exceedingly effective techniques for adding tremendous 3D depth to your scenes. These techniques can be applied with any 3D program and allow for rapid development of very large and continuously unique environments without a great deal of effort. We'll be looking at image map modeling, tileable models, displacement map modeling, and some tricks for creating highly organic natural structures.

Let's get started by taking a look at image map modeling.

COLOR FIGURES ON THE CD-ROM

Now would be a great time to acquaint yourself with the color figures on the companion CD-ROM found in the following chapter2/figures folder.

Image Map Modeling

C reating realistic image maps for your models can be difficult and time-consuming, particularly if you haven't spent a great deal of time working with painting programs. Let's face it, not everyone is going to excel at painting image maps, but anyone can take advantage of photographs. It took me a while before I could wrap my mind around the concept of painting on the computer. I had spent several years working with vector-based illustration programs like CorelDRAW! and Illustrator, but the idea of painting on the computer was foreign. There wasn't much correlation between a mouse and a paintbrush. Actually, I hadn't painted much with a brush, either, so I was more than a bit intimidated by the prospect of creating custom image maps. I have no trouble doing it now, but then I've logged my share of hours experimenting and making mistakes along the way.

Of course, even if you are a whiz at painting image maps, there is still the problem of creating detailed models for complex environments. That's where a little reverse engineering comes into play. While most people have probably used a template to model against at some time, there aren't that many of us who are actually applying image map modeling techniques. So what is image map modeling?

I've found that it's often easier to work backwards when creating detailed photorealistic models. That is, rather than modeling the object and then painting an image map to fit or trying to make a photographic image map work on a pre-existing model, I gather photographic source material and create a model to match the photograph. For example, when creating a brick wall, it's common to

simply take a stock brick wall image map and place it on a flat plane with a heavy bump map. While this is very fast, it's not very convincing. Why? Simply because the object lacks depth. Sure, you can place a bump map on the image map to create the illusion of depth, but that won't hold water most of the time. If you rotate the camera at any angle other than looking directly at the object, you'll find the bump map will flatten itself out, making the object appear unrealistic. This can be a real problem when animating the camera in a scene, since the object will go from realistic to unrealistic in a matter of seconds.

The solution to the problem is to use an image map as a template for creating the detailed model. Basically, you bring the image map into your modeling program and build the actual 3D bricks to match the image. Once the model is complete, you apply the image map template as the surfacing. Sure, it's more work, but the results are amazing. You'll end up with a model that's completely photorealistic at any angle, even to the most discerning eye. In fact, take a look at Figure 2.1 and you'll see an image that was created with models made using image map modeling.

Most of the objects in this image were created with the image map modeling technique: all of the windows, the cobblestone road, the brickwork, and the

Figure 2.1 An example of image map modeling.

cement walls. Later in this chapter you'll perform exercises in which you'll recreate a number of elements from this image. For now, let's take a look at how image map modeling works.

The Image Map Modeling Process

The first step in the image map modeling process is to find a high-quality image of the object you are going to create. There are a number of ways to acquire source material. You can scan images from books, take your own photographs to scan, or find the images in a CD-ROM image map library. You can find a listing of CD-ROM image map libraries in Appendix A. There are a few things to consider when selecting source images:

Viewing angle. When you are gathering source material for image map modeling, you'll want to insure the image is taken from an orthographic view, meaning looking directly at the object. If the subject is viewed from an angle, you can't use it as a source image because you will have to model the object unnaturally to make it conform to the image. And that, of course, means you won't be able to rotate the camera in your shot since the object won't be proportioned properly. (Well, you could, but your image will end up looking like the surreal work of Dali, which may be very cool but is undesirable in a photorealistic world.) Working with an orthographic source allows you to create a model that can be viewed from any angle.

Image resolution. You'll want to start with an original image map that's at least 1000 pixels across at its widest point. This insures you have an image map that will hold up under close inspection. Nothing looks worse than image map pixelization, which occurs when your 3D program tries to resample an image on close-ups. It tends to become impressionistic, which is a unique style but something of an acquired taste. You can always resample the image smaller for use in distance shots and replace it with the larger image map for close-ups. You will also want to reduce the size of the image when it's used for the modeling template since a large image will eat up plenty of system resources.

Scanners. A scanner is the most useful tool in your photorealism toolkit. It allows you the flexibility of scanning source material, which is done on nearly a daily basis when you are creating detailed environments. A scanner is a necessary tool if you plan to do a lot of photorealistic image maps. Not a day has gone by that I haven't scanned something to use in an image map.

If you plan to purchase a scanner, I recommend you get a high-resolution 24-bit scanner. Avoid the lower-resolution models since the scans will be too small to be of any use. Try to get a scanner that has a minimum resolution of 300 DPI—avoid the 150-DPI models. When scanning images, you'll want to

capture them at the largest possible size. Again, you can resample images smaller, but you can't enlarge them without sacrificing image quality.

Scan patterns. If you already have a scanner, I'm sure you are familiar with the problem of patterns in your scanned images. Most color images are printed at a resolution of 300 DPI. While the human eye can't see the individual dots, the scanner certainly has no problem seeing them, and it is more than willing to include them in your scanned image. The best way to remove the patterns created by these dots is to apply a gaussian blur to the image. Blurring the image will blend the dots so they will be indistinguishable to the human eye. Just make sure you don't use a high level of blurring, or you'll end up making the image appear fuzzy. Since the source image will also be used as the surfacing for the model, you'll want to insure that the quality is good. If you are going to use the image only as a modeling template and not a surfacing tool, you don't need to be concerned about the scan patterns.

Once you have your source image in hand, it's time for editing. Unfortunately, most source images have shadows. If the shadows are left in the image, they will fight your 3D lighting. The last thing you want is a shadow going in the wrong direction. To resolve the problem of shadows, you'll need to load the source image into your paint program and remove the shadows with the cloning tool. The cloning tool allows you to take samples from a different part of the image and copy them to a new location, thus covering up the shadows.

While this part of the book focuses on modeling, we should cover the art of correcting source material before we move on to the image map modeling tutorials. Let's take a look at how a source image of a window is converted into a useable image map. Take a look at Figure 2.2.

This is a photograph of an industrial window, which represents a nearly complete disaster when it comes to image maps. It also happens to resemble the windows in my home just prior to cleaning day, which appears to have been several weeks ago. (Okay, they aren't that bad, but they are close.) This image is from the Seamless Textures You Can Really Use image map library from Marlin Studios. This CD-ROM contains a number of really nice image maps. While this particular image map needs plenty of work before it can be used for image map modeling, you'll find that most of the image maps on the CD-ROM are very nice. You can find out more about the Marlin Studio image map libraries by visiting their Web site at www.marlinstudios.com. They are also listed in Appendix A. Tom Marlin has been kind enough to provide several of his great images on the companion CD-ROM in the chapter2/marlin folder. These are yours to use as you wish.

You'll find this image map for the example in Figure 2.2 in the chapter 2/figures folder of the companion CD-ROM. It's named window.jpg. Load the image into your painting program, and we'll edit it for use in our upcoming exercise.

Figure 2.2 A window source image.

Editing a Source Image Map

In this exercise, I'll be using Photoshop. If you are using another program don't worry, the tools we'll be using are common to every major painting program.

The first step in editing the source image map is to determine what needs to change. Figure 2.3 shows the areas of the image that need to be corrected.

As you can see, this image is a bit of a mess. In fact, it's a big mess. Fortunately, we have enough information in the image to correct all of the errors with a little creative cloning. You'll find that even the most screwed up image will have enough positive elements to correct the flaws.

So, what are the flaws in the image? Before we get into specifics, let's take a look at how to determine the problem areas of an image you intend to use as an image map. Generally speaking, there are three elements that will make an image map appear awkward in a 3D model:

Shadows. Since we intend to trace our own shadows to match the lighting in our scene, we need to remove the shadows so they don't conflict with our lighting.

Figure 2.3 Identifying the problem areas.

Reflections. The same rules apply to reflections that we used for shadows. We certainly don't want something reflecting on our objects that isn't in the scene.

Specularity. Specularity in an image shows a reflection of a light source. Since our 3D images will have different lighting, we need to remove all specularity on the image map so it doesn't fight the specularity in our scene. It would be odd to have a highly specular object in the shadows.

Now that we know what the main problem areas are, let's identify them in our image map.

A. Reflections. There are a number of reflections that need to be removed so you can use the image map on your 3D windows. You want to remove all of the reflections so you can have the window reflect the object in your environment. It would look very odd to have the window reflect objects that aren't in your environment. The most obvious reflection is the photographer. You certainly don't want this reflection.

B. Caulking. The caulking in the upper right windowpane tells us the window was fixed at one point. It would also appear that this effort was rather point-

less since the window is now a complete disaster, but they do get a point for trying. You'll want to remove the caulking in the image map since it is far too white due to the heat of the sunlight and camera flash. You could model the caulking, but then you would need to resurface it to make it appear natural.

C. Hot spots. The frame on the right side of the window is being oversaturated by the sunlight. You need to replace this area so you can use the window with different lighting scenarios. This hot spot would be an obvious problem in nighttime shots or those around sunrise and sunset.

D. Shadows. The shadows need to be removed so they don't fight your light source.

Now that you've identified the problem areas you can begin correcting them. Let's start by setting the Contrast to 20 percent, which will sharpen the colors in the image. This removes the washed-out appearance of the colors, which are common with hazy daytime photography. Now we can start editing the details. We'll start with the window frame since it's the easiest element to correct.

EXERCISE: EDITING THE SOURCE IMAGE

1. Select the board on left sides of the frame and feather it 3 pixels, as shown in Figure 2.4.

2. The white area on the left side of the image shows the selection. Copy and paste this selection to a new layer, and then flip it horizontally and move it to the far right as shown in Figure 2.5.

3. Replace the upper panel of the window frame by selecting the lower frame board as shown in Figure 2.6.

4. Copy and paste this selection to a new layer, flip it vertically, and place it at the top of the image as shown in Figure 2.7.

5. Now the frame editing is nearly complete. The last step is to edit the elements on the top of the frame that don't belong, such as the bird droppings. The bird droppings look fine on the bottom, but that would be one talented bird to do his business upside down. To remove the droppings, set the clone tool size to 27 pixels and sample a selection of the upper board and paint it over the bird droppings as shown in Figure 2.8.

6. Now we're getting somewhere. There is one small element of the frame you still need to fix. The crossbeams are being saturated with too much light, so you need to tone them down. This is another job for the clone tool. First, select the crossbeams as shown in Figure 2.9.

7. Once you've made the selection, set the clone tool to 75 percent opacity, select a portion of the left or right frame, and paint it over the center crossbeam. Now select a sample from the top of the frame and paint it across the horizontal crossbeam to complete the crossbeams as seen in Figure 2.10.

Figure 2.4 Selecting the left frame board.

Figure 2.5 Placing the selection.

Figure 2.6 Selecting the lower frame.

Figure 2.7 Placing the upper frame selection.

Figure 2.8 Removing the inverted bird droppings.

Figure 2.9 Selecting the crossbeams.

Figure 2.10 The corrected crossbeams.

8. Okay, now it's time for a little glasswork. The glass is the biggest mess we have to clean up, but fortunately, it won't be terribly difficult. We'll use the clone tool to cover up the reflections and glare. We'll start with the lower right pane since it's the best for sampling. To see how we'll be cloning the surface, take a look at Figure 2.11.

9. To clean up the lower right pane, sample the area in (A) and copy it to (B). Be sure to keep the opacity of the clone tool at 75 percent so some of the dirt from the original texture shows through. When you are finished, it should look like Figure 2.12.

10. Now repeat the process by cloning the lower right panel to the lower left as shown in Figure 2.13.

11. You need to set the opacity to 100 percent when cloning over the reflection of the guy to make sure he doesn't show through. Now it's time to focus on the upper left pane. The first step is to black out the area where the glass is gone, as seen in Figure 2.14.

12. You should eliminate the vertical bar that attaches to the twisted crossbeam since it will be less desirable to model later on. Once the hole is corrected, you are ready to clean up the glass, which is done the same way as before by sampling one of the corrected windowpanes and painting over

Figure 2.11 The sampling method.

Figure 2.12 The corrected lower right pane.

Figure 2.13 The corrected lower left pane.

Figure 2.14 Blacking out the dead space.

the problem areas. In this case, you'll want to use a clone tool with the opacity set to 100 percent to remove the reflection of the photographer. You'll also need to be careful not to clone over the cracks in the glass. These are great details that shouldn't be removed. To avoid erasing the cracks, use a smaller brush, which will give you more control. The finished windowpane should resemble Figure 2.15.

13. Now for the disaster area. The upper right windowpane is a mess. You'll need to remove some reflections and the caulking while keeping the cracks intact. It's a bit tricky, but the key is to use a small brush to paint around the cracks. Now I'm sure you've noticed that plenty of the gunk is over the bars behind the glass. This is easy to correct by setting the clone tool opacity to 100 percent and cloning the bar from the pane below. Basically, you need to sample parts from all of the other windowpanes to complete the last pane. When you are finished, the glass should look like Figure 2.16.

That's much better. The source image map is now something we can use to actually surface the window model. As you can see, correcting source images can be a bit challenging, but it's not too difficult as long as you break it down into segments that can be tackled one at a time. You will probably have to cor-

Figure 2.15 The completed upper left windowpane.

Figure 2.16 The completed window.

rect nearly every source image you find because many will have shadows that conflict with your lighting. Of course, you probably won't come across very many that require as much editing as the one we just did, but now you are prepared for anything.

Now that you have an edited source image, you can begin modeling the actual window.

Modeling the Window

With the source image ready to go, load it into your modeling program as the background image as shown in Figure 2.17.

Using template images can be complicated at times because not every 3D program provides you with a clear, crisp background image. If your program doesn't allow for clear template images, you can use the template for the basic shapes and refer to the image in your painting program to identify the location of specific details.

Modeling the window is actually quite simple. It's really no more than several simple shapes combined to form the completed window. In fact, most image map modeling is based on simple shapes.

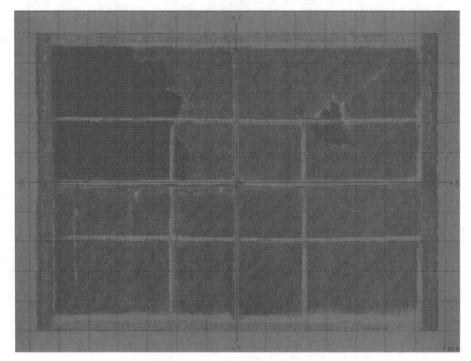

Figure 2.17 The source image loaded as the background template.

NOTE

You'll also find that it's best to use polygons when doing image map modeling. While you can use NURBS or splines, they are really meant for curved lines and don't fare well when doing linear models.

EXERCISE: MODELING THE WINDOW

1. The first step is to build the window frame. On the left side, create a simple box that runs the height of the window frame as shown in Figure 2.18.

2. Don't make it the full width of the frame because there are actually two pieces that comprise the sides of the window frame. You'll make the smaller piece next. With the box added, you need to bevel it to create specular reality. Apply a small bevel to the front face of the box as shown in Figure 2.19.

3. Now you can create the smaller board by copying this box, placing it directly beside the first box and moving the points on the right side inward to make it thinner, as seen in Figure 2.20.

4. You don't want to scale the small board because it will compress the bevel you added earlier. Manually moving the points preserves the bevel. Now that you have both boards completed, you can mirror them horizontally to create the right side of the frame, as shown in Figure 2.21.

Figure 2.18 Creating the left side of the frame.

Figure 2.19 Beveling the box.

Figure 2.20 Adding the smaller board.

5. Creating the top and bottom of the frame is easy. Simply copy the two boards on the left side and rotate them 90 degrees clockwise. Then place them at the top of the template, with the left side flush against the small board on the left. Now select the points on the opposite end and drag them to the right until they meet the small board on the right. Finally, select the two boards on the top and mirror them vertically to create the lower frame, as shown in Figure 2.22.

6. Now you're ready to apply the crossbeams. Once again, use one of the boards you have already constructed. Select the small board on the top of the frame, and move it over the horizontal crossbeam in the middle of the window template image as shown in Figure 2.23.

7. Once the crossbeam is in place, you need to lengthen it along the x-axis so it penetrates the frame as seen in Figure 2.24.

8. Make sure you select the points on the ends of the crossbeam and move them manually so the bevel isn't distorted. Now you need to shorten it along the z-axis so it doesn't rest flush with the frame. Figure 2.25 shows the proper sizing of the crossbeam.

9. That's better. You want the crossbeams to be smaller so the window shows more depth. It's always a good idea to create visual depth when

Figure 2.21 Creating the right side of the frame.

Figure 2.22 The completed frame.

Figure 2.23 Creating the first crossbeam.

Figure 2.24 Sizing the crossbeam along the x-axis.

building architectural elements for your environments. To complete the crossbeams, simply copy the current crossbeam. Rotate it 90 degrees clockwise and place it over the vertical crossbeam in the template as shown in Figure 2.26.

10. Once the crossbeam is placed, you'll want to shorten it along the y-axis but make sure it penetrates the frame. Okay, you're done with the frame. Before you move on to the glass, name this surface Windowframe. You'll need to separate the frame, glass, and bars so you can surface them properly. We certainly don't want a transparent window frame.

The next step is to create the glass.

Modeling the Glass

The broken glass in the source image is great. We'll want to preserve the holes and cracks when we create our glass object. The glass is a relatively simple object to create. It's basically a Boolean subtract operation. Let's get started.

Figure 2.25 Sizing the crossbeam.

Figure 2.26 Completing the crossbeams.

EXERCISE: MODELING THE GLASS

1. Create a thin box that represents the glass volume, which should extend beyond the inside edge of the frame and fall slightly behind the front edge of the crossbeams as seen in Figure 2.27.

2. Create the Boolean modifier object you will use to cut holes in the glass. This can be done a number of ways, but I'll use the point method since it's the easiest and most accurate. With the template visible in the background, begin laying down points along the edges of the two holes in the glass. Once you have encircled the holes with points, select them in series and create a polygon. Then extrude the polygon as shown in Figure 2.28.

3. If your program doesn't allow you to manually build polygons you can create the Boolean modifiers using a simple disc. Create a disc with at least 40 points, and drag the points so they line up with the rough edge of the hole as shown in Figure 2.29.

4. When you are finished with the Boolean modifier, use it to Boolean subtract its mass from the glass you created earlier. The result can be seen in Figure 2.30.

5. Now the glass is complete, with holes for character. Name the surface Glass and move on to completing the window. The final step in the construction of the window is to create the security bars that sit behind the glass.

Figure 2.27 Positioning the glass.

Figure 2.28 Creating the Boolean modifier object.

Figure 2.29 Creating the Boolean modifier from a disc.

Figure 2.30 Cutting the holes out of the glass.

Modeling the Security Bars

Creating the security bars is nothing more than modifying a few simple tube primitives.

EXERCISE: MODELING THE SECURITY BARS

1. Start the security bars by creating a thin tube with 32 segments and placing it over the first horizontal bar in the template image. Then select and move the points so your bar conforms to the flowing shape of the template bar as shown in Figure 2.31.

2. The remaining steps are simple. Copy the bar and place it over the lower horizontal bar in the template image, then move the points so it conforms to the template bar shape. Now copy the bar again, rotate it 90 degrees clockwise, and then place it over the center vertical bar on the template and adjust the points. You should now have something similar to Figure 2.32.

3. Clone the vertical security bar to create the two smaller security bars on either side, as seen in Figure 2.33.

4. Name the bars SecurityBars.

The window is now complete. Once you put all of the parts together, the window should look like the one in Figure 2.34.

Figure 2.31 Creating the first security bar.

Figure 2.32 Creating more security bars.

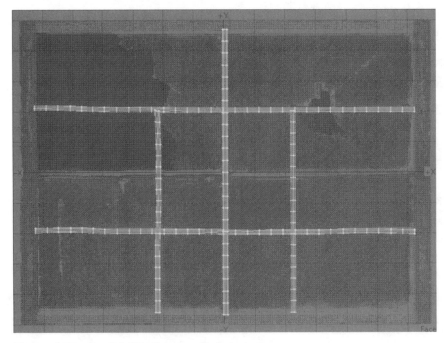

Figure 2.33 Completing the security bars.

Figure 2.34 The completed window.

As you can see, the window is nothing more than a few simple primitives that have been modified slightly. You'll find that most image map modeling is based on modified primitives, which makes the process rather simple to manage. Now save the object as Window before you forget.

Surfacing the Window

Now that we've modeled the window to match the image map, surfacing the window is very simple—if you know a few tricks. The window is a fine example since it has three unique surfaces, all with very different attributes. Before we can surface the window properly, we'll need to make some modifications to the image map, which we'll explore as we surface the window. Let's get started.

EXERCISE: SURFACING THE WINDOW

1. Start with the easy part, which is the frame. Load the window object you created earlier and the window image map you edited in the first part of this chapter into your rendering application. Now apply the window image map to the window frame surface as a planar map along the z-axis, as shown in Figure 2.35.

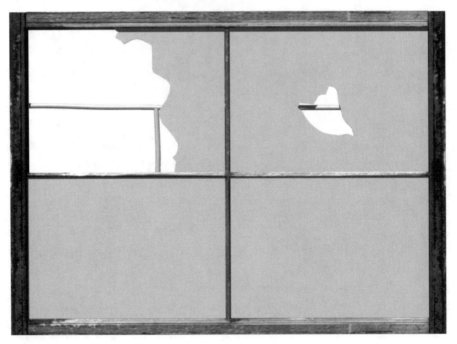

Figure 2.35 Surfacing the window frame.

2. To completely surface the wood frame, you set the specularity to 12 percent; use the window image map as a diffusion map, with an opacity of 50 percent; and apply the window map as a bump map with 50 percent bump. This will give the wood the attribute of a heavily weathered, painted appearance.

3. Surfacing the wood frame first is critical. Why? Because it's the surface with the outermost polygons, meaning it's the exact size of the image map and you can automatically size the image map to the surface. Most programs will do this for you. To avoid having to deal with making image map templates, you can copy the frame surface to the other surfaces so your image map scaling and alignment will match. That way, you can edit the original window image map without having to create a new map to match the exact size of the other surfaces. There's no reason to make our lives any more difficult than necessary—we already have enough to deal with just trying to create 3D photorealism.

4. Now we'll surface the security bars. This is accomplished by copying the window frame surface to the security bars and making a few surface attribute changes. You'll need to make the bars more specular due to the crystals in the rust, so set the specularity to 35 percent. The bars are metal, or at least some metal is showing through, so they will need to be 15 per-

cent reflective. The last attribute change is to set the bump value to 100 percent to make the rust depth clearly visible. When you are done, the object should look like the one in Figure 2.36.

5. Now you're down to the last surface—the glass. The glass requires some image map editing so you can remove the bars. It would look odd with the reflection of the metal bars burned into the glass, although it would be a very original design for stained glass. To remove the bars load the image into your paint program and use the clone tool to sample portions of the glass and paint them over the bars. When finished, your image map should resemble Figure 2.37.

6. Now save the new image map as WindowGlass and load it into your rendering program. Then copy the frame surface to the glass surface and replace the Window image map with your new WindowGlass image map. Of course, you'll need to make a few surface attribute changes, so the glass doesn't look like wood.

7. To start, set the specularity to 40 percent. Glass is typically fairly specular, but you want to keep the specularity of this window a bit lower since it's covered in dirt and oxidation. Next, set the reflectivity to 15 percent as you did with the security bars. You'll also need to set the bump map to 12 percent since you don't want a lumpy window. Finally, set the transparency to

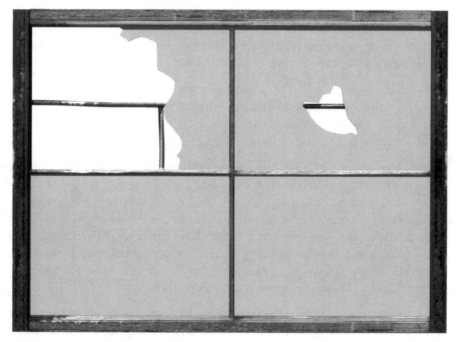

Figure 2.36 The surfaced security bars.

Figure 2.37 Removing the security bars.

15 percent so you can see through the window but not clearly. The glass should appear cloudy, diffusing the security bars behind it. The completed window should look like Figure 2.38 when you render a test image.

Now that's more like it. The window looks completely realistic and has depth to boot. You can see how image map modeling is a powerful technique for creating very realistic objects rather quickly. To see how the window looks in an actual environment, take a look at Figure 2.39.

It looks great doesn't it? While image map modeling requires more work than simply slapping an image map on a flat plane, it goes a long way toward creating a realistic environment. One of the great advantages of image map modeling is that you can create very complex effects. For example, you can place an object behind the window and have it show through with dimensional objects in front of it such as the crossbeams and security bars to add depth. This can't be done with a simple flat plane. Figure 2.40 shows what happens when we light the room so we can see through the window.

As you can see, the image map modeled window lets us see objects through the glass. Another good example of an image map modeled window can be seen in Figure 2.41.

Figure 2.38 The fully surfaced window.

Figure 2.39 The window used in a realistic environment.

Figure 2.40 Objects seen through the window.

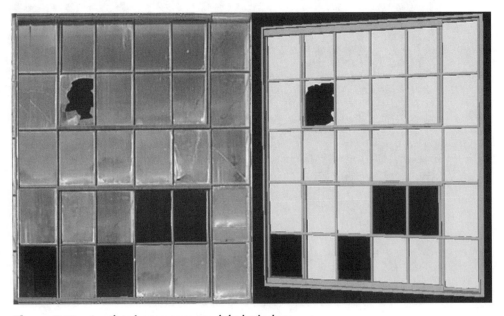

Figure 2.41 Another image map modeled window.

On the left is the image map, which was pulled from Marlin Studios' Seamless Textures You Can Really Use image map library, and on the right is the model created using the image map as a template. This window is a bit more complicated than the one we just created, but it's still composed of nothing more than primitive shapes. Figure 2.42 shows the window being used in the alley scene we saw in the beginning of this chapter in Figure 2.1.

You can see how great it looks, particularly from an angle other than orthographic, where we get the advantage of seeing the depth of the window frame. This is another case in which the transparent window allows you to add depth to the scene. Figure 2.43 shows the same window with a character sneaking around behind it.

Not bad—it definitely adds character to the scene (no pun intended). Image map modeling can be a valuable asset in your 3D modeling efforts. I've found it to be indispensable when it comes to rapidly creating realistic environments.

Of course, image map modeling is good for more than just windows. It can be used to create countless objects, such as walls, doors, floors, streets, and sidewalks. You name it, and image map modeling can probably do it. If it's rela-

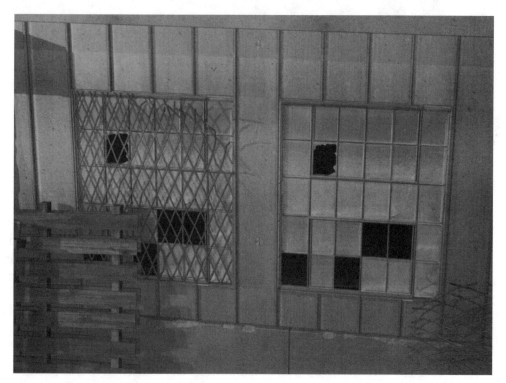

Figure 2.42 The image map modeled window in use.

Figure 2.43 The depth created with the transparent window.

tively flat, you can model it with image map modeling—it doesn't even necessarily have to be flat. Why don't we take a look at how the protruding bricks in the alley scene were created with image map modeling?

Image Map Modeling with Depth

While bump maps can do the job for distant shots, they fall short of the mark when you zoom up close. There are times when you want the depth of the surface details to be more severe. Bricks are an excellent example. Because they protrude from the surface of the wall, they require some physical depth to appear realistic. That's where image map modeling comes into play. Image map modeling allows you to add as much depth as you like. Of course, there are a few things to consider such as surfacing of the added depth. We'll be taking a look at surfacing solutions in a minute, but first we'll take a look at how we model for depth.

In these exercises, you'll re-create the heavily extruded bricks seen on the left side of the alley image. They are a wonderful addition to the scene because they add tremendous depth to an otherwise flat wall. When creating 3D envi-

ronments, it's a good idea to reach for more depth to really take advantage of the tools you have before you and to wow the viewer with more detail. Yes, most walls in reality are relatively flat, but that's where you have the advantage. You can alter reality while still making it appear photorealistic. Life as a 3D artist would be very boring if you didn't take the opportunity to be creative with your reproductions of reality.

Enough balderdash, let's get started with the exercise.

EXERCISE: MODELING THE BRICKS

1. The first step is to load the brick image map template into your modeling program. On the companion CD-ROM you'll find the brick.jpg template, which looks like Figure 2.44, in the chapter2/figures folder.

2. I'm sure you noticed that this image map is well under the recommended 1000-pixel width. You can't always find image maps in the size you need, but that doesn't mean you can't use a file. You just need to be more creative about how you use it. For example, you could use tileable models, which are covered in Chapter 3, "Adding Depth with Seamless, Tileable Models."

 Now that you have the template loaded you can begin construction of the details. Building the bricks is a similar process to the way you built the window, except it's a little more organic. The bricks have unique shapes, so you can't use a simple box. Instead, you'll need to make custom shapes for each brick. This sounds time consuming, but it really isn't.

3. To begin, zoom into the brick in the upper left corner. Now place points around the brick to define the general shape. Don't use too many points since it's unlikely you will be this close to the actual bricks in the scene.

Figure 2.44 The brick image map template.

Once the points are placed, select them in series and create a polygon. If you don't have point-editing tools, you can always use a disc to drag the points into the proper location. Use a 16-point disc so you have enough points to cover the details. When you are finished, you should have something similar to Figure 2.45.

4. Now it gets a bit redundant. To create the rest of the bricks, copy the one you just created and paste it over the next brick on the template. Then drag the points to match that brick. Repeat this process until you have modeled all of the bricks. It should take about 15 minutes to complete the bricks. When you are finished, you should have something resembling Figure 2.46.

5. The next step is to add some depth. The exact amount of depth is open to interpretation, but the source image will give you a good idea of how deep the bricks actually are. It looks like the bricks are half as deep as they are wide, so you'll need to extrude the bricks back a fair amount. Figure 2.47 shows the extruded bricks.

6. The bricks are almost complete, but now you need to incorporate one of the principles of 3D photorealism: specularity. While bricks aren't terribly specular, they will catch some light due to their crystalline nature. You'll need to bevel the front edge of the bricks so they catch some light when we

Figure 2.45 Creating the first brick.

Figure 2.46 The completed bricks.

Figure 2.47 The extruded bricks.

view them from an angle, particularly when you animate the camera. Go ahead and bevel the front face of the bricks with a small bevel like the one shown in Figure 2.48.

7. Now the bricks are complete. The only thing left to add is a wall behind them. Create a narrow box that is flush with the edge of the template on all sides and place it directly behind the bricks as shown in Figure 2.49.

8. Before you save the object, let's assign it a surface named bricks. Now save the object as bricks.

9. The next step is to surface the bricks. Load the object into your rendering program, and apply the bricks image map as a planar map on the z-axis. You should also apply the image map as a bump map with a setting of 100 percent, so there is some visual surface texture. Now set the specularity to 7 percent and if you have diffusion set it to 75 percent. Okay, let's do a test render, which should look something like Figure 2.50.

10. Well, the front of the brick looks great, but the sides are showing significant stretching, which is killing the photorealism of the model. To correct this problem, you'll need to make the sides of the bricks a separate surface. This can be done two ways, depending on which program you use. Some programs allow you to select the polygons on the sides of the bricks and

Figure 2.48 Beveling the bricks.

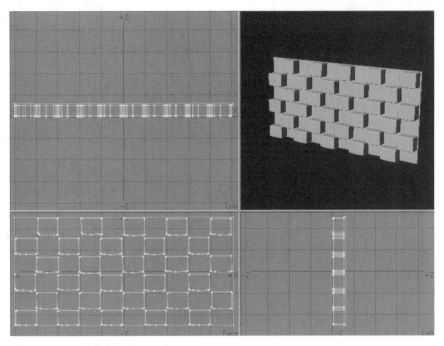

Figure 2.49 Adding the wall.

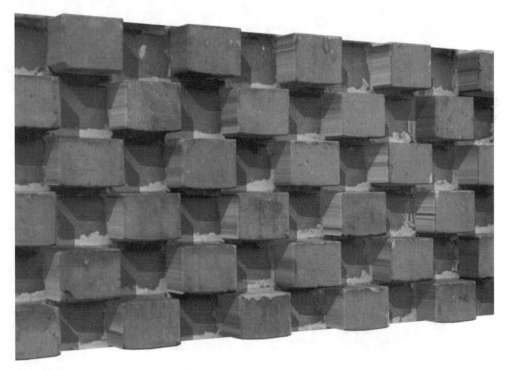

Figure 2.50 The brick test render.

give them a new surface name, such as "BrickSides." This is the preferred method. On the other hand, some programs require you to make them a separate object so they can have a unique surface. In this case you'll need to select the polygons on the sides, cut them, paste them as a new object, and then assign them the new surface name BrickSides. Figure 2.51 shows the new surface assignments for the bricks.

11. The dark sides of the bricks represent the new surface. To surface the sides properly, you'll need to use a cubic map. Of course, you'll have to make one first. This is actually quite simple. First load the bricks.jpg file into your painting program. Then select a square region of the image map that has the most consistent surface color, as indicated in Figure 2.52.

12. With the selection still active, use the clone tool to sample the bricks with a consistent orange tone and paint it into the selected region until you have filled the entire selection as shown in Figure 2.53.

13. Now simply crop the image to the selected area, and save the new image as BrickSides.

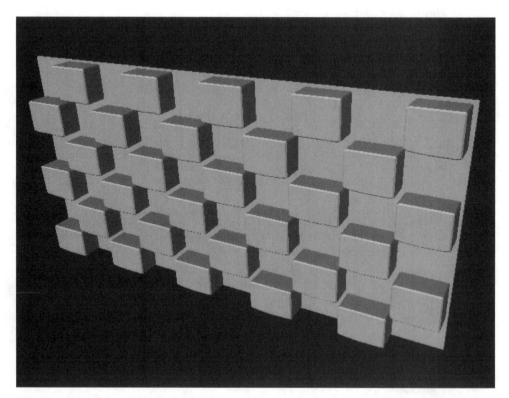

Figure 2.51 The new surface assignments.

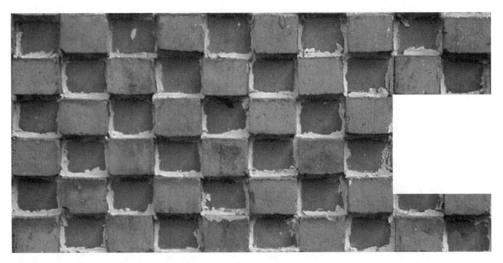

Figure 2.52 Selecting the consistent surface tone.

14. Now you're ready to correct the surface stretching on the bricks. First, load the new bricks object into your rendering program. Then reapply the surfacing you did earlier to the bricks surface. Copy this surface to the BrickSides surface. You want to copy the surface so you have identical settings for the specularity and bump. Replace the color image map with the new BrickSides image map and set the mapping to cubic. Then set the size to 40 centimeters on the x-, y-, and z-axes.

How did we come up with this number? Well, the total height of the brick wall is about 1 meter, and it's 6 bricks tall, so each brick is roughly 16

Figure 2.53 Filling the selection.

centimeters. Your image map is about 2.5 bricks square so multiply 16 by 2.5 and you get 40 centimeters. It is imperative that you size the side image map properly or it won't match the texture scaling of the front. Nothing looks odder than details that are out of proportion. (Okay, so the stretching looks worse, but the disproportionate details are bad.)

15. Now that you have a properly sized color map, you need to do the same for the bump map. Replace the bricks image map with the BrickSides and set the mapping to cubic and the size to 40 centimeters on all three axes. Now do a test render and the bricks should look like Figure 2.54.

Now that's more like it. The bricks look completely realistic and natural. You can see how these bricks would add a great deal more depth to a scene than if we merely slapped an image map on a flat plane. You can actually place objects on the tops of the bricks or have characters climb them, grabbing each brick with their hands. They are particularly impressive when the camera is moving since they add so much depth to the environment. Remember, you can never add too much depth to a 3D environment.

Of course, don't limit yourself to industrial, man-made objects. The image map modeling process can be applied to a number of natural organic objects. Let's take a look at how organic image map modeling differs from industrial.

Figure 2.54 The corrected bricks.

Organic Image Map Modeling

Modeling organic objects with the image map modeling method can be a bit more complicated since the shapes are rarely linear and you'll need to apply more ingenuity with your guesswork since you'll be modeling from a single-axis template. For example, take a look at the large leaf that Drale the Bug King is sliding down in Figure 2.55.

This leaf was modeled from an image map template. I originally scanned the leaf from a sample I gathered in my backyard. I often find myself back there in the middle of the night hacking up my wife's landscaping. Now, I don't sneak around at night to avoid being caught—I just never sleep, though my wife is less than pleased with my somewhat black thumb.

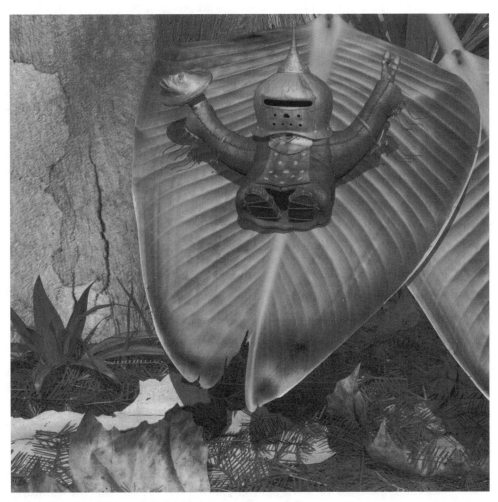

Figure 2.55 A leaf modeled with image map modeling.

Here is a case where a scanner was invaluable. Most of the image maps used in this image were scanned from samples I collected. Of course, the scanner gives you only one dimension to work with, which means we need to work from the actual object or our own creativity when creating the actual three-dimensional model.

So you are probably wondering what this image is all about. Well, it will be a bit of a tangent, but it never hurts to elaborate on an image. Drale is a 4-inch tall Goblin who lived in the rain forests on the Goblin Island located in Lake Victoria, Tanzania, Africa, 60 million years ago during the Tertiary period. Drale is called the "Bug King" because he's the master of all insects. He's rather the oddity in the Goblin kingdom since most Goblins are deathly afraid of insects, particularly since many of them are nearly the size of a Goblin.

Drale is also an entrepreneur, one of the few enterprising Goblins. He has many businesses, but his main one is creating Goblin transportation. He is also responsible for most of the Goblin inventions. Actually, he doesn't invent them himself but rather employs Grilch, the Goblin inventor. Drale is liked by most Goblins but is hated by Batra, the Frog Czar, because they have a bit of a conflict in regard to insects. Insects are Drale's loyal subjects, but frogs eat them—you can see how this would create a conflict. Even though Drale is liked by most Goblins, he tends to be a solitary character and prefers the company of insects.

There you have it. Now we have a better understanding of the scene. You can see how it would be imperative that we create very detailed models since we'll be viewing this world at such close range. While it may not always be necessary to create models that can be viewed at extreme close-ups, it's usually a good idea since you never know when you'll need to zoom in on something. It can be a real pain to go back and remodel something you have already created. I usually model all objects for close shots just in case. Of course, I can always reduce the polygons with a push of a button so I can use them for background props, but I can't do the reverse. A lower-resolution object can be subdivided, but then the low-resolution model needs to be designed properly for subdivision to work.

Speaking of subdivision, that's exactly what we'll be using in the next tutorial to re-create the leaf Drale is sliding down in Figure 2.55. Subdivision can be found in most 3D programs as either a feature or a plug-in. In brief, it smoothes the mesh, softening the rough edges and increasing the intensity of details. Subdivision goes by many names, it all depends on the program you use. In 3D Studio Max it is called MeshSmooth. In LightWave it's referred to as MetaForm. TrueSpace has a plug-in called ThermoClay that does subdivision. If you don't know how it's referenced in your program, crack open that user manual and track it down before you begin this example. It's an indispensable

tool for creating organic models and something we will be revisiting frequently in this book.

Enough talk, let's get started with our leaf.

EXERCISE: MODELING THE LEAF

1. Open your modeling program and load the image map template into the background of the z-axis. You can find the template image in the chapter 2 folder on the companion CD-ROM. It's named leaf.jpg and is shown in Figure 2.56.

2. Now for the fun part. Natural, organic image map modeling is different from industrial because we can't start with primitives. It requires more detail so you'll need to create custom polygons, the way you did with the holes in the window glass. Of course, if your modeling program doesn't have point-editing tools, you can begin with a faceted plane, which I'll cover after we get the point-editing version started. Let's start modeling the leaf.

3. The first thing to do is create a flat mesh that represents the shape of the leaf. This is the most important step because you'll be using portions of this mesh to build the details of the leaf. There is one area of the leaf that

Figure 2.56 The leaf template.

requires special attention, the petiole, or stalk. The lamina (blade) is relatively easy to build, but the stalk needs more depth to be realistic, so you have to incorporate enough polygons in your flat mesh to develop the depth of the stalk. The flat mesh is modeled by placing points on the screen that define the shape of the template and then selecting them in sequence to create polygons. It's best to use 4-point polygons when using subdivision but many programs won't allow you to use 4-point polygons so a 3-point will be fine. Figure 2.57 shows the completed flat mesh for the leaf.

4. You can see a higher mesh density along the stalk of the leaf. You'll be using these polygons to create the depth of the stalk. To get a better idea of how the stalk polygons are formed, let's take a closer look. Figure 2.58 shows the tip of the stalk.

5. The stalk is two polygons wide, with a row of polygons on either side that will reinforce the stalk when you apply subdivision. You need to make the stalk two polygons wide so you can manipulate the center points to add depth to the stalk. Figure 2.59 shows how the stalk appears at the base.

6. The rest of the polygons that make up the leaf aren't as important as the stalk. You can simply create a few rows of polygons on either side to create the bulk of the leaf. As discussed earlier, you could also make the flat mesh

Figure 2.57 The leaf flat mesh.

Figure 2.58 The tip of the stalk.

Figure 2.59 The base of the stalk.

using a faceted plane with 12 segments vertically and 10 segments horizontally, as shown in Figure 2.60.

7. The points are moved around to align with the shape of the template, packing them tighter together in the middle to accommodate the stalk. Of course, there will be excess polygons along the margin (outside edge) of the leaf, so these will need to be split to form the edge as shown in Figure 2.61.

8. Now the excess polygons can be deleted. This technique is a little more work, but it can be accomplished in most programs and is equally effective. Now you're ready to continue.

9. The next step is to extrude the polygons to add depth to the leaf as shown in Figure 2.62.

10. Be sure to only extrude them a bit so the leaf isn't too thick. Speaking of thick, now would be a great time to add some depth to the stalk. This is accomplished by selecting the two rows of stalk polygons on the back of the model and smooth shifting or sweeping them back a bit and then dragging the outside points inward to taper the stalk as shown in Figure 2.63.

11. Your program might refer to the sweep function by another name. It's similar to extrude but shifts the selected polygons as a single surface rather than individual polygons. The last step in adding depth to the stalk is to select the center row of points and pull them back slightly as seen in Figure 2.64.

Figure 2.60 Creating the flat mesh with a faceted plane.

Figure 2.61 Splitting the excess polygons.

Figure 2.62 Extruding the leaf polygons.

Figure 2.63 Adding depth to the stalk.

Figure 2.64 Pulling the center points backward.

12. You also need to taper the stalk so it's thicker at the bottom and narrow at the top as shown in Figure 2.65.

13. Now you're getting somewhere, but you still need to perform a few more edits on the stalk. The first is to add a depression along the front of the stalk by selecting the centerline points on the front and rotating them inward, using the top of the leaf as the rotation axis. This makes the depression slight at the top and deep at the bottom as shown in Figure 2.66.

The bulk of the leaf now is complete. The last step is to complete the length of the stalk.

EXERCISE: MODELING THE STALK

1. Start by selecting the polygons at the base of the stalk and sweeping them down a bit. Once they have been swept, move them down a bit and drag the points out to make the end more rounded as shown in Figure 2.67.

2. Now sweep the polygons several more times, moving them down to create the length of the stalk, which should be equal to the height of the leaf as shown in Figure 2.68.

3. It's looking great now. You have just a few more subtle details and you're done. You need to add a depression at the end of the stalk where it would connect with the trunk of the tree. This is accomplished by selecting the

Figure 2.65 Tapering the stalk.

Figure 2.66 Adding a depression to the front of the stalk.

Figure 2.67 Beginning the long stalk.

Figure 2.68 Building the length of the stalk.

lower three points in the middle of the stalk on the bottom and rotating them backward, with the rotation axis being at the uppermost point. The result is shown in Figure 2.69.

4. Now you have a nice depression tapering down the end of the stalk, making it appear more natural and realistic. We could quit here, subdivide the object, and surface, but I can't fight the urge to be a bit more detail-neurotic. At the base of the leaf, where it meets the stalk, there is a deep depression (cuneate base) that is common on leaves of this classification. This is a relatively simple detail to add, yet it really sharpens the reality of the leaf. If we didn't create the physical dent that's represented on the image map, it would show a dent with no physical depth, undermining all of the realistic credibility we've worked so hard to establish. Let's take a stab at creating the dent.

5. Begin by selecting the two polygons at the base of the leaf, where it meets the stalk. These are the polygons that rest on the slope before the stalk. Now move them so they lie directly over the dent on the template image. Then sweep them and scale them down slightly as shown in Figure 2.70.

6. The next step is to drag the points of these polygons so they are all aligned with the angle of the slope. Then they are swept again, scaled down slightly and moved back into the stalk a bit as shown in Figure 2.71.

Figure 2.69 Adding a depression at the end of the stalk.

Figure 2.70 Beginning the cuneate base dent.

7. Great. Now the dent is complete and so is your leaf. See, it wasn't that difficult to add the detail, but it sure adds credibility to the model. The small details are what brings your objects to life and makes them photorealistic. If we skip the small details, we might never achieve photorealism.

8. Before you save our object, there are two more steps. First, you need to assign the surfaces. You'll need to separate the leaf from the stalk, so you can surface them individually. Figure 2.72 shows the selection area for the leaf.

9. Notice how the leaf selection begins where the template image begins in the background. This insures your surfacing will line up properly. Name this surface Leaf. Now simply select the stalk and name it Stalk.

10. The last step is to subdivide the model, which will smooth it and sharpen the details. The method of subdivision is similar from one program to another though the interface will vary widely. Basically, you need to subdivide it with one iteration, which is the standard in most programs. If your program has a max smoothing angle option, set this value to 179, which will smooth all angles less than 179 degrees. When the subdivision is complete, you'll have something similar to Figure 2.73.

You can see how the leaf is now very smooth and organic. Subdivision is a real lifesaver when it comes to creating detailed organic objects. Now save the object as Leaf, and we'll move on to surfacing.

Figure 2.71 Completing the dent.

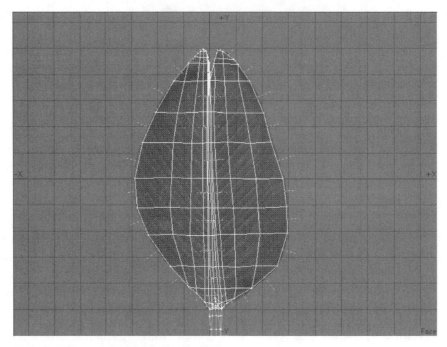

Figure 2.72 The leaf surface selection.

Figure 2.73 The subdivided leaf.

Surfacing the Leaf

Most of our surfacing work has already been done for us by the image map template, though we do need to do some work on the stalk.

EXERCISE: SURFACING THE LEAF

1. Let's load the Leaf object into our rendering program and apply the leaf.jpg as a planar map on the z-axis. Of course, you need to apply additional surface attributes to make the leaf realistic, so let's set the specularity to 35 percent. If you have diffusion, you can set it to 75 percent. The last step is to apply the leaf.jpg as a planar bump map on the z-axis, with a value of 100 percent. If your program allows for values in excess of 100 percent, I suggest 600 percent so the veins and details of the leaf really pop out. Now do a test render. The result should resemble Figure 2.74.

2. This looks pretty good. You can now move on to the stalk surfacing. You don't have an image map for the stalk, so you'll need to make one, using the leaf image map as the template. This is relatively simple to do, but first you'll need to create a painting template. This can be accomplished a number of ways. You could render an orthographic view, but that would require setting the camera zoom to 1000, meaning you would need to edit your scene. There is no reason to do that since you are creating a rather simple

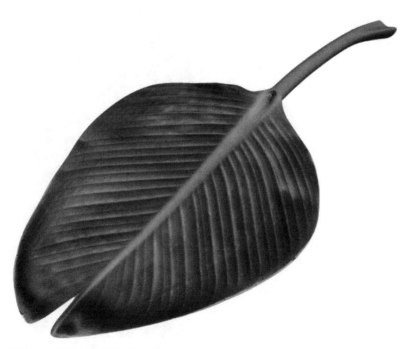

Figure 2.74 Testing the leaf surface.

template. For the stalk you merely need to take a screen shot from the modeling program.

3. Before you take the screen shot, you need to hide the leaf polygons so they don't take up any space on the screen. Then zoom in as close as possible to the stalk so you can see the details better. Now do a screen capture and paste the image into your painting program. Then crop the image around the mesh as shown in Figure 2.75.

4. Now you need to size the template so your stalk texture matches the scale of the leaf. Since the leaf and stalk are the same height you need to resize our template to be the same height as the leaf image map, which is 1000 pixels tall. Now for the painting.

5. First, add a new layer to the stalk template, then sample segments of the stalk on the leaf image map with the clone tool and paint it on the stalk template so the leaf stalk and your new image map will coordinate. You should also clone the base of the leaf image map to the top of the stalk image map to insure they are seamless, as shown in Figure 2.76.

6. Now you have a perfect image map for the stalk that blends seamlessly with the leaf. While it took a bit of cloning work to create the stalk, the information was already there in the leaf image map. You'll find your

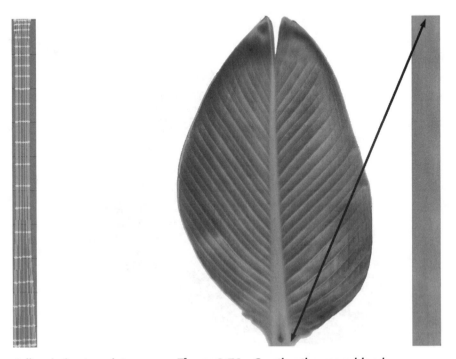

Figure 2.75 The stalk painting template. **Figure 2.76** Creating the seam blend.

source image map usually contains all the information you'll need to build upon it. It's just a matter of making liberal use of the cloning tool.

7. Now you're ready to finish surfacing the leaf. First, save the new image map as stalk, and then load it into your rendering program. Now copy the leaf surface to the stalk so they have the same settings. Then replace the color map with the new stalk image map and make sure the image map is sized to fit the stalk. You could have used a cylindrical map on the stalk, but since the color is fairly constant it wasn't necessary. You won't be able to see any texture stretching, so there is no point in complicating the process.

8. The last step is to replace the bump image map with the stalk image map and setting the bump value to 50 percent. You don't want the stalk to be too bumpy since they are typically very smooth. Now render a test, which should resemble Figure 2.77.

Well, that's one photorealistic leaf! While it was a bit of work, the results are definitely worth the effort. You can see how very detailed organic objects can be created with the image map template technique. They just require a bit more creativity since we have to add depth to them. This, of course, is easy if we have the actual object in our hands, but it can be a bit more challenging

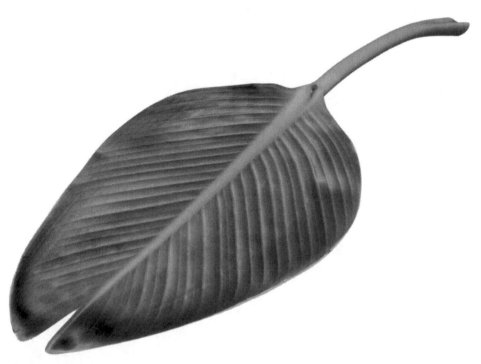

Figure 2.77 The final, surfaced leaf.

when we don't. Fortunately, we usually have access to something similar in the world around us, which we can use as the dimensional reference.

Wrap Up

Well, that was certainly a long chapter, but it was well worth the time spent. Image map modeling is a tremendous time saver, not to mention great for alleviating headaches. Creating detailed photorealistic environments can be a great deal of work if you don't use image map modeling. This modeling technique can be applied to countless detailed objects. Just about any model can be greatly enhanced through the use of image map modeling.

While working on the *Platinum* comic book, I used this same technique to create all the buildings in the street shots, not to mention a great deal of the interior work. All of the walls and windows were modeled using image maps as templates and then applying the image map as the surface. Try using this technique in your next photorealistic 3D project, and you'll soon realize why it's an invaluable tool in your photorealistic toolkit.

Now that you have a handle on image map modeling, you're ready to move on to tileable models. Nothing is more powerful for adding tremendous detail to a scene than tileable models. Let's take a look at how to use tileable models to add shocking depth to your 3D environments.

Adding Depth with Seamless, Tileable Models

Creating depth in 3D environments can be complicated, and it usually requires a great deal more work. Fortunately there is a technique called "seamless tileable models" that allows you to simplify the process. Seamless tileable models work under the same principle as tileable image maps. It's basically a 3D tileable image map. Rather than apply an image map to a simple plane, you create an image map modeled object from the tileable image map and then tile the model in your rendering program. This gives you the benefit of the tileable image map and the depth of an image map modeled object. Of course, the tileable model doesn't always have to be seamless. There are many uses for nonseamless tileable models, which we will explore in Chapter 4, "Creating Tileable Ground Covers."

In this chapter we'll explore several techniques for creating tileable models. We'll start with the seamless image map modeled method, and then we'll take a look at creating tileable props. Seamless tileable models are typically used in industrial environments since man-made objects tend to be repeating. For example, sidewalks repeat segments that are roughly 6-feet square. Nature is less particular with dirt trails. Therefore, seamless, tileable models are usually used to create industrial environments. Let's take a look at how to create a seamless, tileable model.

Creating Seamless Tileable Models

The typical seamless tileable model is created using image map modeling. The only real difference between standard image map modeling and that done for

seamless models is the source image. You must use an image map that tiles seamlessly when modeling seamless tileable models. Pretty obvious isn't it? Well, it had to be said anyway. It's actually very easy to create seamless tileable models. Let's take a look at how it's done.

In the next exercise you're going to create the cobblestone tileable object seen in Figure 3.1. Notice how the cobblestones in the alley have a great deal of depth. There's a physical depth to the stones in the road. This effect is easy to achieve, yet it adds a lot of credibility to the image. Simple bump maps on flat planes wouldn't create such depth, particularly upon close inspection. You could give physical height to the individual stones with a displacement map, but the polygon resolution of your street mesh would have to be very high, which would slow down your screen refresh, not to mention add to your render times. Yes, you can apply a displacement map to a simple NURBS surface, but you won't be able to see the actual depth until you render, making it difficult to place those cigarette butts between the cracks of the bricks. Polygons are very useful for making low resolution, seamless image map models that can be viewed in real time.

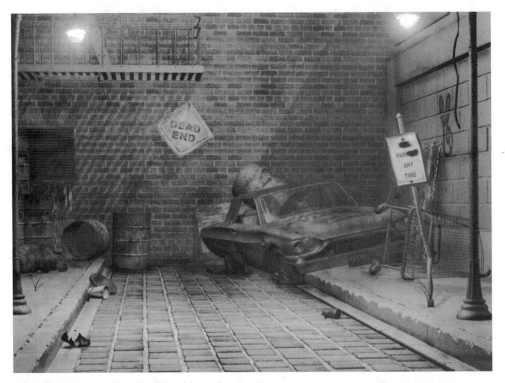

Figure 3.1 Seamless tileable objects in use.

Figure 3.2 The cobblestone image map.

The first step in creating the cobblestones is to locate a seamless image map. Figure 3.2 shows the cobblestone image map you'll be using for this tutorial. This file can be found in the chapter3 folder on the companion CD-ROM under the name cobblestones.jpg. This image map was created from a photograph of bricks. The original photograph had shadows and weeds in the cracks that had to be removed to make it a useable image map. We don't want anything in the image map that we won't be modeling. The weeds are a great addition to any scene using the cobblestones, but they should be applied as a separate object rather than part of the tileable model since they require more extreme depth. Besides, you wouldn't want to see heavily repeating grass in your scenes. On the other hand, it's fine to do mild repeating of bricks since masons tend to be linear in their design and often create patterns with bricks of unique colors. Weeds tend to be less discriminating about where they grow.

REMOVE REPEATING DETAILS

Be sure to remove any details from your source image map that will be repeated frequently when the object is tiled. It will undermine the realism of your scene since nature doesn't repeat itself. It's acceptable to have minor repeating of man-made objects, since we tend to be linear in our development.

Take a close look at the figure and you'll notice that a few of the bricks on the left and right sides of the image are terminated in the middle. This may look like it will be a problem when you tile the model, but it won't be. While there

might be a hairline seam between the models when you tile them, it will be visible only upon extremely close inspection, which is unlikely to occur.

Before you begin modeling the cobblestone tile, you need to edit the image map so it makes a better modeling template. It can be very difficult to see the separation of detail on an image map that is an even tone such as this one. We need to be able to clearly see where the bricks meet the mortar. Therefore, you need to adjust the contrast between the brick and the mortar, particularly if your program uses grayscale images for templates. Let's edit the image map template so you can start modeling cobblestones.

INCREASE THE DETAIL CONTRAST

Even-tone image maps make awkward templates because it's difficult to discern the details. You should increase the color contrast between the details so you can see them more clearly when you are modeling your objects.

EXERCISE: EDITING THE COBBLESTONES SOURCE IMAGE

1. Load the image map into your painting program. I'll be using Photoshop, but the same techniques can be applied in most paint programs.

2. Once the image is loaded, convert it to grayscale. While your program might handle color template images, it's easier to adjust the contrast as a grayscale image.

3. Open the Levels panel, and set the input levels to the following values: 61, 1.18, 181. This will make the bricks darker and the mortar lighter.

4. You need to adjust the brightness and contrast to make the difference between the bricks and mortar even more obvious. Open the Brightness/Contrast panel and set the Brightness to –29 and the Contrast to +70. Great, now we have a high-contrast image map template, which should look similar to Figure 3.3.

5. Save the image as cobbletemp.jpg so you can use it as your modeling template.

Okay, now let's get right to modeling the cobblestones.

EXERCISE: MODELING THE COBBLESTONES

1. Load the cobbletemp.jpg image as a background template on the y-axis as shown in Figure 3.4. You want to use the y-axis because the stones will be flat on the ground so you need to model them from above.

 Notice how the bricks are clearly separated from the mortar, making it easy to model each brick to perfectly match the image map. Of course, you'll save a lot of time by cloning a single brick. Speaking of a single brick, let's get started on the first brick.

Figure 3.3 The edited image map template.

Figure 3.4 Loading the background template.

2. Zoom in to the block on the upper left corner of the template. Then create a flat plane with five horizontal segments and four vertical segments as shown in Figure 3.5.

 I added multiple segments to the plane so we can manipulate the points to line up with the contours of the block on the template. You don't have to be exact or very detailed with the contours, but you do need to create the basic shape.

3. Add depth to the block by extruding it as shown in the lower part of Figure 3.6.

4. Now you can begin to shape the block by dragging in the y-axis view. Drag the outer points of the mesh to align with the contours of the block as shown in Figure 3.7.

 Notice how I've pulled the points to the corners to shear them off. The corners are the most important contour of the brick since sharp corners would be very unrealistic. Shearing the corners adds character to the block.

5. The last detail we need to add is a bevel on the top so it will catch the light. The blocks in our source image are slightly rounded on the top so we need to add a bevel on the model. Simply select the bevel tool and a small bevel to the top of the block as shown in Figure 3.8.

Figure 3.5 Creating the flat plane.

Figure 3.6 Extruding the flat plane.

Figure 3.7 Shaping the block.

Figure 3.8 Creating the bevel.

EXTRUDE AND SCALE TO MANUALLY BEVEL OBJECTS

■■■■■ **Some programs won't bevel multiple polygons as a single surface, so you'll need to do it manually by selecting the polygons on the top and extruding them slightly, then scaling them down to create the small bevel. This is a great way to create bevels if your program doesn't offer bevels as an option.**

6. Now that we have one block completed, you can clone it to create the other blocks. There is no point in building them from scratch since they are basically the same. You can save a great deal of time by cloning them. It is a bit tedious, but the process can be greatly expedited by using a few simple tricks, which I will cover as we go.

7. Start by copying the block and placing it over the next block on the template. Then, using the magnet tool, drag the points on the object to contour to the template block. This is a great way to expedite the shaping process. It would take much longer if we had to drag each point. Using a small magnet tool you can quickly shape the blocks with accuracy. Repeat this process until you have a few blocks completed as shown in Figure 3.9.

8. Now we come to one of the severed blocks on the edge. To create this block, clone one of the other blocks and move it into place so the right side of the block lines up with the template. Then select the row of points clos-

Figure 3.9 Creating additional blocks.

est to the edge of the template and stretch them so they all line up flush with the edge of the template as shown in Figure 3.10.

9. Now select the polygons on the outside of the template and delete them as shown in Figure 3.11.

10. Next we need to complete the rest of the block by cloning them and using the magnet tool to contour them to the template. All of the severed blocks on the sides should be created using the same technique you used in Step 9. When you are finished you should have something similar to Figure 3.12.

11. Now we have one final element to add before we are ready to surface the cobblestones. We need to add the mortar object, which also serves as the border for our seamless object. This step is simple. First, hide the blocks. Then create a single polygon flat plane that lines up with the outside edge of the template as shown in Figure 3.13.

12. Now unhide the blocks, and you should have the completed cobblestones as shown in the OpenGL preview in Figure 3.14.

13. I'm sure you've noticed the polygons on the tops of the blocks are a bit chaotic and tend to confuse the eye when you look at them. You can simplify the appearance of the blocks by merging the polygons on the top and bottoms of the blocks to create a single polygon on both sides. Not all pro-

Figure 3.10 Lining up the edge points.

Figure 3.11 Deleting the excess polygons.

Figure 3.12 The completed blocks.

Figure 3.13 Creating the mortar plane.

Figure 3.14 The completed cobblestones.

grams can handle polygons with more than four points, but if yours does, I suggest you optimize your mesh by merging these polygons. Simply select the polygons on the top and bottom of all the blocks with the selection tool and then merge them using your merge polygon tool, creating single polygons on both sides as shown in Figure 3.15.

While merging isn't necessary, it does make the screen less confusing, particularly when you have several of the cobblestone tiles in a scene. Speaking of the scene, we are almost ready to surface the object. First assign the object a surface called cobblestone, and then save the object as cobblestonetile.

As you can see, creating the detailed, 3D cobblestones was quite easy. It's simply a matter of creating the first block, cloning it, and modifying the clones. Surfacing the cobblestones is even easier since we modeled the object to match the image map. Let's surface the cobblestones.

EXERCISE: SURFACING THE COBBLESTONE TILE

1. Load the cobblestonetile object into your rendering program, and then load the cobblestone.jpg file you used earlier so you can apply it to the object.

2. Now apply the cobblestone.jpg file as a color map on the y-axis. Most programs will automatically size the image to the surface of the object. If yours doesn't, there may be an automatic sizing feature you can use, or you might

Figure 3.15 Merging the polygons.

need to manually size the image map using a bounding box. Either way, be sure to fit the image map to the surface.

3. Apply the image map to the bump channel of the surface and set the value to 100 percent. If your program allows for values greater than 100 percent set it to 150 percent.

4. If your program allows for diffusion maps, apply the image map to the diffusion channel and set its opacity to 50 percent. If you set the value to 100 percent, the surface will be nearly black, so we need to back down the strength of the diffusion map by lowering the opacity. I know I've discussed diffusion a number of times in several books, but I can't stress how important it is for creating realistic surfaces.

 Diffusion scatters the light on the surface of your object, effectively lightening or darkening areas of the surface. For example, on our cobblestones, the dark pits in the stones will be diffused more heavily than the lighter surface areas, meaning less light will be reflected back by the pits, which is what happens in reality.

5. Set the specularity to 12 percent and the glossiness/hardness to 20 percent. This will make the blocks somewhat specular, but the hot spot will be wide so the blocks will appear chalky instead of hard like plastic. Now do a test render. You should have something similar to Figure 3.16.

Figure 3.16 The surfaced cobblestones.

Notice how they have great depth with subtle specular highlights on the edges of the blocks. We now have something that will appear very realistic in a scene because it has real depth and detail.

The key to creating realistic images is to add plenty of depth. The more perceived depth, the greater the realism. Let's face it, an incredibly detailed 3D object, like the motorcycle in Figure 3.17, is deceptively realistic for a moment because of the great amount of detail.

Of course, on close inspection it has a few traits that aren't quite real, such as the surfacing on the seat and the signal lights in particular. These areas lack detail, but the incredible detail of the model duped us into thinking it was real for a moment. That's the power of detailed surfaces. This same principle is used in nearly every science fiction special effect. I'm sure you've noticed the high volume of surface detail on space ships in sci-fi movies. These details are called "nurnies." Yes, it's a bit of an odd name, but if you know any special effects people, you completely understand why. They tend to be a bit nutty, but then so are 3D artists. You have to be a bit "off" to do computer graphics. Anyway, nurnies are basically simple details that make the entire object appear very detailed, and therefore very realistic. Figure 3.18 shows a prime example of a very realistic 3D space ship that is loaded with nurnies for realism.

Notice how there are small details all over the ship. This visual chaos helps to make it appear more realistic. Of course, it also has wonderfully detailed surfacing that clinches the photorealism deal.

Figure 3.17 A highly detailed object.

Figure 3.18 Nurnie power.

ALWAYS ADD DEPTH TO YOUR OBJECTS

■■■■ **Depth is an important aspect of realism. If you want your viewers to believe that objects are real, you need to add depth. Image map modeling is the fastest and best way to add depth to your objects. Bump maps may work for distant shots, but if you want to be convincing up close, you'll need to incorporate physical depth.**

Okay, now that we have our completed cobblestone tile we're ready to put it to good use. This is where we reap the reward of tileable models. To create a cobblestone street with amazing depth, all you need to do is clone the object and move the clones into position next to one another as shown in Figure 3.19.

As you can see, it's very easy to create the road using a tileable model. If you do a test render, you should have a seamlessly tiled street like the one shown in Figure 3.20.

Now that's more like it, a great seamless road with depth. The best thing is we can now create very complex environments by merely cloning the single cobblestone object. This is the beauty of tileable models and image map models. We create a collection of parts that can be assembled in a rendering program to create an unlimited variety of buildings and props, which is much easier than constructing each building individually. We'll talk more about how to use seamless tileable models to create complex industrial environments in Part

Figure 3.19 Tiling the cobblestone model.

Figure 3.20 The seamlessly tiled cobblestone street.

Four, "Creating Industrial Environments." For now, let's take a look at another example of a seamless tileable model.

In Chapter 2, "Image Map Modeling," we created a brick wall with depth using the image map modeling technique, which also happens to be a seamless, tileable model since the original image map was seamless. This object was tiled to create the brick wall in Figure 3.21.

Notice how realistic the wall appears. Figure 3.22 shows a close-up of the bricks.

You can see the wall appears completely seamless, but it's actually six copies of the original brick wall we created. This wall could have been modeled as a single object, but then we would have had to create a larger and more complicated texture to surface it. Of course, there are times when a seamless tileable model presents a few problems. For example, you may need a square segment of bricks, but your seamless model is rectangular. This presents a bit of a problem. You can't stretch the object because then the bricks will be deformed. So what do you do? Well, typically you would start from scratch and build a custom wall with a corresponding custom image map. This, of course, is undesirable since we already have a great seamless, tileable model in which we

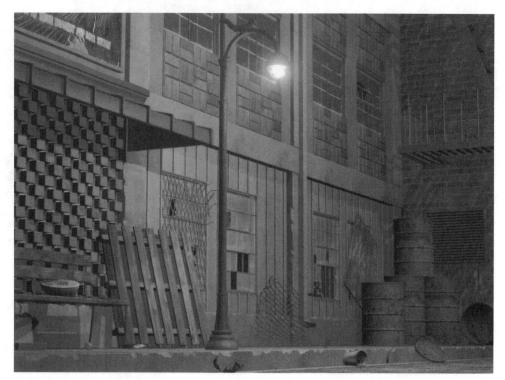

Figure 3.21 A seamless, tileable brick wall used in a street scene.

invested a good deal of time perfecting. What's the solution? You use the seamless, tileable model to build custom shapes by using a bit of surfacing trickery. Allow me to explain.

Custom Shapes from Seamless, Tileable Models

The main pitfall of creating custom buildings with unique details is the work involved both in modeling and surfacing the details. A custom brick wall can be a nuisance to model and a real nightmare to surface because the image maps can be huge when covering a complete custom surface. It's also really annoying to keep creating custom image maps. The last thing we want to do is add more work to our already hectic schedules. This is where a seamless, tileable model can save you a great deal of time and effort.

The trick is to save the surface of the seamless tileable model and apply it to your new custom model. Okay, that requires a bit more explanation. Let's take

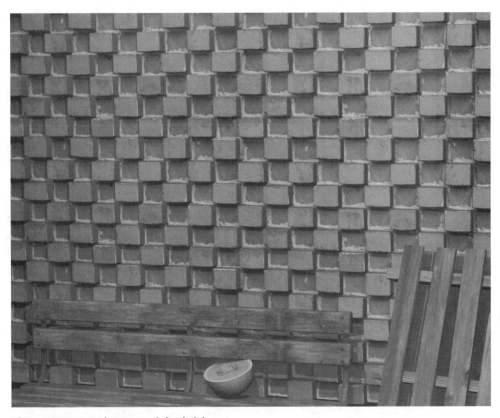

Figure 3.22 A close-up of the bricks.

this opportunity to walk through an exercise on creating a custom object from a seamless, tileable model so we can get a handle on the process.

**EXERCISE: CREATING A CUSTOM MODEL FROM A SEAMLESS
TILEABLE MODEL**

1. Load the brick object created in Chapter 2, "Image Map Modeling." If you haven't already performed the brick modeling exercise in Chapter 2, I suggest you do so before continuing with this exercise. If you forgot to save the model, don't worry. You can find a copy of it called bricks.3ds in the chapter3 folder on the companion CD-ROM. The file is also provided in several other popular file formats.

FLIP 3DS MODEL SURFACE NORMALS

You might find the surface normals are flipped when you import the 3DS model. This is a common problem when they are converted from another format. Simply flip the surface normals for the object, and you'll be ready to go.

2. Now we need a template for our custom shape. For this exercise, we'll be using a room I created. The file is called room.3ds and can be found in the chapter3 folder on the companion CD-ROM. Load this file into your modeling program now.

3. Now we're ready to start tweaking the brick model. What you're going to do is complete the front wall of the room using the seamless brick model. The first thing to notice is the brick object isn't positioned properly on the wall of the room. While it's easy enough to move it, this will change the surfacing coordinates of the model. That's fine for now since we will be correcting the coordinates in a minute. Go ahead and move the bricks so they are snug in the upper left corner of the hole as shown in Figure 3.23.

4. Clone the brick object, but first we need to group it so we can select it later. We'll be using this first group of bricks for the image mapping coordinates, so we need to be able to select it. If your program allows for groups, select the bricks and group them with the name brick base. If you don't have grouping, you'll need to manually select these objects later. If you have layers, you can skip the grouping since you can create the clones on a different layer.

5. Now it's time to build the wall. Simply copy the group three times and place the clones around the original as shown in Figure 3.24. Be sure to place the clones flush against the original so there is no visible seam. If you

Figure 3.23 Positioning the bricks.

Figure 3.24 Cloning the brick group.

are working with layers you should copy the clones to a new layer so they are separated from the original.

6. Now we have the full wall segment, but it's too big for the hole. You need to scale the bricks down to fit in the hole. Scale the bricks down so they meet with the lower edge of the hole as seen in Figure 3.25. Be sure to use the upper left corner of the bricks as your axis for the scaling.

7. Now we're making some progress. Of course, the bricks are too wide for the hole, so we need to remove the extra bricks on the right. Start by selecting the six blocks that overhang the hole on the right side and delete them, as shown in Figure 3.26.

8. Select the points on the right side of the flat mortar planes and move them to the left until they are flush with the edge of the hole. Use Figure 3.27 as a reference.

 Now the bricks should be positioned within the frame of the wall as seen in the OpenGL preview in Figure 3.28.

9. The wall is now complete and ready to be surfaced. Before we surface it, let's save the room with the new brick wall as roomcomplete.

10. Now it's time to use a little surfacing trickery to save a great deal of time and effort. What we're going to do is surface the original brick group and

Figure 3.25 Scaling down the bricks.

Figure 3.26 Deleting the excess bricks.

Figure 3.27 Sizing the brick mortar plane.

Figure 3.28 The completed brick wall.

let it automatically repeat across the new bricks. Since your original brick group is seamless, the image maps will seamlessly tile across the new brick segments. Of course, you did scale the bricks down earlier, so our original surfacing coordinates will no longer work. We need to correct them for the original brick segment, but to do so we need to separate it from the new brick segments we created. We want to automatically size the image maps so we have to use only the original group or we'll be stretching the textures across the entire wall, which will look very strange. Select the original brick group indicated in Figure 3.29 and save it as bricktemplate.

11. Load this object into your rendering program, and do a test render. You should have something similar to Figure 3.30.

12. It looks terrible doesn't it? Why? Because the surfacing of the bricks no longer matches the geometry since we scaled the bricks down. Fortunately this is easy to fix by using your automatic sizing feature for the image maps or by simply reapplying them. You can also manually adjust the texture bounding box if your program permits. You'll need to resize the image maps for the color, bump and diffuse surface channels of the brick wall blocks surface only. The brick wall blocks side surface is cubic mapped, so you won't need to change the mapping coordinates since it

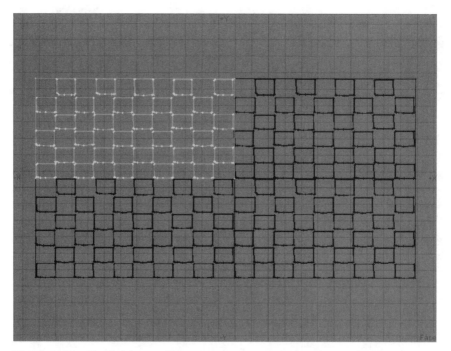

Figure 3.29 The brick template.

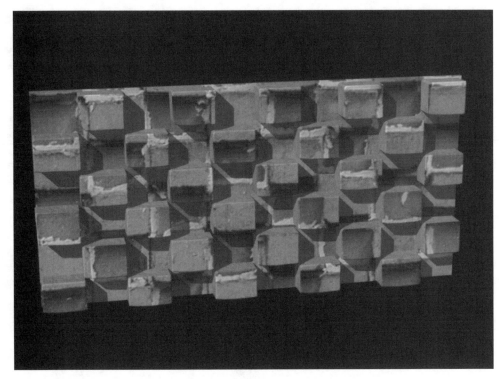

Figure 3.30 Incorrect image map coordinates.

repeats anyway and it doesn't have specific details that are fixed to the geometry. Speaking of repeating, you should make sure you have texture repeating turned on for all surfaces so the image maps are repeated across the entire wall of our room.

13. Once you have resized the image maps, do another test render to make sure it worked properly. You should have something similar to Figure 3.31.

14. That's much better. Now we're ready to apply this new surface to our brick wall on the room. We have two ways to apply this new surface. We can save the surface attributes as a resource file, which most programs allow, or we can save the bricktemplate object so it retains the new surface attributes. I suggest we do both. Go ahead and save the surface attributes as Bricks and then save the bricktemplate object.

15. Load the roomcomplete object into your rendering program and apply the new surfacing to the bricks. You can select the brick wall blocks surface and load the bricks surface attribute you just saved, or you can simply load the bricktemplate object, which will automatically apply the new surface to the bricks. Either way is just as effective. Of course, if you load the brick-

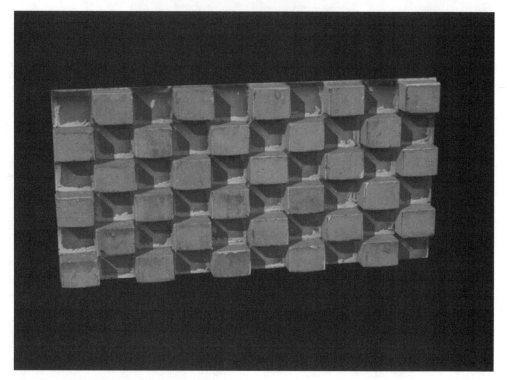

Figure 3.31 The corrected surface.

template object to update the surfacing you'll need to delete it immediately so you don't have it in your scene.

16. Now that the surfaces are updated, you can do a test render to see the results. Figure 3.32 shows the surfaced brick wall.

Not bad. We managed to surface the new bricks without creating a custom image map. We also drastically reduced the size of the image map required to surface the entire wall since the actual size of the image map is one quarter the size of the wall, which saves a great deal of memory, and we didn't have to paint a new image map. You probably noticed the cement texture on the room in Figure 3.32. You can find this image map, called cementtile.jpg, in the chapter3 folder on the companion CD-ROM. To surface the cement blocks simply copy the brick wall blocks side surface to the cement surface and then replace the BrickTile.jpg image map with cementtile.jpg, on the color, bump, and diffusion channels. Now you can copy this surface to the cement gouges and cement ledge gouges surfaces. I recommend using a little crumple texture on the bump channel of these surfaces to make them look like rough cement. You should experiment with the settings to get the right look. I found a 3-cm crumple with 100 percent bump was perfect for simulating the rough edges of broken cement.

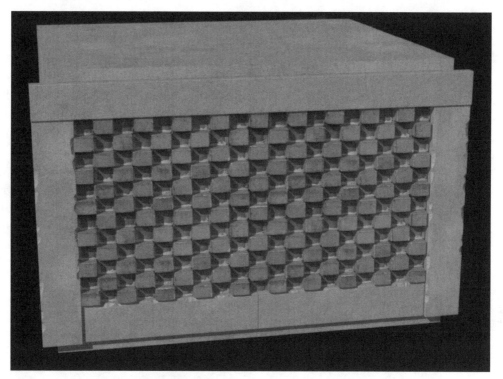

Figure 3.32 The surfaced brick wall.

As you can see, the seamless, tileable models are very useful for creating amazingly realistic objects and saving you countless hours of modeling and surfacing time. They are truly the backbone of photorealistic industrial modeling. If you want to build a city scene, the seamless, tileable model will be your most productive tool. Speaking of building city streets, let's take this opportunity to explore more complex tileable models, which are the elements of industrial development.

Creating Complex Tileable Models

Seamless, tileable models aren't limited to simple objects like brick walls or cobblestone streets. They can be used to create much more complex objects like the room we completed in the last exercise. When you are building a large city scene the last thing you want is huge objects, which will eat up your resources. It's easier and more resource-friendly to use tileable objects to create complex objects such as buildings. We basically build segments of a building that can be repeated when we stage the scene, creating the complete building. For exam-

ple, the room we completed earlier can be repeated to create the side of a building, as shown in Figure 3.33.

In a matter of seconds, the single room object was used to create the side of a building. While it looks great, the room object isn't a good seamless object since the cement beams on the sides of the room meet each other when the room is tiled. The double beams look a bit odd since it would typically be a single beam. To make the room a truly seamless object, we'll need to do a bit of editing.

When creating tileable models, we want to make sure they fit together like pieces of a puzzle. This means the beam on one side of our room needs to be removed so the bricks of one side will meet the beam of the other when the room is tiled. Let's take a look at how we modify the room to be tileable.

EXERCISE: CREATING A TILEABLE ROOM

1. Load the roomcomplete object into your modeling program.

2. Group the object, copy it, and place the copy to the left of the original so the beams where they meet overlap as shown in Figure 3.34.

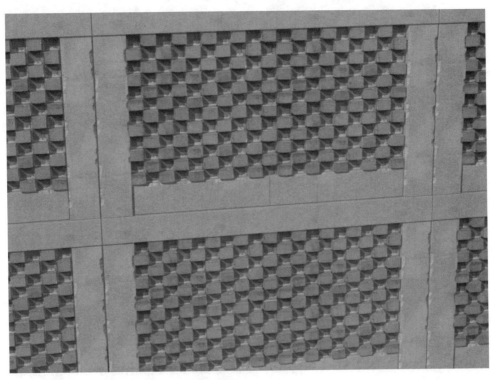

Figure 3.33 Repeating the room segment.

Figure 3.34 Copying the room.

If you have a layers option in your program, I suggest you place the copy on a separate layer to make the editing easier. If you don't have layers, it's not a problem—you'll just have to be careful when selecting the polygons to be edited.

3. Delete the cement beam on the right side of the room to the left. This is where the rooms will meet so you want to create a seam where they come together by deleting the beam of one object. Figure 3.35 shows how the room should now appear.

4. Now it's time for some detail editing. We need to move the polygons where the rooms come together to create clean seams, so the object details don't overlap. We'll start by editing the top crossbeam on the front of the rooms. Select the polygons on the leading edge of the crossbeams, and move them so they meet flush in the middle of the vertical beam as shown in Figure 3.36.

5. We're almost done editing the top of the rooms. All you need to do now is create a seam where the ceilings meet in the middle. Select the polygons on the leading edge of the ceilings as you did earlier with the crossbeams and move them so they come together in the middle of the vertical beam as shown in Figure 3.37.

Figure 3.35 Deleting the beam.

Figure 3.36 Creating a seam for the upper crossbeams.

Figure 3.37 Creating the seam for the ceilings.

6. Great, now we can edit the floor of the rooms in the same manner. Select the polygons on the leading edge of the floors, and move them so they come together in the middle of the vertical beam as shown in Figure 3.38.

7. Now the right side of our room is complete. To complete the left side you need to mirror the changes we did to the background room on the left side of our room. To do this, move the left room so it's directly over the right room. You'll notice the crossbeam, ceiling, and floor of the left room extend beyond the right. You need to move the leading edge of these elements so they line up with their complements on the room in the background. We'll start with the ceiling and floor.

8. Select the leading edge of the ceiling and floor and move them to the right until they line up with the background room as shown in Figure 3.39.

9. Now select the leading edge of the upper crossbeam and move it to the right until it lines up with the background room as seen in Figure 3.40.

Great, now we're done editing the room. The left and right sides of the room will now come together seamlessly like a puzzle when we tile the object. You should now have something similar to the OpenGL preview in Figure 3.41.

The object actually looks like a 3D puzzle piece. We can already visualize the ends coming together to form a perfect seam. Speaking of coming together,

Figure 3.38 Creating the seam for the floors.

Figure 3.39 Moving the ceiling and floor leading edge.

Figure 3.40 Moving the upper crossbeam leading edge.

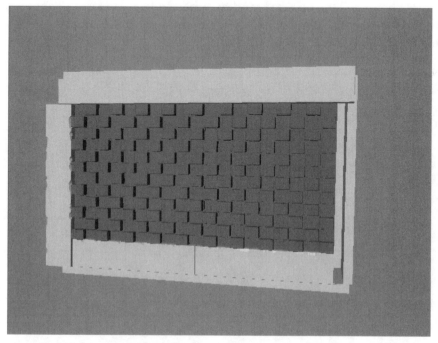

Figure 3.41 The completed tileable room.

let's save the model as roomtile and load the object into our rendering program where we can test it to see how it tiles.

With the object loaded, clone it five times and place the clones end to end as shown in the bounding box preview in Figure 3.42.

Notice how the objects overlap. This is because the vertical beam of the model extends beyond the rest of the geometry so they need to be overlapped for the seams to meet. Figure 3.43 shows a wireframe preview of the models, which shows how they overlap.

Now we're ready to test our creation. Do a simple render of the rooms to see how they come together. You should have something similar to Figure 3.44.

Notice how the rooms are perfectly seamless and look a great deal more natural with a single vertical beam between the rooms. It now looks like a very realistic wall.

As you can see, seamless, tileable models can be very useful when creating complex industrial objects such as buildings. The same technique can be used to create sidewalks like the one seen in Figure 3.45.

You can see how this object can be easily tiled. The curb edge on the left meets the curb edge on the right in the middle of the sidewalk segment as shown in Figure 3.46.

Notice how well the objects blend together. In fact, Figure 3.47 shows a render of the final, surfaced sidewalk in use with our tileable cobblestone street and the tileable room with the brick wall.

Figure 3.42 Aligning the room objects.

Figure 3.43 The overlapping of the rooms.

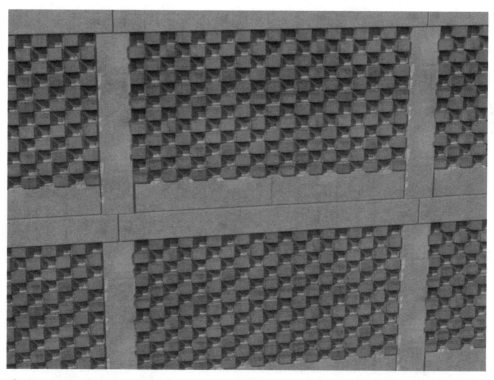

Figure 3.44 The seamless rooms.

Figure 3.45 A seamless, tileable sidewalk.

Figure 3.46 Tiling the sidewalk.

Figure 3.47 The rendered sidewalk.

This scene looks very realistic, and it's entirely comprised of tileable models, which are very simple and fast to assemble. When creating scenes with city sidewalks, such as this one, you'll want to make liberal use of tileable models to save on system resources. For example, creating the complete sidewalks for each building individually can be abusive to your resources and would involve a great deal of unnecessary effort on your part. What you'll want to do instead is create a tileable sidewalk model for the sides of the building and a generic corner model so you can wrap the sidewalk around the building. While it's important to focus on the detail when creating photorealistic models, it's equally important to optimize your efforts so you get the biggest bang for your buck. Let's face it, in this business time is money and you can never have too much money.

Wrap Up

Seamless, tileable objects are a real lifesaver when it comes to creating complex objects and environments. They are an important tool when creating detailed city environments since they are relatively simple to create and very flexible

when developing your scenes. They are a staple of every photorealistic industrial scene. You should put them to use in all of your industrial environments—you'll be pleased you did.

Of course, the world isn't just industrial environments. It also includes natural settings, which brings us to the next topic, creating tileable ground covers. The one element that makes natural 3D settings incredibly realistic is the use of a ground cover to break up the scene. Of course, it's one of the least used elements because of its complexity. In Chapter 4, we'll explore a number of techniques for easily creating mind-blowing detail in your natural settings with 3D ground covers.

Creating Tileable Ground Covers

N othing is more challenging than creating photorealistic natural environments, particularly if you plan to shoot close-ups. While there are a number of programs that create digital botany and natural terrain, such as World Constructions Set, Bryce, View de Spirit, and World Builder, you'll find the effects they create tend to be rather unrealistic upon close inspection. These programs do a great job of creating wonderful mountains covered in trees and snow or marvelous bodies of water that reflect the surrounding environment and mirror the sky, but they aren't the best choice when you need to get a close look at a bug on a leaf or a snake in the grass. So what do you do if you want to zoom in on the environment?

This is where it gets more complicated, requiring a deep study of natural worlds. Mother Nature has a habit of creating a great deal of chaos and detail, which makes replicating her work a somewhat daunting task. If we want to do a convincing job, we are forced to manually create the details in the surrounding environment. We have all seen attempts at re-creating natural realities in 3D images, but how many times has the image looked like a photograph? Unfortunately most 3D worlds tend to look barren. They can be filled with trees, rocks, and dirt but they still don't appear completely realistic. That's because nature likes to accessorize reality.

Take a look outside, and you'll notice that you rarely see dirt. It's almost always covered in some form of ground cover. This is nature's way of preserving the moisture and nutrients of the soil. If there weren't ground covers, the world would be one big desert. Ground covers are all around us so we need to

incorporate them into our images if we want the viewer to believe the image is realistic. While we could simply drop a detailed image map on a simple ground plane, that won't work on close-ups since the ground cover's lack of depth would be obvious. What we need to do is build the physical ground cover ourselves. Yes, it sounds like a nightmare, but fortunately tileable models make this task rather simple, and the results are quite amazing. For example, take a look at the image in Figure 4.1.

Here we have an image of a lunch ball in a field of clover. Okay, I know you are wondering what a lunch ball is, so let's take a brief look at them before we move on. Lunch ball is a game Goblin babies play during lunch, hence the name. It's similar to soccer except the ball is actually twenty times larger than the players.

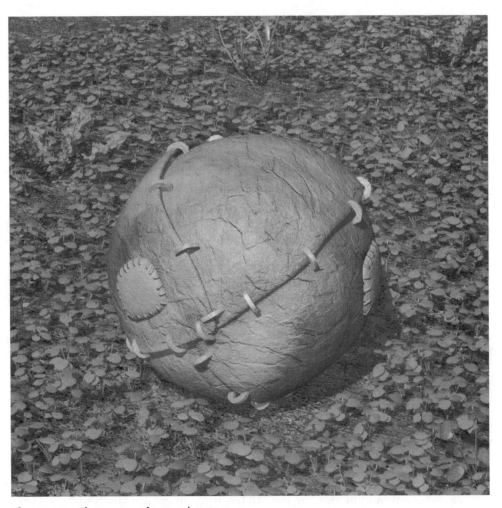

Figure 4.1 The power of ground covers.

The goal is to get the ball through the other team's goal without being crushed beneath it. Figure 4.2 shows several baby Goblins playing lunch ball.

As you can see, the game is rather challenging and dangerous. Of course, baby Goblins are like beanbags, so they aren't harmed when they get squashed by the lunch ball. In fact, you could say they are the original Beanie Babies. Anyway, that's the story behind lunch ball. Now that we've had our Goblin history lesson, let's get back to ground cover.

Take another look at Figure 4.1. Notice how the clover breaks up the appearance of the dirt and adds tremendous depth to the image. While this is a simple scene with very little in the way of major chaos, it shows the true power of ground covers. The ground cover makes the image more dynamic, giving the

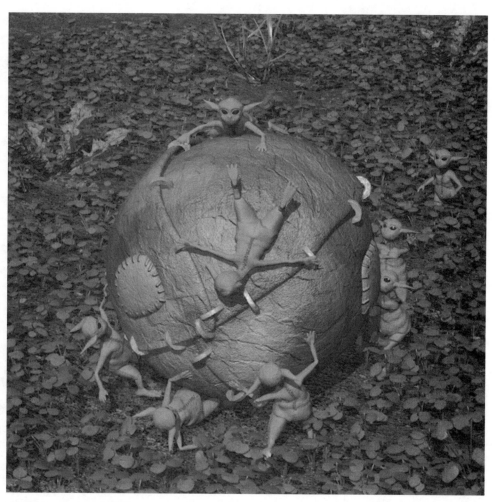

Figure 4.2 Lunch ball.

viewer much more depth to explore. Figure 4.2 shows a great example of depth. Notice how the ground cover hides portions of the baby Goblin players. This is a wonderful way to make the image more dynamic. If we could see all of the player's bodies the image would have less visual appeal.

The ground cover also stimulates the viewer's imagination. Now they get to wonder what is under the ground cover. Could it be insects or maybe a snake? The more depth we can add to a scene, the more photorealistic it becomes. For example, take a look at the image in Figure 4.3.

This is the same shot without the ground cover. While the dirt is most certainly interesting with the moss covering portions of it, there is much less depth to the image and therefore it's less interesting. Adding the ground cover has done

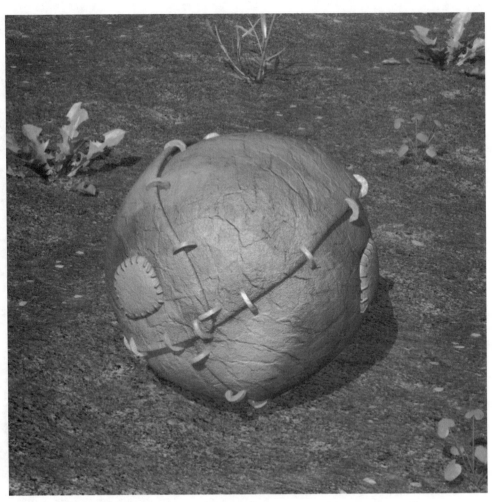

Figure 4.3 Minimal depth.

two things for us: it made the image more interesting to view and it added more depth, making it more photorealistic. Let's face it, there aren't too many places in nature where we find a nice clear patch of dirt. Most of the world is blanketed in ground covers. In fact, peat moss bogs, a very common ground cover in Europe, are responsible for 80 percent of the world's oxygen supply. Ground covers are not simply interesting to view, they also support life.

In this chapter we'll explore a number of ways to quickly and easily create tileable ground covers in 3D images. They do eat up system resources, but that's the price we pay for re-creating natural realities in 3D. On the other hand, making them tileable helps us to reduce the amount of system resources required to get the job done. Let's jump in and take a look at how we create tileable 3D ground covers.

Creating a Field of Clover

One of the most common ground covers we see in nature is clover. It's also one of the more interesting. Clover is a great 3D ground cover because it's a simple shape and uses a low volume of system resources. Grass is the only ground cover that uses less system resources, though it actually uses more if we make the grass thick enough to cover the dirt completely.

The clover's leaves give it a large surface footprint, which makes it an ideal 3D ground cover. Clover covers a healthy portion of the ground without requiring a lot of objects. Take another look at Figure 4.1 and you'll see that the clover covers the ground very well, yet the clover isn't that abundant in the image. We want to avoid using ground covers that have a lot of detail or a small footprint because they'll eat up system resources when we use enough objects to cover the ground. We don't necessarily want to avoid them entirely, but rather use them only when it's required to make the shot.

There are a number of ways we could create flowing ground covers for our 3D environments, but the fastest and most efficient method is to create tileable models, just as we did in Chapter 3, "Adding Depth with Seamless, Tileable Models." Tileable models make it easy for us to quickly cover the ground in our scenes without having to create a huge, unmanageable object to cover the entire surface. Creating a single object for the ground cover would likely bring our computers to their knees, gobbling up system resources like a school of piranha. Creating a small, tileable ground cover is the most logical approach since it's easy on system resources, we can manually tile it to cover the ground, and we have a greater degree of control over where the ground cover is placed. We can also vary the concentration of the ground cover by overlapping tiles. Basically, there are many benefits to tileable ground covers. We'll talk more

about how to use tileable ground covers later in the chapter. For now, let's take a look at how to create a simple, yet visually complex clover ground cover.

EXERCISE: CREATING A BED OF CLOVER

1. We'll start by making a single clover leaf and stem, and then we'll clone it into a small group, which is the way clover grows. Finally, we'll clone the group to make the complete ground cover tile. The first step is to create the leaf, which begins with a simple flat plane with two segments and four rows as shown in Figure 4.4.

2. Now shape the leaf by dragging the points into a rounded spearhead shape as shown in Figure 4.5.

3. Yes, the leaf looks a bit polygonal, but this won't be noticed unless we are directly on the leaf. If you want to zoom in close to the leaf, all you need to do is subdivide the completed leaf to make it higher resolution for the extreme close-up shots.

MAKE MULTIPLE RESOLUTION MODELS

It's a great idea to make low-resolution models for distant shots and high-resolution models for close-ups. This is where subdivision is perfect since it will take your low-resolution model and smooth it for close-ups. The closer you intend to get, the more passes of subdivision you can make to insure the object isn't polygonal.

Figure 4.4 Starting the clover leaf.

Figure 4.5 Shaping the leaf.

4. Next add organic curvature to the leaf by selecting the points down the middle and moving them upward as seen in Figure 4.6.

5. It's looking better, but the leaf needs to have some chaos if we want it to be realistic so we'll need to bend it up a bit. We'll start by bending the tip. From the side view select the two segments of points at the end of the tip and rotate them as shown in Figure 4.7.

6. Be sure to use the point indicated by the arrow as the reference point for rotation. We are going to bend the tip again with the same points, but this time at a different location so we can curl the tip downward a bit more. Figure 4.8 shows the next bend to make and the point of rotation.

USE MULTIPLE ROTATION POINTS

You can save yourself time by using multiple rotation points for the same selection instead of selecting the points, rotating them, and then making another selection to rotate. While it may not seem like much now, when you perform hundreds of actions on a model, every one you can avoid makes a significant difference over the course of a project.

7. Now it's time to make the leaf asymmetrical. We don't want it to be balanced on both sides, so we need to change one side. A symmetrical leaf

Figure 4.6 Adding depth to the leaf.

Figure 4.7 Bending the tip of the leaf.

Figure 4.8 Rotating the tip.

would appear unnatural. To contour the leaf, select the two segments of points on the right side of the leaf and rotate them downward as shown in Figure 4.9.

8. The leaf is now complete. Next you need to create the stem by making a simple plane at the base of the leaf, seen in Figure 4.10.

9. Now extrude this polygon with five segments as shown in Figure 4.11.

10. Now we're making progress. The last step is to bend the stem so it appears more natural. Mother Nature doesn't create straight lines, so we need to make the stem more organic to be believable, as shown in Figure 4.12.

11. Okay, we now have one clover leaf completed. The next step is to clone the leaf to create a little cluster of leaves as shown in Figure 4.13.

12. To create the clover cluster, clone the leaf three times, and then rotate and scale them so the stems are packed tightly together in the middle.

13. We now have a cluster that can be cloned to create the small tileable clover patch. Before we move on to creating the patch, save the clover cluster as clovercluster. You never know when you may need it in the future.

Creating the patch can be done two ways, automatic and manual. Let's take a look at how both are accomplished.

Figure 4.9 Making the leaf asymmetrical.

Figure 4.10 Starting the stem.

Figure 4.11 Extruding the stem.

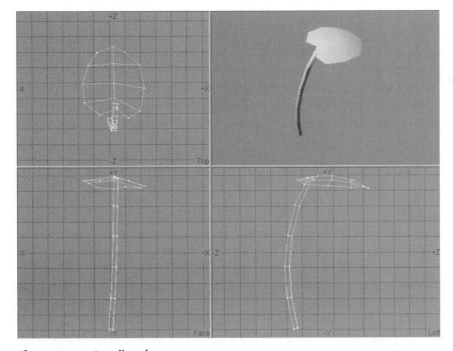

Figure 4.12 Bending the stem.

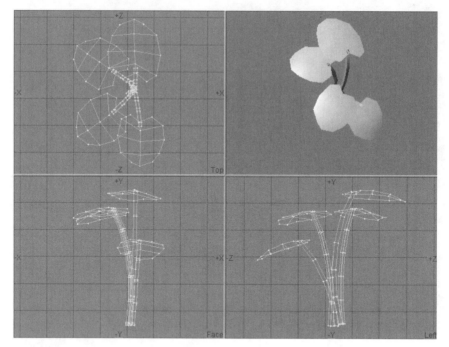

Figure 4.13 Creating a clover cluster.

ALWAYS SAVE YOUR STEPS

You should save, and save frequently. Yes, it's wise to back-up your work, but what's more important is to save the steps you are making as different files so you can go back and use these undeveloped models in the future. Saving the steps individually allows you to make custom editing changes in the future. I typically have 20 to 30 copies of my models as they progress through development.

Creating the Clover Patch

When we create the clover patch we want a square patch of clover with clusters that are varied in size, rotation, and height. We don't want a uniform patch, since it will be too linear for nature. We also don't want the clover to be the same uniform size since that won't happen in reality either. Plenty of chaos needs to be added to the clover to make it photorealistic. The easiest way to add chaos is to use automatic cloning based on the location of points in a reference object. This method is available in a number of programs, such as 3D Studio Max and LightWave. If you don't have an automatic cloning tool, you can jump down to the next exercise, which illustrates the manual method. Let's take a look at how we can automatically clone the clover cluster.

EXERCISE: AUTOMATICALLY CLONING THE CLOVER CLUSTERS

1. The first step is to create a reference object that contains the points we'll reference when cloning. It basically represents a square patch of ground where we'll be growing the clover. Make a flat plane on the y-axis with 15 horizontal and 15 vertical segments as shown in Figure 4.14.

2. We now have a plane with 304 points. Each point represents a location where a clover cluster will be placed when we clone it. Before we do the cloning, we need to add chaos to the points so we don't end up with parallel rows of clover. To add chaos, apply a simple jitter to the points, which does exactly what it says. It moves the points around chaotically on all three axes. The amount of jitter depends on the size of your object. You want to apply only enough jitter to shift the points a bit. You don't want to create a twisted mass of points, since the clover needs to be nearly parallel to the ground. The amount of jitter depends on the size of your plane. It will take a bit of experimentation to get the right look. Once you have applied the jitter properly your object should look something similar to Figure 4.15.

3. Great, now we're ready for some cloning. This is where it gets a bit tricky since most programs have different reference cloning features. You'll have

Figure 4.14 Making the reference object.

Figure 4.15 Jittering the points in the reference object.

to experiment with your program's cloning tools before you continue with this exercise since they vary widely from one program to another. Most allow you to control the size and rotation of the clones and typically provide a minimum and maximum setting for these values.

4. Let's clone the clover cluster. Select the clover cluster as the cloning object and the plane we just created as the reference object, and then activate your automatic cloning function. Use the following values for the cloning attributes:

- Scale/Size: minimum 1, maximum 2
- Rotation: minimum 0, maximum 360

5. Now perform the cloning operation, and you should end up with a tight grouping of clover clusters like the one seen in Figure 4.16.

6. Before we continue let's save the clover patch as CloverPatch.

As you can see, it was very easy to create a dense patch of clover clusters with the press of a button. Figure 4.17 shows a close-up OpenGL preview of the clover patch.

Notice how the clover is chaotically rotated and sized so there are no repeating

Figure 4.16 Cloning the clover clusters.

Figure 4.17 An OpenGL preview of the clover patch.

patterns in the clover. This is essential if we want the clover to appear realistic. I'm sure you noticed that a few of the clover leaves are penetrating the stems of other clover clusters. This is fine since we won't be zooming in close enough to notice. Even if we did zoom in tight it would be very difficult to see these problems due to the chaos of the cluster.

Now that we've seen the automatic method of cloning the clover clusters, let's take a moment to examine the manual method. It's a bit more work, but if you don't have the automatic cloning tools it's what you'll have to do. It's really not as bad as you might think. You can take some great shortcuts to expedite the process so you don't have to manually edit 304 clover clusters. Let's begin the exercise.

EXERCISE: MANUALLY CREATING THE CLOVER PATCH

1. We start the same way as the automatic method by creating a reference plane with points representing where the clusters will be placed. Make a flat plane on the y-axis with 15 horizontal and 15 vertical segments, and then apply a small jitter to chaotically arrange the points.

2. Now we're ready to start cloning the clusters. First load the clovercluster object. If you have layers in your program, load the cluster on a new layer; if you don't simply load the cluster in with your reference object. Now position the cluster in the middle of the reference object as shown in Figure 4.18.

3. Clone the cluster eighteen times, rotating and sizing each clone so they are different. Then place the clones over the points in the reference object, creating a small, nearly square patch in the middle of the reference object as shown in Figure 4.19.

4. Now select all of the objects in this patch and group them with the name CloverPatch. This will make it easier to select the patch since we will be cloning it to create the larger patch, and it saves a great deal of time. Instead of manually creating 304 clones we create only about 26, which is certainly a lot better and likely to save you a serious headache. 3D graphics are hard enough without us making it harder by doing things the hard way. It's always a good idea to seek out shortcuts to save yourself time and frustration. Of course, you have to be careful that your shortcut doesn't create problems. For example, if we merely tiled the cloned object to cover the template we'd end up creating a pattern because the chaos of the patch would repeat itself. To avoid this problem we need to be creative in the way we place the clones. Let's take a look at how that's done.

5. Move the CloverPatch group to the upper left corner of the reference object. Now create a clone of the group and place it immediately to the right. If we left it like this we might end up with a repeating pattern in the clover patch. To make sure we don't, rotate the new group 90 degrees clockwise and position it flush against the first group. Now they won't repeat because

Figure 4.18 Positioning the first cluster.

Figure 4.19 Creating a small patch of clover.

we've rotated the pattern of the group. Now make another copy of the first group, rotate it 90 degrees counterclockwise and place it directly beneath the first group. Make one more clone of the group, rotate it 180 degrees clockwise, and place it next to the last group to complete the square patch shown in Figure 4.20.

6. To make sure we don't create a repeating pattern in the final clover patch, repeat the process with this larger patch to complete the tileable clover patch.

 Now that we have our completed clover patch let's save it as Clover-Patch, unless you already completed the automatic cloning exercise. If you have, you don't need to save this copy.

As you can see, it really wasn't that difficult to create the clover patch manually. We just needed to find some creative shortcuts.

We now have a very detailed tileable clover patch that can be used as ground cover in our natural settings. The great thing about natural tileable models is they don't have to be seamless. They are seamless by default since there is no pattern to form a seam. Of course, there are some tricks to placement when you tile them in your scenes. Even though they are chaotic internally, we are still faced with the possibility of a noticeable repeating pattern if we tile the clover several times in our scene. Since the clover patches are all the same,

Figure 4.20 Expanding the clover patch.

they will start to form a pattern of repeating chaos. They can also create patterns where the patches meet each other since they will always be the same. To avoid these problems we use the same technique as we did when manually creating the clover patch—that is, we rotate the copies. Speaking of tricks, let's take a look at some of the staging tricks for natural tileable models.

Staging Natural Tileable Models

There are a number of things to consider when using natural tileable ground covers in your scenes. The foremost is how well they will tile. We certainly don't want to see any seams in our ground covers, nor do we want repeating patterns. We have already seen how to remove the repeating pattern problem by rotating the clones. This works well, but we also need to be cautious about how we place the clones. For example, take a look at the bounding box preview in Figure 4.21.

Notice how the clones are all rotated at different angles. You would think this would remove any seam problems, but it doesn't as you can see by the wireframe preview in Figure 4.22.

See the very obvious seam between the clover tiles? This occurs because the clover doesn't have a linear edge. The leaves reach out beyond the general mass of the object. Therefore we need to overlap the tiles to bring the general mass together and remove the seams, as shown in Figure 4.23.

Figure 4.21 Tiling the clover patch.

Figure 4.22 Seam problems.

Now we have removed the seams, as seen in the wireframe preview in Figure 4.24.

This is much better and completely natural. The clover patch we created is now free of repeating and seams. Of course, you need to be careful not to overlap the tiles too much or you'll end up with super dense lines of clover where they overlap, which will create a seam. Overlap them just enough to close the gap and no more. Figure 4.25 shows a rendered view of our newly created field of clover.

It looks great doesn't it? Not a seam in sight and plenty of chaos and depth. Note that the clover in this image is surfaced. If you want to surface your clover, you'll find an image file named clover.jpg in the chapter4 folder of the companion CD-ROM. This is a simple image map that's nothing more than a bit of rendered clouds and fractal noise. You'll find you can get away with relatively simple image maps for most ground covers since they tend to have small surface details. All you really need is some color shifting and a bit of noise to break up the colors.

All we need to do now is build a world around the clover. Well, okay, we won't be doing that much work but we will be exploring some techniques for adding elements in the middle of ground covers. Let's take a look at how we place objects in the clover naturally, so the clover doesn't penetrate the object.

Figure 4.23 Overlapping the tiles.

Figure 4.24 Seams removed.

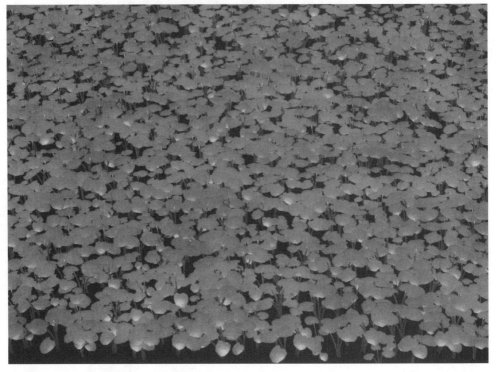

Figure 4.25 The completed field of clover.

Placing Objects in Ground Covers

Having a dense ground cover presents a unique problem. It can make it challenging to place objects in the middle of the ground cover without having the ground cover penetrate the object. For example, it won't look very realistic if we drop a rock in the middle of the clover since the clover leaves will penetrate the rock. Nothing is more artificial than objects penetrating each other, but it's a common problem when creating natural 3D settings. There is so much detail and chaos in the real world that it can be challenging to re-create it convincingly in 3D because we aren't lucky enough to have object collision detection and physics when staging our scenes. In reality, the rock would simply compress the clover, but in a 3D world that just doesn't happen.

I remember seeing a character holding a bunch of balloons done in Maya on the front of *Computer Graphics World* magazine. While the character was great, the string from the balloons was penetrating her fingers. Now I don't know about you, but I imagine that would be painful. It undermined the entire image, making it look artificial and sloppy. There is nothing more important to

photorealism than attention to detail. Therefore, when creating our natural worlds we need to be conscious of how the objects interact.

The optimal method for blending objects into ground covers is to delete the ground cover beneath the object you are adding to the scene. Of course, this isn't always as easy as it sounds. The problem lies in the complexity of natural environments. If we knew the exact placement of the rock in the scene and the ground cover beneath it, we could simply delete the clover under the rock. Of course, that would work only if the clover in our scene is one object since we'd need to know where on the clover the rock is to be placed.

Okay, so our world is never perfect and a single ground cover would be simply far too large an object to be manageable. What's the solution? Well, we'll need to be a bit creative. We build scenes with pieces, and we don't usually know their exact location until we bring the scene together. The rock may need to be moved around to accommodate other objects in the scene. We're also using tileable ground covers to save on system resources, so we now have a situation where the rock could land over one of several tiles, if not a few of them simultaneously. It's really starting to get complicated. Fortunately, there is a simple solution that involves a bit of ingenuity and the ability to export models.

Most 3D programs will allow you to export a model in the newly transformed position. That means you can save the object with the new scale, position, and rotation. For example, our clover tiles have been moved and rotated. Saving as transformed allows us to save the object in this position, rather than the original one when it was loaded. This feature is useful because we can load the rock, position it over the clover, and then export it and the clover tiles it covers to be edited. Let's see how we use the export-as-transformed feature to blend objects with ground covers.

EXERCISE: PLACING OBJECTS IN GROUND COVERS

1. The first thing we need to do is create our clover patch. Load the Clover-Patch object into your rendering program, make three copies, and position them around the first tile as you saw in the previous example, rotating the copies each time. Be sure to overlap the tiles a bit to remove the gap.

2. Now we're ready for some fun. On the companion CD-ROM, you'll find a rock.3ds object in the chapter4 folder. Load this object into your scene as shown in Figure 4.26.

3. This object is unsurfaced but if you'd like to surface it you'll find an image map called rock.jpg in the same folder.

4. The next step is to place the rock so we can properly edit the clover tiles. Basically, we want to place the object within the boundaries of a single tile

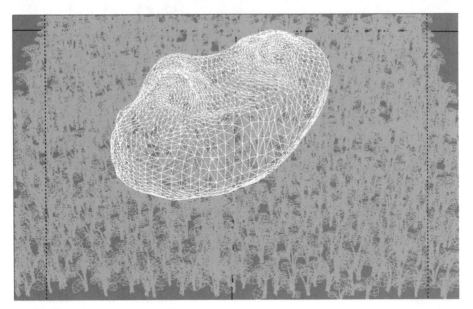

Figure 4.26 Loading the rock.

because we don't want to edit multiple clover tiles. The goal is to keep the number of tiles we edit to a minimum to avoid using excessive system resources. If we have the rock overlapping multiple tiles, we're going to significantly increase our editing work and reduce the system resources because we'll need to load several unique clover tiles. Of course, we won't always be able to contain the editing to a single tile, but we should always try. For the purpose of this exercise we will be editing a single clover tile, so let's move the rock so that it's in the middle of the upper right tile as seen in Figure 4.27.

5. Now we need to save the rock and the tile beneath it in their current position and rotation so we can edit them properly. First select the rock and export it as a transformed object with the name rocktrans. Be sure to change the file name so you don't overwrite the original object. Now export the clover tile beneath the rock as clovertrans.

6. Load both the rocktrans and clovertrans objects into your modeling program. Then select the polygons below the rock as shown in Figure 4.28.

7. Now delete the polygons. You should have a hole like the one seen in Figure 4.29.

8. We now have a perfect hole for our rock. There won't be any penetration by the clover to make the image appear unrealistic. Figure 4.30 shows an OpenGL preview of the rock and clover combined.

Figure 4.27 Positioning the rock.

Figure 4.28 Selecting the polygons beneath the rock.

Figure 4.29 Deleting the polygons.

9. Now we need to do a little trickery to make the clover work for us. There are a number of problems when saving an object transformed. The main problem is the surfacing will no longer match because the object has been changed. This isn't a problem with our clover since we have a simple planar map, which isn't fixed to any particular detail on the clover. We're fine on this front, but what if the texturing was fixed to specific details on the model? Well, morphing would normally work, but it won't in this case because we have changed the point count of the new clover tile. This means we'll have to manually place the new clover tile in the original position so the surfacing will work properly.

10. This is easily accomplished by loading the clover object and using it as a template for positioning the new clover tile. Go ahead and load the clover object. You should now see both clover objects as seen in Figure 4.31.

11. You can see we aren't too far off from the original position and rotation. Since the new tile was rotated 90 degrees clockwise originally, we'll need to rotate it 90 degrees counterclockwise to get it back to normal. Then we need to position it directly over the original as shown in Figure 4.32.

12. Great, now save the object as cloverrock.

13. The next step is to replace the clover object in the upper right corner of our scene with the one we just saved. Most programs have a replace object fea-

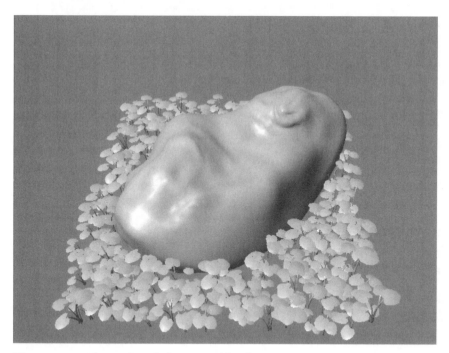

Figure 4.30 The rock and clover combined.

Figure 4.31 Loading the original clover tile.

Figure 4.32 Placing the tile.

ture. If yours does, simply select the clover tile in the upper right corner and replace it with the cloverrock object. If you don't have a replace object feature, you can load the cloverrock object, rotate it 90 degrees clockwise, and place it directly over the clover tile in the upper right corner. Then select the original clover tile beneath it and delete it. You should now have a scene similar to the image in Figure 4.33.

14. Do a test render to see if the new clover tile works properly. You should have something similar to Figure 4.34.

Now that's more like it. The clover flows naturally around the rock without penetrating it. While it was certainly more work than merely dropping the rock in the scene, it definitely looks more realistic. If we are to achieve realism, we are going to have to get used to detail work. It's what separates 3D from reality. Figure 4.35 shows a great example of an object sitting in the middle of ground cover tiles.

Notice how the ground cover flows around the rock but not into it. The depth achieved by having objects pop out of ground cover is extraordinary. Not only is it visually intriguing, but it's also a major touch of reality. Of course, the objects that penetrate ground covers don't always have to be as simple as a rock. In fact, take a look at the image in Figure 4.36.

Figure 4.33 The new clover tile place in the scene.

Figure 4.34 The rendered scene.

Figure 4.35 Amazing reality with ground covers.

Here we have Grumpy the Goblin warrior riding his Komodosaur. They are on a Troll hunt in the rain forest of the great Goblin Island in Lake Victoria in Tanzania, Africa. Goblins aren't big fans of Trolls. In fact, they are constantly at war. You see, Goblins like to use the baby Trolls as weapons. They strap them to the ends of sticks. Now I know you're thinking that's cruel, but have you ever seen a baby Troll? Well, they aren't exactly the sweetest babies you'll meet. In fact, they are downright tenacious little critters that bite everything in sight, which makes them a great weapon, particularly since they bite Trolls. Of course, the Trolls aren't thrilled by the Goblins stealing their babies so they go to war with them frequently.

If you take a close look at Figure 4.36 you'll notice the leaves on the vines are pushed away from the Komodosaur's legs and tail. It looks as if he has

stepped on the vines and they are pushed away. This effect was achieved the same way as the rock in the clover. The Komodosaur and the vine tile were saved as transformed. Then the vines were moved away from the Komodosaur's legs and body. In this case the ground cover wasn't deleted because the object penetrating it is merely temporary. The rock was a permanent obstruction, so the clover needed to be removed since it wouldn't grow under it. Our Komodosaur is just passing through, so the ground cover wouldn't be removed but compressed and pushed away. Not only is it more natural, but the effect of the leaves pressing up against the Komodosaur's body is awesome. It really adds depth to the scene.

This image also shows another great detail not seen in many 3D images, multiple ground covers. Notice how there are both vines and clover on the ground.

Figure 4.36 Precision blending of objects and ground covers.

This combination of ground covers really adds tremendous depth and detail to the environment. The clover isn't terribly dense because that would be over-doing it. In this case, a clover tile with fewer clover clusters was used since we want the main focus of the ground cover to be the vines. We also want some of the dirt to be visible since it's unlikely there would be complete coverage where there are creatures traveling through the ground cover. It's obviously not a beaten path, but there is apparently some movement through this area, which would thin the more delicate clover ground cover. It's important to explore every detail of an environment before you settle on how it will appear. While it may seem neurotic to work these small details, they make a huge dif-ference in the photorealism of the scene.

Speaking of details, remember when we discussed how high detail dupes the viewer into believing the image is real in Chapter 3, "Adding Depth with Seamless, Tileable Models"? Well, ground covers are the definitive high-detail element of natural worlds. They solidify the realism of a 3D scene. Ground covers are a visual smorgasbord of detail. They will turn an ordinary scene into something extraordinary, yet they are all relatively easy to make. Even the vines in the Komodosaur image were easy to make. First, a simple vine, shown in Figure 4.37, was created.

Figure 4.37 A basic ground cover vine.

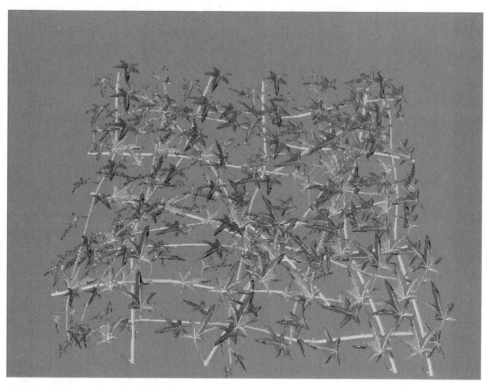

Figure 4.38 The vine tileable model.

Then it was manually cloned and rotated to create a square tile of vines shown in Figure 4.38.

It certainly looks more complicated now doesn't it? Actually, it's more complicated to make than a clover tile since you need to make sure the branch doesn't penetrate anything. It's a fairly obvious detail of the vine, so special care needed to be taken to prevent penetration. Each of the vine segments was manually rotated for precision. They weren't grouped and cloned like the clover.

As you can see, it's not at all difficult to create amazingly complex ground covers. All it requires is a bit of patience and some attention to detail, which are the two main ingredients of 3D photorealism. If you have patience and pay attention to detail, the rest is purely academic.

Wrap Up

Well, there you have it, incredible depth with tileable ground covers. It's truly amazing how much detail can be added with a simple tileable ground cover. It

turns an image from ordinary into extraordinary. They are perfect for close-up shots, and they make a distant shot even more extraordinary. Of course, there is a point where they are completely unreasonable. You certainly don't want to use them when you would require more than ten of them to complete a scene. Anything greater and you'll truly test the limits of your computer. Remember, each polygon you add is that much more to be rendered. In their defense I will say they really don't add too much to the render time in most programs. Most of the examples in the chapter were rendered in less than 30 minutes on a Pentium 200, and we're not talking Pentium II, either.

Now that we have an understanding of ground covers, how to create them, and where they should be used, we're ready to explore the finer details of adding chaos to them and other objects in natural environments with displacement maps. You'd be surprised at how easily you can add incredible realistic detail to 3D scenes with displacement maps. Of course, before we jump into the next chapter, why don't you take some time to experiment with your own tileable ground covers? The possibilities are literally endless. You might even try your hand at pine needles.

Displacement Map Effects

Re-creating the chaos of nature can be challenging, particularly when creating dense areas of repeating objects such as ground covers, grass, and weeds. The last thing we want is a scene full of identical clones. No matter how we may size, rotate, and move the objects they will still look painfully similar. Mother Nature just isn't that linear. Of course, we can create several variations of the objects, but that will take more time, eat up system resources, and likely frustrate us. We certainly don't need to make the task of re-creating reality more tedious, it's difficult enough as it is. So what's the solution? It's simple, really: Use displacement maps to add natural chaos.

Displacement maps are the most neglected resource in 3D imaging. Traditionally, they have been used to create terrain and sometimes the occasional detail on a NURBS creature model, but they have many more uses, particularly when mirroring the chaos of nature. Displacement maps can be used to make the flow of detail irregular on a ground cover and even twist the leaves of a bush in various angles to make it more naturally chaotic. They can even be animated to create awesome effects like grass blowing in the wind.

In this chapter we're going to explore a number of ways to use displacement maps to make our images photorealistic. Let's start by taking a look at how we can use them to add natural chaos to ground covers.

Adding Chaos to Ground Covers

In Chapter 4 we covered the technique for creating tileable ground covers. Now we're going to take a look at how the ground covers can be improved with a displacement map. You see, most times manually creating a tileable ground cover is perfect for scenes where you don't have any natural elements that affect the ground cover, such as wind or creatures. Remember how we discussed the Komodosaur scene in Chapter 4, "Creating Tileable Ground Covers?" The Komodosaur was tromping through the vines, compressing them and pushing them aside. The vines were manually edited to move them out of the way so they wouldn't penetrate the Komodosaur's legs, but what do we do when the Komodosaur has left the scene? What happens to the ground cover when a creature has passed through and trampled it? Well, we need to move it around to show the chaos added by the creature or creatures that have passed through. This is where the displacement map becomes a necessity. We could manually edit the ground cover, but that would take too long. The displacement map allows us to quickly add chaos without much work. Let's take a look at how we use a displacement map to make ground covers appear more natural.

Before we apply the displacement map we need to create a ground cover. There are many we can create, but grass is the one ground cover that is impacted the most by environmental changes. It's very fragile and lightweight, unlike vines or jade plants. It's also a tall ground cover, which means it will be affected by the wind and creatures. Pine needles and clover are light ground covers, but they are too low to the ground to be affected by wind, and they don't show much change when stepped upon, unless they are squashed, which is something we will explore later in this chapter. For now, let's take a look at how we create a tileable grass object.

EXERCISE: CREATING A TILEABLE GRASS OBJECT

1. The first step is to build a single blade. This is an important step since a blade of grass is relatively unique in its shape. You'll find most 3D grass is nothing more than a completely flat plane that ends in a point. That's a great starting point, but we need to add much more detail if we want it to appear realistic. Start by creating a flat plane on the z-axis with four vertical segments and two horizontal segments. Then select the three points at the top and weld them together to make a point. Using your drag tool, taper the base of the blade as shown in Figure 5.1.

 In Figure 5.1, A shows how the tip should appear, and B shows how the points along the blade would be staggered horizontally to make the blade asymmetrical. While there will be many blades of grass in the tile, we don't want them to appear symmetrical since that doesn't happen in reality. Every little detail counts.

Figure 5.1 Creating the blade of grass.

2. Now we need to add some depth to the blade by selecting the four points in the middle of the blade and pulling them back to create a canoe shape as shown in Figure 5.2. This is the most important step in creating grass since it adds more depth to the object. Remember, the more depth, the more realistic the object. A perfectly flat blade of grass is unrealistic. While it may fool you at first glance, it won't hold up under close inspection.

3. Now we need to add the final detail to the blade, a curvature. All blades of grass have a slight curvature to them, which is important to incorporate so the grass appears natural. Using your magnet tool, pull the center of the blade backward in the X viewport. You should now have something similar to Figure 5.3.

NEVER CREATE A FLAT OBJECT IN NATURE

Mother Nature doesn't create flat objects, so neither should you when you are re-creating her handiwork. Flat objects show a great deal of specularity due to their large, flat surface area. Natural objects don't have large specular spots because they are never flat. They may appear flat from a distance, but upon close inspection they are actually quite irregular. For natural objects to be photorealistic, they must be organically shaped.

Figure 5.2 Adding depth to the blade.

Figure 5.3 Curving the blade of grass.

4. Now it's time to clone the blade. We'll be making a tileable model from the blade, using the reference cloning method since it's faster. Of course, you can do it manually if you don't have reference cloning in your program. If you haven't already read Chapter 4, "Creating Tileable Ground Covers," I suggest you do so now before continuing with this chapter since it covers reference object modeling in detail. First we need a reference plane, so create a flat plane on the y-axis with 35 horizontal and 35 vertical segments, as shown in Figure 5.4.

5. Now we need to add chaos to the reference plane, so the grass doesn't grow in perfect rows. We're going to jitter the points in the reference object. This can be done with a jitter or noise tool, depending on your program. Apply noise with a small value, just enough to add some chaos to the points. It will take a bit of experimentation with the values to get the right look. You want to jitter the points more on the x- and z-axes, and less on the y-axis. We don't want a bubbly surface, just a few jostled points to create chaos. When finished you should have something similar to Figure 5.5.

6. The reference object looks good, but we need more points. Right now, there aren't enough to create a thick patch of grass. To increase the points, we will apply subdivision to the mesh, which is commonly referred to as MeshSmooth or Metaform, depending on which program you are using.

Figure 5.4 Making the reference plane.

Figure 5.5 Adding chaos to the reference object.

Subdivision multiplies the mesh density and smoothes the details simultaneously. Different programs offer different subdivision setting. For this exercise you can simply apply the default setting to create the mesh shown in Figure 5.6.

You're probably wondering why we didn't just start off with a higher-density mesh instead of subdividing it. If you take a close look at the mesh, you'll notice small clumps on the mesh where the point density is greater. This is created by subdivision. If we simply started off with more points and skipped the subdivision, our point distribution would be too even. The subdivision created nice, tight clumps of points, which will result in chaotic clutches of grass when we clone the blade. Speaking of cloning, let's do it now.

The reference cloning features in programs vary widely. For the most part, they clone the object based on the shape and density of the mesh in the background object. Some allow you to specify the number of clones, while others clone based on the points in the reference object. Either way is fine, though this exercise makes use of the point-cloning method since it will create the tight clumps of blades. One thing you should do, regardless of which program you use, is move the axis for the blade to the very bottom of the object since this will be the reference point for the cloning. If the axis

Figure 5.6 Subdividing the mesh.

was in the middle or top, the blade would rotate out of the ground when we applied the randomizing setting for the cloning function.

7. To make the clones select the blade and either use a scatter function and specify 5000 clones or use a point-clone function. In either case you'll need to select the jittered plane as the reference object. You will also need to enter some setting to add chaos to the blades. We want them rotated at different angles so they won't appear too organized, so enter the following values:

- Y Rotate: minimum 0, maximum 360
- X&Z Rotate: minimum –25, maximum 25
- Size: minimum 1, maximum 1.3

Your settings may vary, so you might need to do a little experimenting to get the right look. After the cloning is applied, you should end up with 5000 chaotic blades of grass as seen in Figure 5.7.

8. Now save the object as grasstile, and we'll move on to the displacement effect exercise.

It looks pretty realistic already doesn't it? Notice how the blades are rotated randomly. This really helps to create the illusion of reality since grass tends to grow in all directions.

Figure 5.7 The completed grass tile.

Using Displacement Maps to Create Chaos

Displacement maps are powerful tools for creating 3D chaos. A displacement map is an image map or fractal noise that affects the actual shape of the mesh. This is very useful for adding chaos to ground covers since it will change the shape of the object. There are two main types of displacement effects: image maps and fractal noise. Image maps are the most flexible because they can have very specific details since they are painted. On the other hand, fractal noise is superb for displacing ground covers because it's a true 3D texture and uses very little memory. Because fractal noise is a mathematical algorithm, it displaces the mesh in all three axes, while an image map will displace the mesh on only two axes. We'll be taking a look at both methods in this chapter, starting with fractal noise displacement maps. Let's take a look at how we create some very realistic chaos for our grass using fractal noise displacement.

EXERCISE: ADDING CHAOS TO THE GRASS WITH DISPLACEMENT MAPS

1. Load the grasstile object into your rendering program. Of course, it wouldn't hurt to add some surfacing to the grass so our tests are more accurate. In the chapter5folder on the companion CD-ROM, you'll find a file named grass.jpg. Load this image map, and apply it as a color planar map on the z-axis. This map is designed to be repeated, so you should size it to repeat ten times along the x-axis. If you have a diffusion feature, apply the image map with the same settings as the color channel, but make it 25 percent opaque. Now set the following attributes:

 ■ Specularity: 35 percent

 ■ Hardness: 30 percent

2. The last step is to add some fractal noise bump to break up the light on the surface. You should use a very small size with a bump value of 50 percent. We just want to break up the light, not make the grass covered in warts, although that would make a great Goblin grass surface.

3. To make the grass appear more realistic when we test it I've added a ground plane beneath the grass with a mossy image map. You can find both the ground plane and mossy image map in the chapter5 folder of the companion CD-ROM. They are named ground.3ds and moss.jpg. You should scale the ground plane to be twice the size of the grass tile and apply the image map so it sizes to the full dimensions of the ground plane. Be sure to set a large bump value to make the moss pop a bit.

4. Now let's render a test of the grass to see what it looks like without the displacement map. You would have something similar to Figure 5.8.

 It looks great doesn't it? So why do we need a displacement map? Well, the problem is it looks too perfect. The blades of grass are bent in different directions, but there just isn't enough chaos in the grass. If we look at the grass from the front, it looks like a crewcut, as seen in Figure 5.9.

 It looks like it's been cut by the perfect lawnmower. This is very unnatural, even if it has been mowed recently. It's also very unrealistic if the grass

Figure 5.8 The grass with no displacement.

Figure 5.9 The perfect top.

were walked upon, since there would be waves in the grass where it was compressed and didn't pop up to the vertical position. It's the same effect we see in shag carpets. When you look at the carpet there will be dark patches where the fibers are bent down. This is what we need to see in the grass to make it realistic. The grass in Figure 5.8 doesn't show these dark patches, so we need to add a displacement map to create them. The size and depth of the wave depends on the movement over the grass. While this grass looks great, it doesn't show any movement through it. We need to add a subtle fractal noise displacement to create movement waves.

5. Select the first grass tile and add a fractal displacement to it. Set the size to 1/10 the width of the grass tile. For example, I have a tile that's 100 cm wide so I set the fractal noise to 10 cm on the x-, y-, and z-axes. The strength settings of your displacement effects may vary. Typically, they are based on physical measurements. We want to apply a small displacement to the grass so it looks traveled but not trampled, so set the displacement value to 10 percent of the grass height. My grass is 20 cm tall so I set the displacement to 2 cm, which means the grass will be compressed to 10 percent of its height in random places, as seen in Figure 5.10.

6. Now that's more like it. Notice the variations on the top of the grass. It definitely looks like something has jostled the grass about. Now let's do a test render so we can see the difference our displacement map has made. Figure 5.11 shows a render of the displaced grass.

Figure 5.10 The displaced grass.

7. Before we move on, let's save this scene file so we can come back to it later. Save the scene as grass, and save all of the objects to make sure we don't lose any of the surfacing we've done.

Look at the subtle dark areas around the middle of the patch and in the upper right corner. These are fabulous little details that give the illusion of movement through the grass. We are used to seeing the subtle color shifting of grass in reality, so we need to replicate this variation in our 3D images to make them realistic. While we may not stop to contemplate the origin of the color shifting in the grass, we will most certainly notice if it's missing in a 3D image.

Take another look at Figure 5.11, and you can also see many of the blades are bent farther over, giving the impression that something had pushed them down. The effect is subtle, but it makes a big impact on the photorealism of the image. Remember, it's the small details that make an image realistic.

Okay, so now we have some very realistic grass, but it's still a bit common. Displacement maps are great for adding the uncommon details, too, so let's see if we can tell a story with the grass. A story? Yes, the displacement of the grass tells us what has happened, or at least gives us a general idea. For example, if a couple of puppies were wrestling on the grass, it would be heavily compressed in some areas. It takes grass a while to spring back to its normal position, so we can expect to see major waves in the grass after a puppy brawl. Fortunately, this effect is extremely easy to create with a fractal dis-

Figure 5.11 The rendered displacement.

placement. Let's modify our displacement map to create the puppy power aftermath.

EXERCISE: CREATING MAJOR CHAOS WITH A DISPLACEMENT MAP
To create the major displacement we can simply modify the existing displacement settings. We want the grass to be heavily compressed in random places, but we have to be careful not to displace the grass too much. If we use a setting that's too large, we'll end up burying the grass under the ground plane. Finding the right value requires a bit of experimentation. The best value to use for our pummeled grass is 1/4 the height of the grass, or 5 cm in the case of my grass. This will compress portions of the grass without pushing it through the ground. Figure 5.12 shows how the grass looks with the new displacement applied.

It looks awesome doesn't it? Notice how the grass is compressed with a circular sweeping motion, with radical changes in direction. That's the beauty of using a fractal displacement. This effect couldn't be achieved with a displacement map because they are only two-dimensional. The fractal displacement is three-dimensional, so it moves the grass down and forward. It's like having a 3D ball pressing the grass down.

Figure 5.12 The pummeled grass.

Creating photorealistic effects is about knowing which tool to use to achieve specific effects. It's really a matter of experimentation. As you can see, fractal-displacement maps are quite useful for creating natural chaos in ground covers. It's the perfect tool for the job. You could create chaos with an image map displacement, but it would be limited to two dimensions, meaning the grass would merely be compressed down and not forward, so it's not the best choice for the job. On the other hand, there are times when an image map displacement is absolutely perfect. Let's take a look at when we should use an image map displacement.

Custom Contours
with Image Map Displacement

Image map displacements are perfect when you want modify an object on two dimensions. For example, if you wanted to put a ball in the middle of the grass, you would want to use an image map displacement to press the grass down under the ball. In Chapter 4, "Creating Tileable Ground Covers," we placed a rock in clover by deleting the clover under the rock. Deleting the

clover made sense for an permanent object, but the ball is only temporary, so we need to compress the ground cover, not delete it. This is where an image map displacement is perfect. It will compress the grass on the y-axis, which is all we want. If we don't compress the grass, we'll end up with blades penetrating the ball, which is very unrealistic. Just take a look at the image in Figure 5.13 to see my point.

Not very convincing, is it? While the grass and the ball look realistic, they are compromised by the fact they penetrate each other. This is a common problem in most 3D images, but the solution is very simple. All it needs is a displacement image map to depress the grass. Speaking of making a depression, let's look at a scenario that requires a displacement image map.

Let's assume that Goblin babies have been playing lunch ball in a field of grass. The grass would be chaotic, very similar to the chaos created by the wrestling puppies. Let's also assume the Goblin babies have gone off to eat lunch or terrorize their mothers. Now all that remains from their game is chaotic grass and a lunch ball in the middle of the field. We already have the chaotic grass, but now we need a depression under the lunch ball. Let's

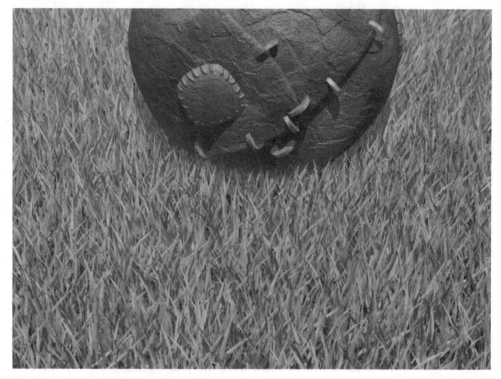

Figure 5.13 Grass penetrating the ball.

add a lunch ball to the scene and create a depression with an image map displacement.

EXERCISE: CREATING A DEPRESSION IN THE GRASS

1. The first thing we need to do is size the lunch ball to the scene. You'll find an object called lunchball.3ds in the chapter5 folder of the companion CD-ROM. Load this object and the ground plane from our grass scene into your modeling program. Position the ball on top of the ground plane and size it as shown in Figure 5.14.

2. Now save the lunch ball object and load it into your grass scene. The next step is to create a painting template for the displacement map. This is accomplished by doing a screen capture from the y-axis in your modeling program. While we could have rendered an orthographic view, the screen capture is quicker and easier. A render is unnecessary since we aren't concerned with specific details but rather with the placement of the ball over the grass. Once you have done a screen capture, create a new file in Photoshop (or whatever painting program you are using) and paste the screen capture in the file. Now crop the image to the edge of the grass object as shown in Figure 5.15.

Figure 5.14 Sizing the lunch ball.

Figure 5.15 Creating the painting template.

3. The next step is fairly simple. Add a new layer, then select the marquee tool, set the shape to elliptical, and make a selection that encompasses the lunch ball. Now feather the selection with a feather radius of 20 pixels. Now fill the selection with black, and you should have something similar to Figure 5.16.

4. Notice how the black spot is solid in the middle and fades on the edges. This will create a curved depression in the grass, roughly the shape of the ball. The last step is to add a new layer beneath the current layer and fill it with RGB 65, 65, 65. This is a fairly dark gray, which is necessary to prevent the displacement from being too exaggerated. If we filled it with white, the displacement would be extreme, pushing the grass though the ground. It takes a bit of experimenting to get the right shade of gray. By now, you've probably noticed there is a great deal of tweaking involved with creating photorealistic detail. Creating 3D photorealism requires a good amount of patience and a commitment to the details. Perfection doesn't come easy.

5. At this point you should have the completed displacement map shown in Figure 5.17.

6. Now save a copy as grassdisp.jpg, and load it into your rendering program.

Figure 5.16 Creating the depression ring.

Figure 5.17 The completed displacement map.

DON'T USE EXTREME COLOR SHIFTING

▬▬▬▬ **Extreme shifting in colors, such as a white background with black details with displacement image maps, will create very severe displacements. This may be desirable when creating terrain with shear cliffs, but it won't be very practical when creating depressions in grass—you'll end up digging a well.**

7. Next select the grass tile and open the displacement channel. Now apply the grassdisp.jpg image as a planar map on the y-axis, size the image map to the dimensions of the grass tile, and set the displacement value to 75 percent of the grass height. In the case of my grass, it's a value of 15 cm. We want to use 75 percent, so the grass is pushed far below the ball. Some of the grass will penetrate the ground, but that's fine since it will be directly under the ball anyway.

8. Now we need a ball in the scene, so load the lunch ball object. It should be centered in the middle of our grass tile since we edited it earlier. The lunch ball isn't surfaced, but if you'd like to surface it you'll find all the required image maps in the chapter5/lunchballfolder on the companion CD-ROM. There are a number of image maps in the folder, many of which were designed to be layered.

Now it's time to test the effect of our displacement image map. Perform a test render, and you should end up with something similar to Figure 5.18.

Very nice! Notice how the grass is depressed around the perimeter of the ball, as if it had landed in this spot. It's a very realistic effect, and it only took a few minutes to create. It's much better and far more realistic than the image in Figure 5.13.

Image map displacement maps are a very powerful tool for creating natural, photorealistic effects. They can do just about anything. You can create footprint depressions, tail trails, dents for fallen fruit, and countless other uses. They are easy to create and take only a few minutes to apply.

Now that we have a handle on the two types of displacement mapping, let's take a look at the real power of the displacement map: animation.

Displacement Map Animation

Using displacement maps for animation is essential when you want to create subtle natural effects such as a breeze blowing grass or leaves shuttering in the trees. You can animate both fractal-noise and image map displacement maps, although using the fractal noise variety is easier since you won't need to create an animated image map sequence, which can be quite complicated. Let's

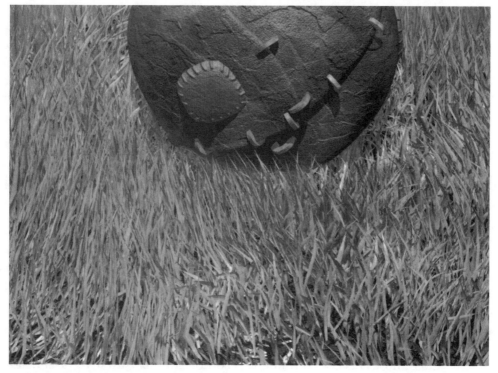

Figure 5.18 The grass with ball depression.

take a look at how fractal-noise displacement can be used to animate the grass we created earlier in this chapter.

EXERCISE: ANIMATING GRASS WITH FRACTAL-NOISE DISPLACEMENT

1. Fractal-displacement animation is actually quite simple. It's really just a matter of tweaking a few settings. In the case of our grass, all we need to do is put into motion the fractal displacement we created earlier in this chapter. Load the grass scene file and open the displacement channel for the grasstile object.

2. The displacement animation settings vary from one program to another, but the principles are the same. What we're going to do is give a motion to the fractal noise displacement. You should have a setting that's called motion, distance, or velocity. This is where you enter the distance the fractal noise will move along all three axes. The values represented here are equal to the movement per frame. Since we'll be making a 30-fps animation, we need to divide the distance we want to move per second by the number of frames per second to determine the velocity. The distance we move is based on the size of our grass. My grass is 100 cm across. If I want

a subtle breeze to blow the grass, I'll need to have it travel from one side of the grass to the other in roughly a second. That means I need to travel 100 cm a second. To determine the velocity, I need to divide 100 cm by 30 fps, which gives me 3.3 cm per frame. That is the value I need to enter for velocity. Of course, I don't want the wind blowing equally on all three axes, or I'll have a twister on my hands. Instead, I want it to blow strongest in one direction, and have a subtle movement in the other two.

MAKE THE DISTANCE LARGER IN ONE DIRECTION

You don't want to move fractal displacement in all directions equally, or you'll create a choppy mess. You should focus the movement in a single direction and provide a small variance in the other two directions to soften the movement so it's not too linear.

3. Let's have the wind blow along the z-axis at 3.3 cm and .5 cm in the x- and y-axes. And that's really all there is to it. Well, there is always some tweaking to find just the right distance for the displacement to travel, but it usually only takes a few minutes to nail down.

Now let's do a test render of 60 frames and see how well the grass blows. In the chapter5 folder of the companion CD-ROM you'll find a movie file called grass.mov. This is a 60-frame, 2-second test I did with my grass. Load this file and take a look.

Not bad. Notice how the grass is waving in the wind, but not blowing back in a single direction. That's the beauty of a fractal displacement. It affects the object on all three axes, creating very convincing effects. The same technique can be used to animate the leaves blowing in a tree and even the branches.

DON'T MAKE THE DISPLACEMENT TOO SMALL

If you make the size of your displacement too small, you'll end up with a very choppy movement. There are currents of air that flow together like giant balls rolling through the scene. If you use a small displacement size, you'll have the equivalent of a shotgun blast ripping through your scene. Make the displacement size large enough that it moves the objects gracefully, not choppily.

Fractal-displacement animation is a very powerful technique for creating realistic effects. It's commonly used to animate the surface of water. Most 3D programs have some form of ripple displacement that allows you to animate waves. It does require a bit of tweaking, but then what doesn't? Don't become discouraged if your experiments with fractal-displacement animation don't work immediately. It takes time to get the hang of it, but when you do there will be no stopping you. Soon you'll be animating everything with fractal displacement.

Wrap Up

Displacement maps are an essential part of natural photorealistic environments. They establish the needed chaos of nature, and they are easy to apply. They have countless applications. Fractal noise displacement can be used to add chaos to ground covers, jitter the leaves of bushes, add irregularities to tree branches, and even animate objects blowing in the wind. Image map displacement is ideal for any situation where you want to blend objects together naturally, such as a fallen apple laying in the grass or footprints of an animal in the woods. They are also useful for adding detail to terrain such as craters, molehills, lakes, and mountains. When you are building natural environments, take a few moments to consider who or what has traveled through your environment and what kind of trail they may have left behind. Remember, just because your characters aren't in the image doesn't mean there shouldn't be signs of them having been there.

Okay, we've covered a lot of ground in this part of the book. Before we move on to Part Three, "Surfacing Complex Objects," let's take a break and clear our minds. If there is one thing you can do to improve your 3D images, it's take frequent breaks to clear out the cobwebs. Nothing will frustrate you faster than a clouded mind.

Surfacing Complex Objects

While modeling detailed photorealistic objects is most certainly a challenge, nothing is quite as challenging as surfacing them. One of the greatest hurdles we face in surfacing organic objects is trying to wrap an image map around an awkwardly shaped object. Our 3D image mapping techniques are limited to planar, spherical, cylindrical, and cubic, which is certainly a useful number of options. Unfortunately, most organic objects require a combination of several mapping methods, meaning no single method will work properly. If we simply apply one of the basic mapping methods, we'll end up with texture stretching, which completely undermines our photorealism efforts.

In addition to mapping dilemmas, we are also faced with creating extreme detail when replicating natural, organic surfaces. Mother Nature has a way of creating exhausting detail in her surfaces, which tends to make our job more difficult and time-consuming. Creating industrial surfaces is a great deal easier than natural surfaces because we aren't required to add a lot of fine details. Industrial surfaces are typically monochromatic, while natural surfaces incorporate an ample amount of small details and color changes.

In this part, we'll explore a number of techniques for photorealistic surfacing of complex organic shapes. We'll start with some techniques for adding the surface chaos we see in nature, and then we'll move on to morph target surfacing, which is a unique and highly effective solution to image mapping complex organic shapes.

Let's get started by taking a look at how to create detailed image maps.

COLOR FIGURES ON THE CD-ROM

All the figures from the book are in color on the CD-ROM. Chapter 6 deals heavily with colors, so you should refer to the color figures in the chapter6/figures folder on the companion CD-ROM before continuing with this part.

6

Creating Detailed Image Maps

The key to photorealistic surfacing is detail, and plenty of it. All surfaces in reality are inundated with extensive details. Even a simple painted surface has a great deal of texture. If we are to create realistic surfaces, we must be prepared to create plenty of detail, particularly in natural surfaces.

While it's common for industrial surfaces to be rather monotone and simplistic, natural surfaces are very detailed and chaotic. Take a look around your office or computer room, and you'll notice most of the surfaces are rather plain. While they may be colorful, they don't really have tremendous detail. Typically, industrial surfaces are painted, so they tend to be monochromatic, which means they have various shades of a single color. For example, multimedia equipment usually has a black or dark gray finish, while computers are often beige; even the more colorful ones are still monochromatic. Yes, they do have a subtle surface texture, but it is typically uniform. Industrial surfaces are very simple and therefore rather easy to imitate. On the other hand, natural surfaces are quite complicated and difficult to replicate convincingly.

Natural textures include anything Mother Nature would create, including rust. Yes, rust is a natural surface, even though it can be commonly referred to as an industrial texture. We associate rust with industry because it covers metal surfaces, but it's actually a product of nature. It's the oxidation and corrosion nature applies to an industrial surface. We can think of rust as the naturalization of an industrial surface.

As humans, we are fascinated by natural textures because of their extreme detail, hence our fascination with rust. Rust is one of the coolest textures in

nature because it has incredible chaos and is composed of earth tones, which are very pleasing to the eye. While we surround ourselves with a plethora of industrial surfaces, we are actually drawn to natural surfaces. Unfortunately, we are also most critical of natural surfaces. We have an expectation of how they should appear. While we have no specific visual queue for rust, we do expect a certain degree of chaos in both color and texture. Basically, we can spot an unrealistic rust surface, even though we may not know exactly why it's unrealistic. Therefore, if we are to convince the viewer that our 3D images are realistic, we need to make a concerted effort to add plenty of natural chaos to our natural textures.

In this chapter we'll be exploring several techniques for creating incredibly detailed image maps for your natural 3D surfaces. I'll be using Photoshop, but these techniques can also be applied to most other painting programs, including Painter, Photopaint, and Paintshop Pro. We'll start by making a little rust, oxidation, and corrosion.

Creating Rust, Oxidation, and Corrosion

One of the most frequent surfaces we see in 3D images is rust. Why? Simply because it's fascinating. We seem to have an obsession with making everything old and rusted. One reason is that new surfaces look plain and ordinary. They aren't much to look at. On the other hand, rust is very interesting and holds our attention because of its range of earth tones and the total chaos of its texture. Of course, if we want the rust to appear realistic, we're going to have to do it right, meaning we must pay strict attention to the details of rust. For example, its foundation is a chaotic fractal texture, with layers of smaller color shifting on top and crowned with a random bumpiness. Therefore, to accurately re-create rust, we'll have to paint it the same way. Let's get our hands dirty by painting a rust texture.

EXERCISE: PAINTING RUST

1. First, open your painting program and create a new file that's 1,024 × 1,024 pixels.

FOR SEAMLESS TEXTURES, USE INCREMENTS OF 256

▬▬▬ **When using Photoshop filters to paint your textures, increments of 256 pixels will create a seamless tile automatically. For example, an image that is 512 x 512 pixels will result in seamless filter effects. This can be very useful and save a lot of time when creating seamless textures.**

2. Set the background color to white and the foreground color to RGB 86, 53, 13, and then fill the background layer with the foreground color, which is the base color of our rust.

3. Now you need to add the initial fractal texture that is the foundation of rust. To do this you'll use the Render Difference Clouds filter. This filter uses randomly generated values that vary between the foreground and background color to produce a cloud pattern. Difference Clouds blends the cloud data with the existing pixels in the same way that the Difference mode blends colors. The first time you choose this filter, portions of the image are inverted in a cloud pattern. Choosing the filter repeatedly creates more exaggerated cloud effects, with radical differences. The white background color will give you some chemical-looking fractal clouds, which resemble the pattern of growing rust corrosion. Before you apply the filter, create a duplicate layer and name it corrosion. Now select the corrosion layer and apply the Difference Clouds filter a single time. You should now have something similar to Figure 6.1. Your results will vary from what you see in Figure 6.1 because the filter effect is completely random. Don't worry, what you have will do just as well.

4. You now have a basic cloudy texture, which is the start of our rust. Don't pay any attention to the colors—they don't matter at this point. For now, all we are concerned with is the texture pattern. We have a good foundation, but we need to add more chaos to mimic the growth of corrosion, so apply the Difference Clouds filter another time. You should now have something similar to Figure 6.2.

Figure 6.1 The first Difference Clouds filter pass.

Figure 6.2 A second pass of Difference Clouds.

5. As you can see, we are starting to show some hot spots in the texture. These are the areas of extreme corrosion in our rust. They are the points where the rust began and is growing outward over the surface. Our corrosion still isn't severe enough, so do one final pass of Difference Clouds to create the texture chaos seen in Figure 6.3.

6. Okay, now we're getting somewhere. We now have several points of extreme corrosion and a chaotic background showing varied levels of rust. But you have a bit of tweaking left to do before your rust is complete. The next thing you need to do is change the color of the corrosion, so duplicate the brown background layer and move just below the corrosion layer. Now select the corrosion layer and set it to Soft Light with an opacity of 100 percent. This changes the colors of the corrosion layer to a reddish brown as seen in Figure 6.4.

7. The next step is to merge the corrosion layer with the new background layer. Be sure to deselect the actual background layer so it isn't merged with the other two.

8. Now you need to add the speckled flecks we are accustomed to seeing on real rust. These are the areas where the corrosion has been oxidized. These flecks vary from nearly white to very dark brown. To create the flecks we'll

Figure 6.3 The corrosion created by the final pass of the Difference Clouds filter.

Figure 6.4 Changing the corrosion layer to reddish brown.

be doing some simple dissolves of solid colors. Let's get started on the flecks. Create a new layer over the corrosion layer called burgundy, and fill this new layer with RGB 91, 0, 18. Keep the layer as normal, and set the opacity to 100 percent.

9. Now create another new layer above this one, and call it orange. Fill this layer with RBG 144, 63, 0. Then set the layer to dissolve with an opacity of 65 percent. You should now have something similar to Figure 6.5.

10. Notice how there are tiny orange flecks over the burgundy color. This is the beginning of the flecks. We'll be adding two more layers of fleck colors to create a nice variety of deep corrosion and oxidation. Add another new layer called brown and fill it with RGB 86, 53, 13. Then set the layer to dissolve and the opacity to 50 percent. You should now have something like the flecks seen in Figure 6.6.

11. You dropped the opacity of this new layer lower than the previous one so you didn't cover up the specks on the previous layer. On each new layer of flecks, you drop the opacity. Speaking of flecks, let's create the final fleck layer. Add a new layer called beige and set the layer to dissolve with 3 percent opacity. You should now have something similar to Figure 6.7.

12. Now we have a great combination of colored flecks! The beige layer represents the high point of the flecks, where the most oxidation occurs. We

Figure 6.5 The first layer of flecks.

Figure 6.6 The second layer of flecks.

Figure 6.7 The final layer of flecks.

used a very low opacity on this layer because we don't want to make the rust look like it's covered in snow. The darker flecks represent the lower levels where the corrosion is highest. Now that you have the completed flecks, merge the burgundy, orange, brown, and beige layers to create your completed fleck layer. Once the layers are merged, set the layer name to flecks. Now we're going to combine the flecks with your corrosion layer. Make sure the flecks' layer is above the corrosion layer, then select the flecks layer and set it to screen and the opacity to 75 percent. You should now see something similar to Figure 6.8.

13. Now it definitely looks like rust. The only thing we're missing is the rough texture, so let's add some bumps to the rust. What you're going to do is use the flecks layer to create a corroded bump texture. Make a duplicate of the flecks layer named bump and set the layer to normal with 100 percent opacity. Now apply the Find Edges filter to this layer, and you should end up with something like Figure 6.9.

The Find Edges filter identifies the areas of the image that have significant transitions, and it emphasizes the edges. It outlines the edges of an image with dark lines against a white background. This effect on your bump layer looks like cells being viewed through a microscope. Well, that's basically what corrosion looks like. There are thousands of tiny corrosion cells on the surface of rust, which you need to replicate for photorealism.

Figure 6.8 The corrosion with flecks.

Figure 6.9 Creating the corrosion bump texture.

14. Now that you have a completed corrosion bump, you need to combine it with the flecks layer to create a rough bump texture. First, make a copy of the flecks and bump layers. Now move the flecks copy layer beneath the bump copy layer. Then select the bump copy layer and change it to luminosity and keep the opacity at 100 percent. Now merge the bump copy with the flecks copy layer, and name the new layer corrosionbump. Finally, you need to convert it to grayscale so you can use it to modify your rust texture. Use Image/Adjust/Desaturate to convert the new corrosionbump layer to shades of gray. You should now have something similar to Figure 6.10.

15. Now move corrosionbump layer above your flecks layer and set it to soft light with 100 percent opacity. You should now have the corrosion layer on the bottom, with the flecks layer in the middle and the corrosionbump layer on the top. The combination of these three layers creates the rust texture seen in Figure 6.11.

16. Now that's a realistic rust texture. Notice the strong color variations, hot spots of corrosion, and flecks of oxidation, all on top of a crusty texture. But even though this texture looks great, it's still too uniform. What I mean is that the bump texture is too linear. It needs to have areas of larger bumps to break up the consistency of its texture. To accomplish this, we'll modify the bump layer. First, select the bump layer and convert it to grayscale by

Figure 6.10 Adding flecks to the corrosion bump.

Figure 6.11 The completed rust texture.

using Image/Adjust/Desaturate. Then select the Emboss filter and apply the following settings:

- Angle: 171
- Height: 2
- Amount: 81 percent

You should now have a lunar-surface-looking image like the one shown in Figure 6.12.

17. This texture is most certainly chaotic, but we don't want the rust to look like the surface of the moon, so we need to soften this texture a bit. For this, apply the gaussian Blur filter with a radius of 1.0 to create the smooth bump texture shown in Figure 6.13.

18. Great, now we have the perfect large corrosion bump texture. Move this layer to the top and make it an overlay with 100 percent opacity. Now activate the corrosion, fleck, and corrosionbump layers beneath it to create the final rust texture shown in Figure 6.14.

That's much better, now we have a combination of a large crusty bump texture with a small bump noise on top. This is truly an authentic rust texture. Of course, rust has many colors and shades, so this merely represents one option. The good news is you can simply modify the colors of the cor-

Figure 6.12 The embossed bump layer.

Figure 6.13 The completed bump texture.

Figure 6.14 The final rust texture.

rosionbump and bump layers to change the colors. For example, if you made the bump layer burgundy, you would change the rust to a burgundy hue. Making rust with multiple layers gives you the flexibility to modify the colors of the rust quickly and easily.

Another way you can modify the rust is to change the saturation levels of the corrosion layer. The lower the saturation, the less color the overall rust will show. I suggest reducing the saturation by 50 percent to create a nice middle-of-the-road rust, which will apply to nearly all situations. Most rust fades over time, so desaturating the rust makes it appear aged.

19. Save the file as rustlayers, and then save a copy as rust.jpg. Now you're ready to surface something with the rust—or are you? While you can, and will, use the color image as your bump map, you do need to create another bump map to make the rust more believable. You see, rust tends to vary in height. There will be low patches of deep corrosion and high patches where the corrosion has piled upon itself. If we want our rusty surface to be realistic, we need to create a bump map to reflect these severe surface altitude changes.

20. To create the new bump map, deselect the corrosionbump and bump layers. You don't want to use these layers because they are too chaotic. You want to make broad changes in the height of the texture, not small chaotic bumps. With these two layers deselected, save a copy as rustbump.jpg.

21. Now load the rustbump.jpg image, and convert it to grayscale.

ALWAYS CONVERT BUMP MAPS TO GRAYSCALE

■■■■■■ Since 3D programs only use levels of gray to determine bump altitudes, there is no reason to waste system resources with a color bump map. A color image occupies three times as much hard drive space as a grayscale image. Therefore, you should always convert your bump maps to grayscale to save systems resources, particularly RAM. You don't want to waste RAM on unnecessary color images.

22. Now open the Image/Adjust/Levels panel and apply the following settings:

 ■ Input levels: 56, 1.00, 149

 ■ Output levels: 0, 255

 This will make the contrast between the light and dark regions of the image more pronounced, as seen in Figure 6.15.

23. This looks pretty good, but we want to make the contrast even greater between the light and dark regions, so open the Brightness/Contrast panel and set the contrast to +40. The result is shown in Figure 6.16.

 The difference won't be really obvious, but it will make an impact on the final effect of this bump map. Adjusting the contrast has sharpened the

Figure 6.15 Adjusting the levels of the bump map image.

Figure 6.16 The final bump map.

boundaries between the light and dark shades, which will make the texture look more natural. We don't want a flowing bump like rolling hills but rather a rough bump like a rocky cliff.

24. Now save the rustbump.jpg file, and do a test of your new image maps.

25. In the chapter6 folder on the companion CD-ROM, you'll find an object file named oilcan.3ds. Load this object into your rendering program, and then load the rust.jpg and rustbump.jpg images.

26. Select the label surface and apply the rust.jpg to the color channel as a cylindrical map on the y-axis. Set the number of width repeats to two so it wraps around the can twice.

27. Now apply the same image map, with the same settings, to the bump channel and set the bump value to 100 percent. If you have a diffusion channel apply the rust.jpg to it and set the opacity to 50 percent. This will make the rust a deep, rich color, which is how the majority of rust appears. Now select the bump channel and add a new layer, then apply the rustbump.jpg image as a cylindrical map on the y-axis. Set the number of width repeats to two so it wraps around the can twice and set the bump value to 100 percent. If your programs allow for bump values greater than 100 percent set it to 200 percent. This will create more severe altitude changes, giving the rust more character.

28. Finally, set the specularity to 35 percent and the glossiness/hardness to 25 percent. This will make the rust appear soft.

29. Now make a copy of this surface and apply it to the cap and oilcan surfaces. Change the mapping method to cubic map on these surfaces to avoid image map stretching. There is a possibility of a seam showing with a cubic map, but it's unlikely when you use a texture as chaotic as rust, though it may happen. If it does, simply separate the surfaces into areas that can be mapped with planar and cylindrical maps. Right now the mapping is less important; what we want to do now is insure the rust is realistic.

30. Save the object, save the scene as oilcan, and then do a test render. You should end up with something similar to Figure 6.17.

Well, that looks great! It's definitely a rusty old can. Notice how the rust texture has large high points where the light areas appear on the surface. The high points of the surface become oxidized, while the low points remain free of oxidation. Therefore, we need to raise the light, oxidized areas of the rust texture so the effect is photorealistic.

As you can see, the small details make a big difference in the photorealism of the surface texture. If we had simply created a rust texture with a few changes in color and no flecks or hot corrosion spots the rust would have appeared too sterile, which is quite the opposite of rust in reality. Of course, now that we've

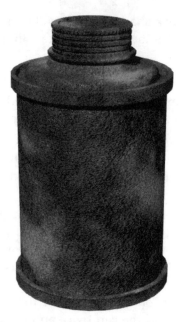

Figure 6.17 Testing the rust texture.

mastered rust, we can use the same techniques to create specific areas of rust on objects, such as a rusty joint on a car door or possibly rust running down the side of a drainpipe. Let's take a look at how we create specific areas of rust.

Creating Patches of Rust

Creating patches of rust is actually quite simple. In fact, we can use the rust texture we just created to apply the unique areas of rust to objects. Let's take a look at how we can apply rust to only the lower part of the oilcan using our seamless rust texture.

EXERCISE: CREATING RUSTY PATCHES

1. Open your painting program, and load the oilcan.jpg file located in the chapter6 folder on the companion CD-ROM. This is a cylindrical image map for the label of the oilcan, which you can see in Figure 6.18.

2. We're going to add rust to the bottom of this oxidized metal texture using the rust image map you created earlier in this chapter. Load the rust.jpg file, and select the entire image. Now select Edit/Define Pattern, which creates a pattern from the image that you can use as a fill. Select the oilcan.jpg image, and add a new layer named rust. Now fill the new layer with the pattern you just defined.

 You should now have a layer of rust similar to the one shown in Figure 6.19.

Figure 6.18 The oil can image map.

3. This rust looks great by itself, but it's too colorful for the oilcan.jpg image so you'll need to reduce the color. Select Adjust/Hue/Saturation and set the saturation to –50, which corrects the color levels, but we need to modify the colors a bit since they are too orange. Select Adjust/Variations, and click once on More Cyan once. This will soften the reds in the rust and make them more compatible with the faded oilcan texture.

4. Okay, now you need to create the selection area for the rust on the lower portion of the can. Using the lasso tool, create a selection with a squiggly

Figure 6.19 The rust layer.

line along the top on the bottom of the image. Figure 6.20 shows the selection area in white.

5. Feather this selection with a feather radius of 12 pixels. This will insure the rust blends into the metal of the oilcan. Save the selection because you'll be using it later in this exercise. Next, invert the selection and then press Delete on the keyboard. You should now see the oilcan image beneath the rust layer as shown in Figure 6.21.

6. We now have a nice layer of rust along the lower portion of the oilcan image map, but the rust is too prominent. For this texture to look realistic, you need to blend the rust with the oilcan texture so it looks like the rust formed on the oil can directly. To do so, select the rust layer and set it to hard light with an opacity of 70 percent. This blends the rust with the oilcan texture, as shown in Figure 6.22.

7. Now that's much better. The rust looks perfectly natural on the oilcan. Okay, we're done with the color image map, so save the file as oilcan, and then save a copy as oilcanrust.jpg. The next step is to create an alpha map for your bump map. What you're going to do is use the rustbump.jpg bump map you created for the rust in the previous exercise to add a high-level bump to the rust on the oilcan. Of course, we don't want the rust bump to be applied to the oilcan metal texture, just to the rusted areas so you'll need an alpha map to filter the bump map.

8. Add a new layer called alphamap and then load the selection you just saved. Now fill this selection with white, then invert the selection and fill it with black. The completed alpha map is shown in Figure 6.23.

Figure 6.20 The rust selection area.

Figure 6.21 The deleted rust selection.

9. The white area of the alpha map will be 100 percent opaque, while the black portion is 100 percent transparent. This will filter out the bump map over the oilcan metal texture. Now save the file, and then save a copy as oilcanalpha.jpg.

10. Now it's time to test your creation, so open your rendering program and load the oilcan scene you saved earlier. Then load the following images, oilcan.jpg, oilcanrust.jpg, and the oilcanalpha.jpg image.

Figure 6.22 The completed rusty oilcan image map.

Figure 6.23 The completed alpha map.

11. Now select the label surface and replace the rust.jpg image with the new oilcanrust.jpg image. Keep the same mapping coordinates, but set the wrap amount to one instead of two. Repeat this same process for the bump and diffusion channels. When you get to the second layer of the bump channel, keep the rustbump.jpg image but set the wrap amount to one. Then apply the oilcanalpha.jpg as the alpha map.

12. You now have the surfacing completed for the label, but you also need to update the cap and oilcan surfaces. This is simple. Just replace the rust.jpg image with the oilcan.jpg image. Then delete the rustbump.jpg image in the bump channel on both surfaces. You don't want the oilcan metal to be rough and bumpy. We'll save that effect for the rust.

 Let's do a test render to see the results. You should have something similar to Figure 6.24.

Excellent, the rust around the base of the can looks perfectly natural. Notice how the rust is very rough, yet the can has a softer bump. This is the result of using the alpha map to filter the rustbump.jpg image on the bump channel.

As you can see, creating specific areas of rust is rather simple now that we have a seamless rust texture. In fact, you'll never have to worry about adding rust to objects anymore, just load your rust texture and get to work.

Well, you've mastered the fine art of creating rusty textures, but there are many other types of textures in nature that we can explore. One of the most common is botany. Plants have a great deal of chaos, and specific chaos at

Figure 6.24 The rusty oil can.

that, so they can be quite challenging to create. For example, a leaf is more than a simple shade of green. In fact, it's several shades of green. Botany is littered with chaotic color changes, but the chaos is organized. Unlike rust, botany has very organized chaos, with the color changes occurring in specific locations on the leaf. Let's take a look at how we create the organized chaos of botany.

Creating Botany Image Maps

Botany is one of the most complicated organic objects to surface because we typically need to be very specific with the surfacing details if we want the object to appear photorealistic. Nobody will believe a simple green leaf is realistic. While it may look real from a distance, it won't hold up under close inspection. Therefore, we have to create detailed image maps to make our digital botany appear natural.

Before we can paint image maps for our digital botany we must first explore the details of botany surfaces. For example, let's consider a leaf, which is the most common and detailed digital botany we'll create. There are many details on a leaf, but they will vary depending on the health of the leaf. Let's take a look at the details we can expect to see on a healthy leaf. Figure 6.25 shows an example of a healthy 3D leaf.

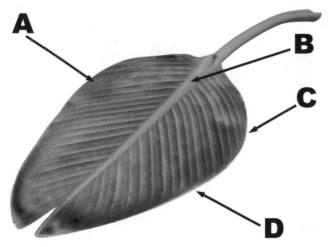

Figure 6.25 A healthy 3D leaf.

Let's take a look at each of the details and examine their significance.

DETAILS OF A HEALTHY LEAF

A. Darker outside edges. On a healthy leaf, we'll see lighter colors in the center, closest to the water source coming from the veins, and darker areas on the outside edge farthest from the water supply. The outside edges of the leaf will age faster.

B. Light colored stalk. The stalk of a healthy leaf is a consistent light tone. The lateral veins are also a lighter tone, though they fade to the color of the leaf blade as they extend towards the margin.

C. Smooth margin. The margin of a healthy leaf is smooth and free of notches, which are typically created by feeding insects.

D. Slight margin browning. This is an optional detail of a healthy leaf. Even though the leaf is healthy there may be areas of slight browning on the margin. It's always a nice detail to add so the leaf has more character.

As you can see, a healthy leaf is fairly clean, with few blemishes and a rather consistent tone. They are typically shades of a single color, or monochromatic, though there may be some yellowing of the leaf if the plant is provided too much or too little water.

Now that we have a handle on healthy leaf details, let's take a look at an unfortunate leaf, shown in Figure 6.26.

Let's take a look at each of the details of an unhealthy leaf.

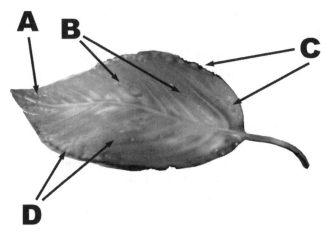

Figure 6.26 An unhealthy 3D leaf.

DETAILS OF AN UNHEALTHY LEAF

A. Pock marks. Unhealthy leaves will quite often have pockmarks on their surface from feeding insects.

B. Dark and light blemishes. Old and unhealthy leaves will be covered in light and dark blemish spots, which are the result of disease and sun damage. They are also caused by feeding insects such as aphids, which gnaw holes in the leaves.

C. Crispy margin. Unhealthy leaves have a brittle, jagged margin where insects like caterpillars have been eating away at them. These areas typically die and dry out leaving a rough, crispy margin. Unlike a healthy leaf, the jagged margin of a dying leaf will be very dark brown and even black.

D. Sun damage. A common detail on unhealthy leaves is sun damage, where the blade has dried out from extreme exposure to the sun. This exposure will also cause the leaf to have radical color changes all over the blade, making it yellow, brown, and dark green in spots.

It's safe to say that an unhealthy leaf has the highest level of detail, and is therefore the most complicated to recreate in 3D. They are also the most interesting leaves to view. A new, healthy leaf is great with its bright colors and clean shape, but an unhealthy leaf is so much more interesting with its decay and deformities.

Obviously, if we want to reach the pinnacle of digital botany surfacing, we'll have to master the fine art of killing a leaf. Well, at least re-creating the withered corpse of a dying leaf. In the following exercise, you'll be painting the image maps for an unhealthy leaf. Let's get started.

EXERCISE: CREATING AN UNHEALTHY LEAF IMAGE MAP

1. Open your painting program, and load the leaftemp.jpg file located in the chapter6 folder on the companion CD-ROM. You should have a painting template like the one shown in Figure 6.27.

2. Now add a new layer called basecolor and fill it with RGB 96, 108, 58. This is the base color of your leaf. Before we start to add any specific color details, we need to make the bump map. Why create the bump map first? Well, it's the most critical map we'll create. It's not only used to create the bump details, but it's also used to modify the color variations of the color map. You'll be using the bump map to vary the tones of your base color. Let's get started with the bump map.

ALWAYS PAINT YOUR BUMP MAP FIRST

The bump map is your most important texture since it can be used to create the variations in color for the color map, as well as being used to create the specularity and diffusions maps. By creating a detailed bump map first, you'll save yourself a great deal of time re-creating the same details on the other maps. Simply create the bump map first, and then apply it as a soft light layer over your color layer. You'll be amazed at the results.

3. Create a new layer above the basecolor layer and name it bump. Now fill the layer with 50 percent gray and set the opacity to 75 percent. You should now have a cloudy template like the one shown in Figure 6.28.

4. The reason you filled the bump layer with 50 percent gray is because it represents ground zero of a bump map. It's right in the middle of the grayscale range, so it will be the neutral altitude for the bump. While there are many ways to create a bump map, the most versatile and fastest is to use the dodge and burn tools to change the tint of a bump map layer filled with 50 percent gray. This way, you don't need to keep swapping colors and will have a more precise control over the effect. Of course, you need to see your leaf template, so set the opacity to 75 percent so you can barely see the template. You don't need to see much, just enough to know where you are painting.

5. Now you're ready to begin painting the bump map. Start by selecting the toning tool, then select the dodge tool from the Toning Tool panel and set the tool to midtones with a 40 percent exposure. Now create a 21-pixel brush with a hardness of 0 percent. Starting at the tip of the leaf, make a stroke down the center to create a bump for the stem, stopping when you reach the end of the blade. Now do another stroke over the first one to make it more prominent. The white line will be very faint with the opacity set to 75 percent, so you'll need to frequently change the opacity to 100 per-

Figure 6.27 The leaf painting template.

Figure 6.28 The bump map layer.

cent to see what you're doing. Go ahead and do it now. You should see a thin white line similar to the one in Figure 6.29.

6. This is a good start, but you'll need to modify this line for it to appear natural. It needs to be wider at the base, so select a 27-pixel brush and make several strokes on the lower third of the line. This will fatten the base, but you still need a more rounded look to the stem, so select a 16-pixel brush and make four strokes down the center of the stem. This created a lighter line down the center as shown in Figure 6.30.

That's much better. You now have a well-rounded stem running up the middle of your leaf. As you can see, it's very easy to create the elevated

Figure 6.29 The stem bump.

Figure 6.30 Rounding the stem.

bump details by simply making several passes over the detail, using a smaller brush each time. This is how we will complete the rest of the bump map. In fact, let's continue by creating the first lateral vein.

7. Set the opacity of the bump layer back to 75 percent. With the 16-pixel brush still selected, create a short stroke to the right side of the stem to create a lateral vein. Now make two more strokes over the first to lighten it, then select a 11-pixel brush and make several more strokes until you have something similar to Figure 6.31.

8. Great, now you have the first lateral vein, but the tip of the vein is too rounded, which will make the effect unnatural. To correct this, simply select the smudge tool, set the brush to normal with a 45 percent pressure and select a 16-pixel brush. Now pull the end of the lateral vein outward

Figure 6.31 Creating the lateral vein.

Figure 6.32 Sharpening the tip of the lateral vein.

by making several strokes on the tip. Then make several strokes on the outside of the vein, pushing inward to bring the vein to a point at the tip, as seen in Figure 6.32.

9. That's much better. A common flaw seen in most bump maps is rounded ends of bump details. The smudge tool is the perfect choice for blending the ends of bump details into the background color. Now that you have a handle on the process of creating the lateral veins, let's finish the veins by making seven more on the right side of the stem, and seven on the left as shown in Figure 6.33.

10. Now you're getting somewhere! The leaf bump map is starting to take shape. Of course, the veins aren't complete yet. While this bump will raise the veins fairly well, you need to sharpen it more to make the veins pop out

Figure 6.33 The completed lateral veins.

Figure 6.34 Darkening the base of the veins.

abruptly from the surface. On a real leaf, the veins are very prominent; they don't gradually rise. There is a very simple trick for making high-altitude bump effects really pop off the surface. All you need to do is darken the areas around the perimeter of the veins, which will lower this area, making the raised area more prominent. To darken the base of the veins, select the burn tool and set the pressure to 20 percent. Then select an 11-pixel brush and make strokes around the outside edge of the veins. Don't stroke all the way down the veins; just go half their length because you don't want to exaggerate the tips. The tips should blend into the blade of the leaf. When you are done you should have something similar to Figure 6.34.

11. Great, now the veins are complete. The next step is to add some subtle changes in altitude to the surface of the leaf. We're going to raise the por-

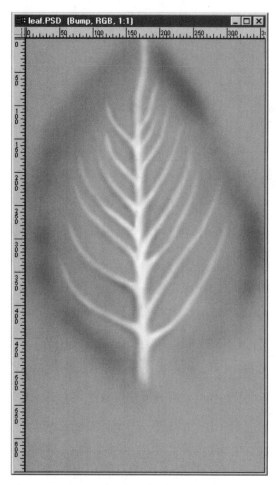

Figure 6.35 Darkening the leaf margin.

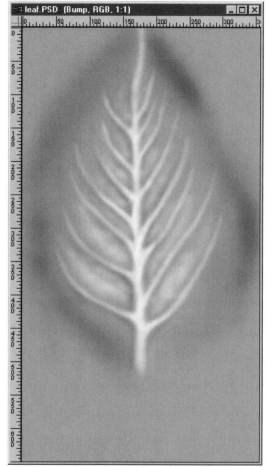

Figure 6.36 Creating the raised spots between the lateral veins.

tions between the veins because they are still somewhat healthy, but we'll lower the outside edge because it's dying. Start by darkening the outside edges. Set the opacity of the bump layer to 75 percent. Then select a 45-pixel brush, change the pressure to 10 percent, and start making strokes around the outside edge of the leaf. First create a consistent dark edge, and then go back and add some dark spots randomly as shown in Figure 6.35.

12. Now select the dodge tool and pick a 16-pixel brush. The trick here is to create a chaotic bump pattern for the raised portions between the lateral veins. Basically, dab the brush down repeatedly between the veins to create a cloudy spot, as seen in Figure 6.36.

13. You're just about done with the bump map. All you have left to add is the decay and erosion spots. With the dodge tool still selected, choose an 11-

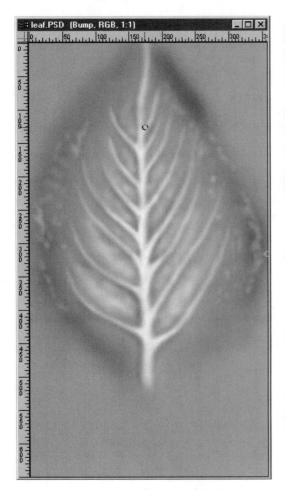

Figure 6.37 Creating the white specks.

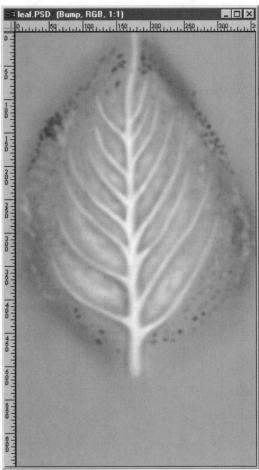

Figure 6.38 Creating the random decay spots.

pixel brush and lay down some random white spots on the blade, making concentrations of them along the outer edge as shown in Figure 6.37.

14. Now select the burn tool, set the pressure to 50 percent and start placing random dots on the blade, creating random dense clusters on the margin. Then set the pressure to 15 percent and place dots all over the blade as shown in Figure 6.38.

15. Now that's more like it, plenty of chaos covering the leaf. It's already starting to look like a realistic leaf, and you're only painting in grayscale. This is the power of high-detail image maps. They really add to the photorealism of the object. Now that we're done with the bump layer, we can save a copy as leafbump.jpg. The next step is to create the color chaos, which starts with the bump map.

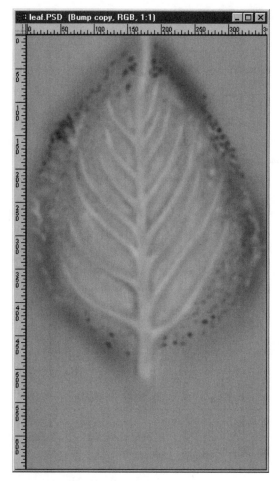

Figure 6.39 Darkening the veins.

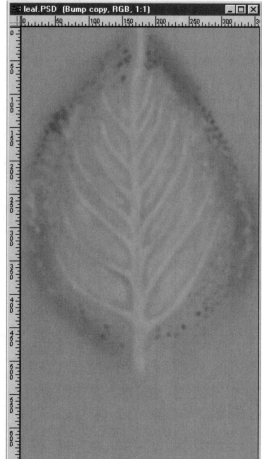

Figure 6.40 The modifier layer combined with the base color layer.

16. We're going to use the bump layer to modify the tones of the basecolor layer, but first we need to modify the bump layer. We need to darken the veins, so they don't appear too light on the color layer. First, create a duplicate of the bump layer and name it modifier. Then select the airbrush tool, set the pressure to 20 percent and select a 45-pixel brush. Now paint over the white veins on the modifier layer, as shown in Figure 6.39.

17. Now the veins won't appear too bright when you combine it with the basecolor layer. Speaking of which, set the modifier layer to soft light, and make sure the bump layer is deactivated. You should now have a green leaf like the one seen in Figure 6.40.

18. It looks good doesn't it? You're well on your way to a great looking color image map. What we need to do now is create some color chaos, so add a

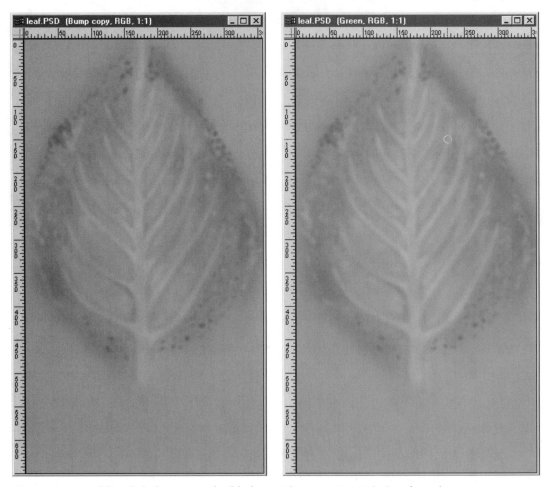

Figure 6.41 Adding faded green to the blade. **Figure 6.42** Painting the veins.

new layer under the modifier layer named green. You want to stack the new layers under the modifier layer, so they are affected by it. On the green layer you are going to be painting some color chaos to make the leaf more natural. Select the airbrush tool, set the pressure to 20 percent and the color to RGB 71, 81, 54. Now paint broad strokes on the left and right sides of the blade as shown in Figure 6.41.

19. You can see how the leaf is starting to come alive, or should I say dead. What we need to do now is accentuate the veins with a rich, yellow green, which shows they are dying from lack of water. Select a 16-pixel brush, set the color to RGB 100, 106, 36, and paint strokes along the veins in the leaf. You should end up with something similar to Figure 6.42.

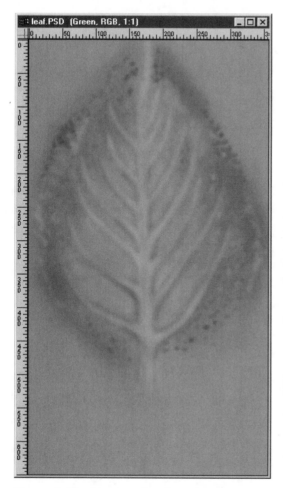

Figure 6.43 Accentuating the veins.

Figure 6.44 Darkening the margin.

20. Now you need to sharpen the veins a bit by adding the occasional dark spots around them, similar to when we darkened the base of the vein bump earlier. Set the brush color to RBG 68, 73, 25, and paint some dark strokes randomly around the base of the lateral veins as seen in Figure 6.43.

21. Now the veins will stand out better. Before we move on to creating the brown elements of the leaf, you need to add more green chaos in the form of dots, scratches, and blotches. Let's start with the blotches. Select the burn tool and set the pressure to 20 percent. Then select a 20-pixel brush and dab some dark spots around the outside edge of the leaf as shown in Figure 6.44.

Figure 6.45 Adding scratches to the leaf.

Figure 6.46 Adding specks to the blade.

22. Now select a 3-pixel brush and place some scratches on the leaf, starting on the outside edge and running down between the lateral veins as shown in Figure 6.45. These scratches will help to make the leaf look old, like it's been blown against a rough tree or even the other branches of the bush where it hangs.

23. Okay, the last element for your green layer is some tiny dark spots to add character. Select a 10-pixel brush and drop some random dots on the leaf as shown in Figure 6.46.

24. Great, now we're finished with the green layer. As you can see, creating a photorealistic leaf requires a great deal of detail. You can't skimp on detail because it's the backbone of realistic surfaces. Speaking of detail, we're now ready to add some brown chaos to the leaf. Create a new layer called brown just above the green layer.

Figure 6.47 Adding some brown to the leaf.

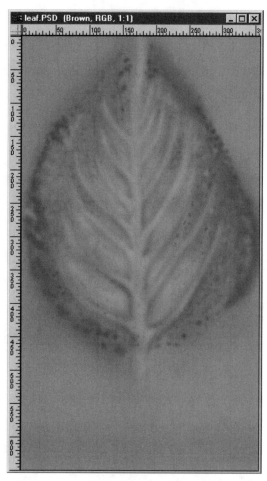

Figure 6.48 Adding light strokes between the lateral veins.

25. Select the airbrush tool, set the pressure to 20 percent, and pick a 45-pixel brush. Now set the brush color to RGB 97, 88, 50 and paint some brown strokes around the outside edge of the leaf, with a few that come inward toward the stem as shown in Figure 6.47.

26. Now set the brush color to RBG 144, 140, 67 and paint some light strokes between the lateral veins as shown in Figure 6.48.

27. The brown layer is now nearly complete. All you need to do is add a bit more chaos. First, lighten the color of your current brush a bit and drop some random light splotches on the leaf as seen in Figure 6.49.

28. Okay, you have one last element to add to the leaf, and then we'll be done! Set the brush color to RBG 53, 47, 27, the size to 25 pixels, and the pressure

Figure 6.49 Adding light splotches.

Figure 6.50 Adding the final dark spots.

to 25 percent. Now paint some random dark spots on the leaf as shown in Figure 6.50.

29. Awesome, you're now finished with the color of your leaf. Save the file, then save a copy as leaf.jpg. As you can see, we've come a long way from the simple green leaf we had a few minutes ago. While it may seem like a great deal of work, the results are certainly worth the time invested. Creating photorealism takes a heavy commitment to the details. No detail is too small to skip. The more detail we add the more realistic the surface becomes.

Well, there's only one image map left to create before we can surface your leaf, the clip map. You need to create a clip map so you can trim the margin of the leaf to make it jagged. A smooth margin will most certainly make the leaf appear artificial, no matter how well we surfaced it. The clip map is relatively simple to create. What we'll do is create a two-color, B&W

image map where the white portion represents the area we want to clip and the black the portion we want to retain.

30. Add a new layer called clip just above the background layer. Now deselect all layers except the background, clip, and modifier. Select the modifier level and set the opacity to 50 percent so you can clearly see the template below. Now select the clip layer and the lasso tool. Then draw a jagged selection around the very edge of the template, making sure to cut into the edge periodically. Be sure to refer to the dark areas of the modifier level for places where the jagged edge will be most severe. Also, on the left side at the top cut a deep notch into the leaf to make it interesting. When your selection is complete, fill it with black. Then invert the selection and fill it with white. You should now have a clip map similar to the one seen in Figure 6.51.

Figure 6.51 The completed clip map.

31. Now save the file, then save a copy as leafclip.jpg.

32. Excellent, we're now done with all of the leaf image maps. The next step is to load your rendering program and test the textures you just created.

33. Load the leaf.3ds object file located in the chapter6 folder on the companion CD-ROM. Then load the leaf.jpg, leafbump.jpg, and leafclip.jpg files.

34. Now apply the leaf.jpg as a planar map on the y-axis to the color channel, then size the image to fit the leaf. Also apply this image to the bump channel and set the bump value to 100 percent. Then add a new bump channel and apply the leafbump.jpg image as a planar map on the y-axis and size the image to fit the leaf, then set the bump value to 100 percent. If your programs allow for bump percentages greater than 100, set it to 400 percent. This will really make the veins pop off the blade.

 If you have diffusion, apply the leaf.jpg as a planar map on the y-axis and set the opacity to 25 percent.

35. Now set the specularity to 35 percent and the glossiness/hardness to 30 percent.

 Another thing you might want to do is add another bump channel with a very fine fractal noise or bump. This will help to break up the specularity in the leaf.

ALWAYS ADD A SMALL NOISE BUMP

You should always add a small noise bump to all your natural surfaces. No surface in reality is perfectly smooth. They all have a subtle surface texture. Applying a small noise bump will break up the specularity of your surface, making it appear more realistic.

36. Finally, to complete your leaf you need to apply the leafclip.jpg to the clip channel as a planar map on the y-axis. This will create the natural jagged edge on your leaf margin.

37. The surfacing is now complete, so do a test render to check the results. You should have something similar to Figure 6.52.

You probably noticed that my leaf is bent. That's because I used a morph target to position it. We'll cover morph target surfacing in Chapter 7, "Morph Target Surfacing." For now, let's focus on the surfacing of your leaf.

Notice how detailed the leaf appears. We have plenty of surface chaos and a nice crispy edge to make it even more dynamic. This is truly a photorealistic leaf. Yes, it was a bit of work to create, but when you think about it, it really wasn't all that bad. It's really a matter of incorporating the small details that make digital botany so fascinating.

Well, we've now seen how to make both random and specific details for photorealistic surfaces, both are really the same process. It's a matter of observing

Figure 6.52 The surfaced leaf.

reality and incorporating the details we see. It means a serious commitment to the fine details. While not everyone will have the patience to add the tiny specks of erosion to the leaf, those who do will reap the reward of a startlingly realistic surface.

Wrap Up

Well, that does it for our exploration of creating surface details. I'm sure you noticed the process is rather labor intensive. This is the commitment we have to make if we're planning to create photorealistic surfaces. Natural surfaces are covered with small chaotic details, meaning we've got our work cut out for us.

Now that we've seen the hard work involved in surfacing natural organic objects, let's take a look at some time-saving tricks we can use to surface complex organic objects. In the next chapter we'll explore morph target surfacing, which is the ultimate time-saver of organic surfacing. Let's turn the page and get started saving time.

Morph Target Surfacing

Surfacing organic objects can be a real nightmare because they have unusual shapes that cause texture stretching when you apply image maps. It's fairly easy to surface objects that are generally planar, spherical, or cylindrical, but what do we do when the object is completely chaotic? For example, take a look at the tree in Figure 7.1.

Here we have a Goblin tree, which is actually a very basic tree with only a few branches. Goblin trees are typically dead, which means they are frequently bare, with only a few twigs at the tips of branches. Of course, in spite of their nakedness, Goblin trees still present a surfacing challenge since they have a number of branches that flow in all three dimensions. With such a chaotic shape, how do we determine the proper surfacing technique? Well, typically we have four image mapping methods to chose from: planar, spherical, cylindrical, and cubic. While these image mapping methods are ideal for a large number of objects, they present a bit of a problem when surfacing organic objects with chaotic details in all three axes. For example, planar mapping won't work for the Goblin tree because we'll end up with vertical lines running through the horizontal branches, as shown in Figure 7.2.

Not a very realistic tree is it? While the model is photorealistic in shape, the surfacing has undermined its realism. The lines of the tree texture should follow the flow of the branches, not intersect it as A indicates in Figure 7.2. Planar mapping also creates very unsightly stretch marks on the sides of the tree, which are indicated by B. Okay, so planar maps won't work. What about a cylindrical map? Figure 7.3 shows the problems associated with a cylindrical map.

Figure 7.1 An organic tree.

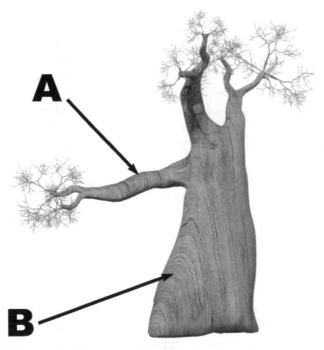

Figure 7.2 Planar mapping the tree.

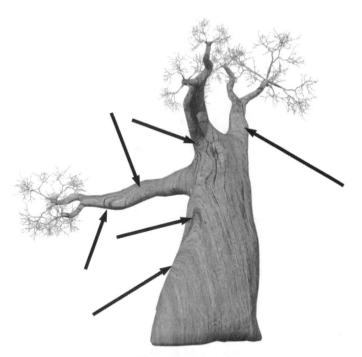

Figure 7.3 Cylindrically mapping the tree.

Notice the unsightly stretch marks indicated by the arrows, which make the tree appear like an obvious 3D object. While the patterns the cylindrical map creates are interesting, they certainly aren't photorealistic. What we need are vertical lines that run up the tree and down the branches. Of course, that's a major challenge in 3D since our image mapping options are limited. Obviously, a spherical map won't work either, since it will create texture stretching as well. A cubic map is a great choice for organic objects, but in this case it's no better than a planar map. While the cubic map will eliminate the texture stretching, it won't remove the vertical lines intersecting the horizontal branches. Even if we unwrapped the trunk mesh to create a painting template, we are still faced with major surfacing hurdles. In fact, take a look at the unwrapped painting template in Figure 7.4.

Rather convoluted isn't it? While unwrapping serves us well for many objects, it hasn't helped much with the tree because the mesh is too chaotic in all directions and the details extend too far into each dimension. It would be very difficult to paint the tree based on this template since it hardly resembles a tree. Unwrapping is typically best suited for a mesh that doesn't have details that extend deep into all three dimensions. For example, a creature head is a great use of an unwrapped mesh template. Figure 7.5 shows a creature head, and Figure 7.6 shows its unwrapped mesh template.

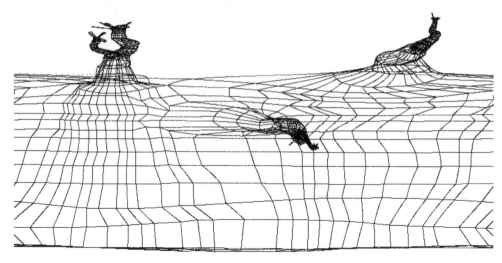

Figure 7.4 The unwrapped tree mesh.

In Figure 7.5 we have the head of a mole creature, an evil warrior from the *P-XG1* graphic novel. These are nasty ten-foot tall cybernetic creatures that are completely blind, but have a keen sense of smell and can pick up on the slightest movement of air, which helps them defeat their enemies. Notice how the details in the unwrapped mesh template in Figure 7.6 are easy to make out. We

Figure 7.5 A creature head.

Figure 7.6 The unwrapped mesh template.

can clearly distinguish where the eyes, nose, and mouth are located. This template is easy to paint on with accuracy because the details are clear, but the template seen in Figure 7.4 is far too chaotic to serve us. We need to paint linear lines running up the tree and extending down the branches if we want the tree to appear realistic, and that just isn't possible with the unwrapped mesh template since the mesh is distorted.

Unwrapping a mesh won't work, so we need to find a more creative solution. Now, typically I would recommend separating organic models into multiple surfaces and using planar maps to texture them, but that won't work well on a tree since there are countless branches in the most precarious positions. This is where morph target surfacing becomes both necessary and a welcomed solution. Let's take a look at how morph target surfacing works.

Using Morph Target Surfacing

Morph target surfacing shouldn't be confused with morphing surfaces. We aren't actually morphing the surface, but instead we morph the object so we can position it for proper surfacing. Basically, we construct our organic object the way we want it to appear, such as the Goblin tree shown in Figure 7.1. Then we create another version that is positioned for proper surfacing. What does proper positioning mean? Well, we basically fold the object, so it conforms to one of our image mapping methods. In the case of our Goblin tree we fold it up like an umbrella so we can cylindrically map it. Figure 7.7 shows the folded Goblin tree.

Figure 7.7 The Goblin tree folded for surfacing.

Notice how the branches are all folded upward to form a cylinder, which means our cylindrical mapping will now work well. Finally, we surface the folded model and then morph it to the original model, which is posed the way we want it. The result is the perfectly natural surfaced tree shown in Figure 7.8.

Notice how the lines run vertically up the trunk and then down the branches horizontally. Take a closer look at where the trunk splits at the top, and you'll see that the texture splits and runs up each segment naturally. This is the power of morph target surfacing. It turns a seemingly impossible task into something relatively simple to accomplish and with extraordinary results. Let's take a closer look at how the morph target surfacing is accomplished by surfacing the Goblin tree.

EXERCISE: EDITING THE GOBLIN TREE FOR MORPH TARGET SURFACING

1. First Open your modeling program, and load the tree.3ds file located in the chapter7 folder on the companion CD-ROM.

2. Now we're going to fold the tree. This isn't a complicated process, but it is a bit tedious. Of course, the results are well worth the effort. Let's start with the top of the tree. Zoom in on the top where the tree splits. Then select the polygons of the right branch and rotate them so they are vertical in the z viewport as shown in Figure 7.9.

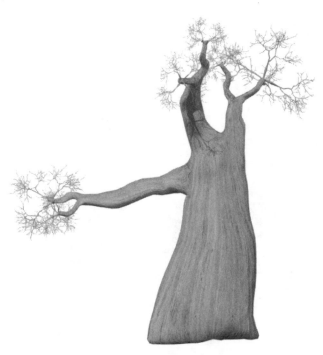

Figure 7.8 The result of morph target surfacing.

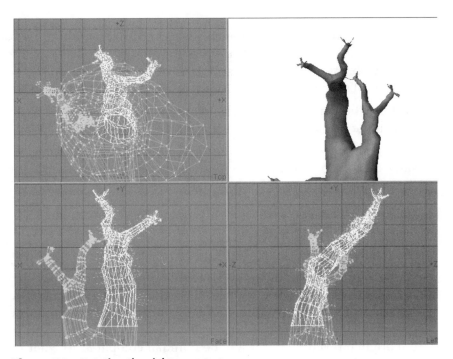

Figure 7.9 Rotating the right segment.

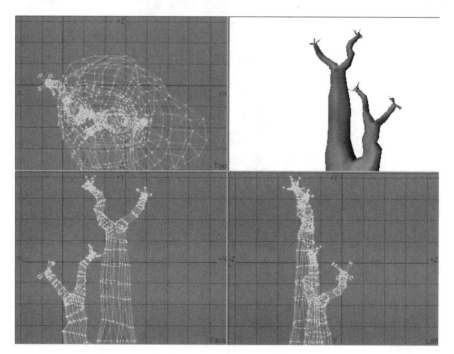

Figure 7.10 The vertical right branch.

3. Now we need to rotate the branch, so it's vertical on the x-axis. Okay, now for some tedium: Repeat this process for each polygon segment going up the branch until you reach the split at the top. The right branch should now be vertical as seen in Figure 7.10.

4. Perform the same process on the left branch, stopping when you reach the split at the top. You should now have something similar to Figure 7.11.

5. Now zoom in on the top of the right branch where it splits. Using the same technique you applied with the larger branches, select the branch on the right and rotate each polygon segment until it's vertical as shown in Figure 7.12.

6. Great, now repeat the same process for the branch on the left. When you fold the branch on the left upright it should overlap the branch on the right to create the appearance of a single branch, as seen in Figure 7.13.

 Overlapping the branches is essential for the surfacing to work properly. If we don't make the tree a single tube, the texture will stretch across the branches of the tree. We have to create a single tube to prevent surface stretching. Yes, minor stretching will occur when the tree is morphed into the original position, but it will be minimal compared to what we would see if we didn't make the morph object a single tube.

Figure 7.11 Making the left branch vertical.

Figure 7.12 Making the right branch vertical.

Figure 7.13 Folding the left branch upward.

7. Okay, now zoom out and perform the same process on the left branch so it is folded vertically as shown in Figure 7.14.

8. We're almost done with the top of the tree now. The next step is to fold the tiny twigs at the top of the tree so they are vertical as seen in Figure 7.15.

9. Now select the branch to the right and move it over the branch on the left as shown in Figure 7.16.

10. Finally, select the overlapping branches and move them to the right so they line up with the trunk of the tree, as shown in Figure 7.17.

11. Now zoom out, select the branch to the left, and rotate its top branches as we just did to the right branch. When you are done, you should have two vertical branches on the top of the tree similar to the ones in Figure 7.18.

12. Now the last step on the top of the tree is to move both branches inward so they overlap as shown in Figure 7.19.

 Well, that was a bit of work. Unfortunately, we aren't quite done yet. You still need to fold up the horizontal branch and straighten the trunk. Let's start with the horizontal branch.

13. You know the drill: Select the polygons of the horizontal branch and line them up along the x-axis as shown in Figure 7.20.

Figure 7.14 Folding the left branch vertically.

Figure 7.15 Folding the twigs at the tip.

Figure 7.16 Overlapping the branches.

Figure 7.17 Moving the top to line up with the trunk.

Figure 7.18 The twin vertical branches.

Figure 7.19 Overlapping the top branches.

Figure 7.20 Folding the horizontal branch.

14. Now select the horizontal branch and fold it upward and inward so it overlaps the trunk of the tree, as seen in Figure 7.21.

15. Okay, the last step is to edit the trunk. Currently, it is a bit out of alignment, which isn't terribly bad, but we need it as close to vertical as possible to prevent the texture from stretching at the top. If the tip of the tree isn't lined up with the base the texture will be stretched at the tip and base. Move the points on the tree trunk so it's lined up vertically, as shown in Figure 7.22.

 We're done editing the tree. Now give the tree a surface named goblintree, and save the object as treemorph.

Well, that wasn't too bad. Yes, it was a bit tedious, but it's really nothing more than rotating all of the segments until the tree is a vertical tube. Now that we have our completed morph object, we can surface it.

EXERCISE: SURFACING THE GOBLIN TREE

Load the tree object into your rendering program. Then load the goblintree.jpg file from the chapter7 folder on the companion CD-ROM.

1. Now apply the goblintree.jpg image to the color channel as a cylindrical map on the y-axis. Be sure to size the map so it fits the heights of the tree

Figure 7.21 Folding the horizontal branch upward.

Figure 7.22 The completed morph object.

then set the number of width repeat to two so it wraps around the tree twice.

2. Next, repeat the same steps for the bump channel and set the bump value to 100 percent. If your program supports settings in excess of 100 percent, set the value to 150 percent. We want the tree to be very rough since it's worn by the harsh elements of a Goblin island in the Tertiary period. If your program supports diffusion maps apply the goblintree.jpg as a cylindrical map on the y-axis to your diffusion channel and set the opacity to 15 percent. We want the tree to be fairly light in color, so we don't want the diffusion to be too high. If you wanted the tree to look like it's rotting, you could set the diffusion opacity higher, to something like 60 percent. This will darken the tree surface and make it absorb more light, as rotten wood will do.

3. Now give the tree 5 percent specularity and set the hardness/glossiness to something low, like 25 percent.

4. Finally, save the object and do a simple test render to check the results of your surfacing. You should have something similar to the tree in Figure 7.23.

 Not bad, but if we look close we'll see some errors in the surfacing. Notice the stretching of the texture indicated by the arrows. Even though we rotated the branches into a tube shape, we still have a stretching prob-

Figure 7.23 The surfaced tree.

lem. This is caused by the irregular shape of the trunk base, as seen in Figure 7.24.

The arrows indicate the problem areas. You see, when we use a cylindrical map on an object that isn't round, it will stretch across the irregular areas. The cylindrical map is centered on the middle of the tree, so it would need to stretch to reach the outer limits of the trunk base. This will create stretching of the texture all the way up the tree. Fortunately, this problem is easy to resolve. We simply need to push the base into a round shape.

USE A PRIMITIVE TEMPLATE WHEN SHAPING OBJECTS

While it's easy enough to get a fairly accurate circle by eyeballing it, you should always create a simple primitive disc as a template when you are editing organic objects to make them round for cylindrical mapping.

6. Let's go back to your modeling program and load the treemorph object you just surfaced. Now, to make it easier to create a round base, create a simple primitive disc as a template. Place the disc on a background layer or just under the tree, then select your magnet tool and push the base of the tree into a disc shape as shown in Figure 7.25.

Figure 7.24 The irregular trunk base.

Figure 7.25 Creating the round base.

7. Now save the treemorph object and replace the object in your rendering program.

Resize your image maps to the new model and do a test render. You should now have something like the tree in Figure 7.26.

That's much better—not a stretch mark on the tree. We now have a realistically surfaced tree, which is ready to be shaped. The only thing left to do is morph the tree into our original shape. Let's take a look at how this is accomplished.

EXERCISE: MORPHING TARGET SURFACING

1. You now have a completed base object for your morph. What we need is the morph target, which is our original tree. Before you load this object you need to give it a unique surface name so it doesn't overwrite your new surfacing. Load the goblintree.3ds object from the chapter7 folder on the companion CD-ROM and assign it a new surface named neutral. Then save the object on your local drive.

GIVE A NEW SURFACE NAME TO MORPH OBJECTS

Always give your morph objects a new surface name so they don't change the surfacing of your base object. If your morph object has multiple surfaces, you can simply combine them into a single surface since the actual surfacing of the morph

Figure 7.26 The corrected surfacing.

object is irrelevant. You don't actually surface this object, but you do need to change the name so it wouldn't affect the surfacing of your base object.

2. Now load the goblintree file into your rendering program and make it 100 percent invisible or dissolved. You don't want this object to be visible in your scene.

3. Next, select the treemorph object and set it to morph to the goblintree object, with a morph value of 100 percent.

4. Now save the scene as goblintreemorph and do a test render. You should end up with something similar to Figure 7.27.

Great looking tree! Take a close look at the tree, and you'll see the lines flow smoothly up the tree and then down the branches. This is a very natural look-ing tree—well, it's a bit bare, but you get the idea. Morph target surfacing has turned a nightmare of a task into something that was relatively simple and straightforward.

Morph target surfacing is a very powerful technique for surfacing complex organic objects, particularly trees and bushes, which are typically the most chaotic and complicated objects to surface. Of course, morph target surfacing isn't just for the ultra-complicated objects, it can also be used to surface sim-pler objects with mild organic shapes.

Figure 7.27 The morph target surfaced tree.

Using Morph Target Surfacing on Simple Objects

There are two ways to surface simple organic objects: bones and morph targets. You can use bones to bend the object into shape or a morph target to morph it into shape. Typically you'll want to use morph targets, particularly if you have a lot of objects to shape. The problem with bones is that they are resource hogs. They will slow you down quite a bit while they compute the transformation of the mesh. On the other hand, a morph target is quick because the points are simply moved to a new location. The program doesn't need to compute the new location of the points as it does with bones because the morph target provides them. Therefore, morph target surfacing is the most efficient means for surfacing simple organic shapes.

For example, if you wanted to surface a curved fallen branch, you'd need to use morph target surfacing. Well, you wouldn't have to use a morph target, you could simply use bones to bend the branch, but that can be an unnecessary resource drain and you would still need to morph the little twigs on the branch. You are better off sticking to the morph target method. Of course, you would probably want to bend the branch using bones and save the transformed object as the morph target. Let's take a look at how this is accomplished.

USE MORPH TARGETS INSTEAD OF BONES

■■■■■ Bones can be a huge resource drain, but morph targets are not. Yes, a morph target adds more points and polygons to the scene, but it computes significantly faster than bones. You are better off using bones to create the morph target, which you will eventually use in your scene.

EXERCISE: USING BONES TO CREATE THE SURFACING MORPH TARGET

Start by loading the branch.3ds object located in the chapter7 folder on the companion CD-ROM into your rendering program.

1. Now place a bone at the base of the branch that is about 1/10 its length as shown in Figure 7.28.

3. Now add nine new bones of the same size, each parented to the previous one as shown in Figure 7.29.

4. Now rotate the bones slightly to create a curved branch like the one shown in Figure 7.30. You don't have to be very exact, simply rotate the bones to create a naturally curved branch.

5. Give this object a new surface name, such as nosurface. Then save it as a transformed object named branchmorph. This will save the object in its new, bent position. We changed the surface name because we don't want it to affect the surfacing of our original object.

6. Now clear your scene.

Figure 7.28 Adding a bone to the branch.

Figure 7.29 Adding the rest of the bones.

Figure 7.30 The transformed branch.

7. Before we do the actual surfacing and morphing, we need to edit the original branch. There are two short branches stemming off it that need to be rotated so the surfacing will be correct. Load the branch object into your modeling program. Now select the polygons for the upper horizontal branch and rotate them against the main branch as shown in Figure 7.31.

8. Now do the same for the lower horizontal branch and save the object as branch. Then load the object into your rendering program. We're going to surface the branch now so load both the branch.jpg and woodcore.jpg files located in the chapter7 folder on the companion CD-ROM.

9. Now apply the branch.jpg image to the color channel of the branch surface as a cylindrical map on the y-axis. Be sure to size the map so it fits the heights of the tree then set the number of width repeats to one.

10. Next, repeat the same steps for the bump channel and set the bump value to 100 percent. If your program supports settings in excess of 100 percent set the value to 150 percent. If your program supports diffusion maps apply the branch.jpg as a cylindrical map on the y-axis to your diffusion channel and set the opacity to 15 percent.

11. Give the branch 5 percent specularity and set hardness/glossiness to 25 percent.

Figure 7.31 Rotating the branch.

12. Now copy this surface to the branchtip surface. This is the very top of the branch where we will see the growth rings. Select the color channel and replace the branch.jpg image map with the woodcore.jpg, then set the mapping to planar on the y-axis. Be sure to make these changes for the bump and diffusion layers as well. Now save the object.

13. Next, do a simple test render to check the results of your surfacing. You should have something similar to the branch in Figure 7.32.

14. It looks pretty good. Now you simply need to load the branchmorph object and set it to 100 percent dissolved. Then select the branch object and set it to morph to the branchmorph object with a value of 100 percent.

15. Now save the scene as branch and do a test render. You should have a twisted branch like the one shown in Figure 7.33.

Well, that one was a great deal easier than the Goblin tree. The morph target surfacing worked well on this simple object, without the added hit on system resources that would accompany the use of bones. Of course, we also need to morph the object so our horizontal branches would surface properly.

Figure 7.32 The surfaced branch.

Figure 7.33 The morph target surfaced branch.

As you can see, using morph targets to surface both complex and simple organic objects can save you countless hours of editing, not to mention the associated headaches. In fact, some objects like the tree would be impossible to surface properly without using a morph target. What's more, morph target surfacing can also be used to save on system resources.

Saving Resources with Morph Target Surfacing

One of the major advantages of morph target surfacing is that it can be used to save on system resources. For example, why surface all the leaves of a plant when you can surface only one? If you have 100 leaves on a plant that needs to be surfaced for a close-up shot, you'd surely kill your computer trying to create a single image map to cover all of the leaves, not to mention the challenge of surfacing leaves at odd angles. This is where the morph target once again shines bright. You can use a morph target to position the leaves so you only have to surface one of them instead of all 100. How does this work? Well, let's take a look at a scene where this technique was used. In Figure 7.34 you'll see an image of Borgis Warf on the Yoran Island in the Great Goblin Lake.

Here we see Drale the Bug King on the pier at Borgis Warf, which is located on the Yoran Island. Drale makes frequent visits to the Yoran Island to rescue worms from the Mud Goblins who find them to be quite the delicacy. You see, Drale is the ruler of all insects on the Goblin Island; he considers them his subjects, so he can't bear to watch them fall prey to the annoying Mud Goblins of Yoran. The Yoran Island is home of the lost civilization of Yoran. The Yorans were an ancient Goblin civilization that perished thousands of years before the Goblins of the Tertiary period. They were an advanced race with inventions that boggle the minds of today's scientists. They can be compared to the Mayan Indians or the ancient Egyptians. They built lavish stone castles on the center of the island, where they worshipped the sun and moon gods.

Now, the Yoran Island is inhabited by the unruly Mud Goblins, who are considered cannibals by the other Goblins. Most Goblins are afraid to enter the Island, but Drale knows he is safe as long as he enters during the day. Mud Goblins are nocturnal, so they are sound asleep in their mud caves during the daylight hours. They come out at sunset and party all night. Their ruckus can be heard for miles, reaching all the way to the mainland of Tanzania.

The Yoran island is covered completely in mud due to the rising waters of the Great Goblin Lake. The Tertiary period experienced a great deal of rainfall, which flooded the Yoran civilization and brought about a major infestation of worms. The entire island is covered in a wiry water weed, which serves as a great shelter for the worms. The water weed in the image was surfaced using

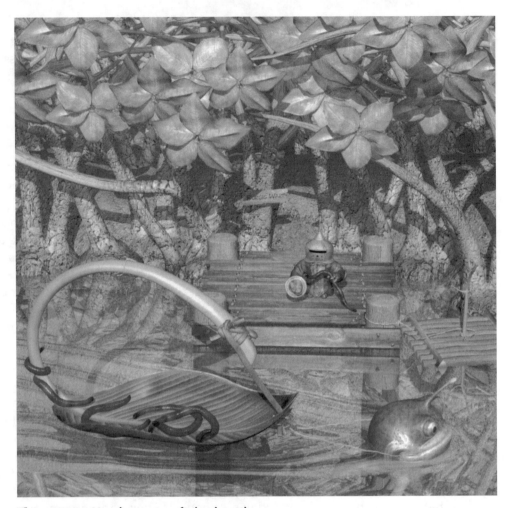

Figure 7.34 Morph target surfacing in action.

morph target surfacing. The basic weed was modeled and then folded up to create the morph target object for surfacing. The surfaced morph target is shown in Figure 7.35.

The basic wood texture was applied to the water weed as a cubic image map instead of a cylindrical map because of the multiple trunks. The trunks were too far apart to be moved together for a cylindrical map, so the object was surfaced with a cubic image map. A cylindrical map would have created texture stretching as shown in Figure 7.36.

Most of the branches look fine, but there is some significant stretching on many of them, which is indicated by the arrows. The water root object is basically an

Figure 7.35 The surfaced water weed.

Figure 7.36 Cylindrical image map texture stretching.

oval shape at the base, which makes cylindrical surfacing impossible. We could have pushed the object into a cylindrical shape, but the trunks would still be too far apart to be moved together. In this case a cubic image map worked well for preventing image map stretching, as you can see in Figure 7.37.

Notice how the texture lines flow up the trunk and down the horizontal branches with no stretching at all. This gives the water weed a very realistic appearance. If you look at the base of the water weed you'll see a dark, wet spot. This is the portion of the water weed that lies below the water line. To create this effect, a cylindrical map was used to lower the diffusion and raise the specularity. The same map was used for both, which is shown in Figure 7.38.

When this image is applied as the specularity map, the white portion makes the object 100 percent specular at the base. To keep the black portion from making the rest of the object 0 percent specular, the same image is applied as an alpha map to filter out the black portion. White on an alpha map is opaque, while black is transparent.

When you make an object wet, you need to lower the diffusion significantly. Water soaks into the porous surface of the water weed, which lowers the diffusion. To diffuse the waterline of the water weed, the image map in Figure

Figure 7.37 The cubic mapped water weed.

Figure 7.38 The water line image map.

7.38 was applied as a cylindrical map on the diffusion channel, but the map was inverted so the portion below the waterline would be black. To prevent making the portion above the waterline 100 percent diffused, the map was also applied as an alpha map, but it was not inverted. As a result, the upper portion is transparent, and it does not affect the basic diffusion of the surface. Of course, with 0 percent diffusion below the waterline the texture would be too dark, so the image map was made 60 percent opaque to reduce its effect. As you can see, the result is a very convincing effect of water-soaked water weed.

Okay, that was a nice surfacing tangent. Now let's get back to the real subject of this section, saving resources with morph target surfacing. Take another look at the water weeds in Figure 7.34 and you'll see they are covered in clumps of leaves. These leaves were surfaced with morph target surfacing to save on system resources and to make the surfacing task a great deal easier. Let's take a look at how they were surfaced.

EXERCISE: MORPH TARGET SURFACING OF LEAVES

1. In the chapter7 folder on the companion CD-ROM, you'll find an object called leaf. Load this object into your modeling program. You should see something similar to the object in Figure 7.39. Basically, you're going to create a clump of five leaves like the ones you see in Figure 7.34. The technique for this type of morph target surfacing is to stack clones of the object beneath one another so they all receive the same image map. Then create the complex morph target object with all the chaos. This is a very fast and efficient means for surfacing the leaves.

2. Make four clones of the leaf and place them directly beneath each other as shown in Figure 7.40.

3. Now you have the base object for your morph. Give the object a surface named leaf, and then save this object as leaves. Now we can move on to creating your morph target.

4. To create the morph target we need to modify each leaf individually. Start with the top leaf. Hide the lower leaves so that you only have the top leaf visible. Now select the polygons for the stem and bend then downward as shown in Figure 7.41.

5. Now we'll add some natural waves to the leaf. Select the magnet tool and pull down the back right corner of the leaf. Then pull the middle left upward as shown in Figure 7.42.

6. It looks better, but we still need more chaos. Using the magnet tool, pull the tip of the leaf upward as shown in Figure 7.43.

7. Now you have a completed leaf, with a very natural flow. Now apply the same type of editing to the remaining leaves. When you are finished, select

Figure 7.39 The leaf.

Figure 7.40 Making the leaf clones.

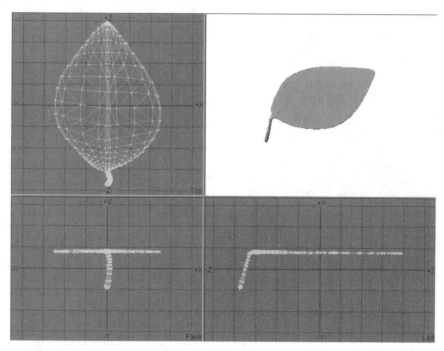

Figure 7.41 Bending the stem.

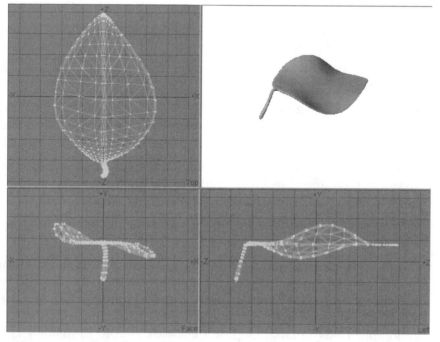

Figure 7.42 Adding waves to the leaf.

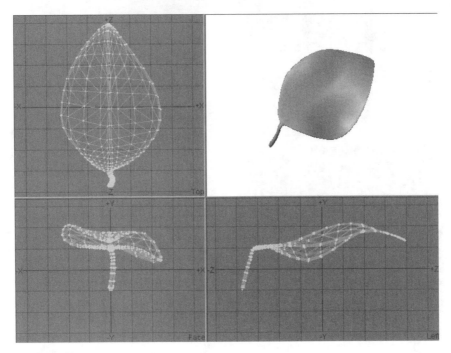

Figure 7.43 Pulling the tip upward.

each leaf and rotate it slightly to create the cluster of leaves shown in Figure 7.44.

That looks like a very realistic cluster of leaves. For a closer look see Figure 7.45.

8. Our last step is to give the leaf cluster a new surface name, such as neutral and then save it as leafmorph. Remember, you need to rename the morph targets so you don't end up changing the surfacing of your base object.

9. Okay, now you're ready to surface the leaves. Load the leaf object into your rendering program, and then load the leaf.jpg image map from the chapter7 folder of the companion CD-ROM.

10. Now apply the leaf.jpg image to the color channel as a planar map on the y-axis. Be sure to size the map so it fits the dimensions of the leaf.

11. Next, repeat the same steps for the bump channel and set the bump value to 100 percent. If your program supports settings in excess of 100 percent, set the value to 400 percent. If your program supports diffusion maps load the leafdiff image from the chapter7 folder of the companion CD-ROM and apply it as a planar map on the y-axis to your diffusion channel and set the opacity to 15 percent.

Figure 7.44 The completed leaf cluster.

Figure 7.45 A closer look at the leaf cluster.

12. Then give the leaf 47 percent specularity, and set hardness/glossiness to 50 percent.

13. Great, now do a test render and you should have something similar to Figure 7.46.

14. Notice how the surfacing travels through the leaves. We only had to create a single leaf image map to surface all five leaves. This has already cut our use of system resources by 80 percent. Now save the object and load the leafmorph object so you can morph the leaves.

15. Make the leafmorph object 100 percent transparent/dissolved, and then select the leaf object.

16. Set the morph object to the leafmorph and the morph value to 100 percent. Now do a test render. You should have a cluster of leaves similar to the one shown in Figure 7.47.

17. Now save your scene as leaves.

They look great don't they? We now have a very realistic cluster of leaves, which we created with a single leaf image map. That isn't the best part. The great thing is we can now create clones of the leaf object to place on the water weeds. Each clone will morph to the shape of our single morph object, which means we save on a tremendous amount of resources we would normally expend trying to surface all the leaves with a single image map.

Figure 7.46 The surfaced leaves.

Figure 7.47 The completed leaf cluster.

As you can see, morph target surfacing can be used to save a great deal of time and resources. There are literally countless uses for morph target surfacing when creating digital botany. You can surface leaves, trees, grass, lily pads, you name it. In fact, you can use a single base object with multiple morph targets to create even more natural chaos and variety in your images. Multiple morph target surfacing was used to surface the bucket fungus in Figure 7.48.

A single base bucket fungus was modeled and surfaced, and then multiple morph targets were created to make the varied appearance of the fungus. Bucket fungus grows in the Goblin rain forest where it collects water from rain. The sap in the bucket fungus ferments with the water to create a 90 proof alcohol that tastes like honey. As you might imagine, it's a very popular beverage among the Goblin travelers who journey through the rain forest. Unfortunately, the Goblins end up getting drunk and eventually lost in the vast rain forest. Many Goblins have been lost eternally in the rain forest as a result of their taste for bucket fungus.

Wrap Up

It's clear that morph target surfacing can be a real lifesaver when you are creating complex organic objects. In fact, it's quite often the only way you can surface an object. Morph target surfacing is not just a great way to surface objects,

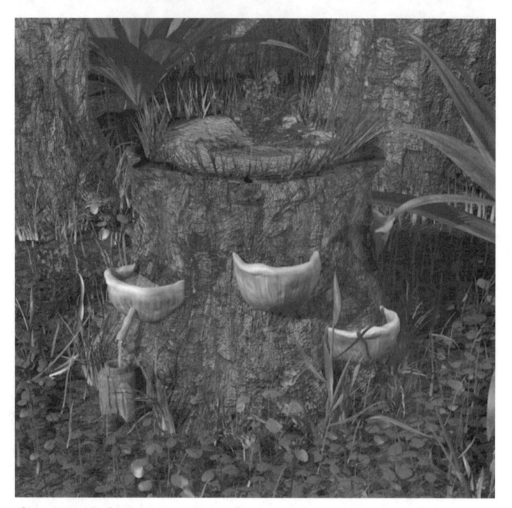

Figure 7.48 Bucket fungus.

it's also an extremely useful way to save on system resources and expedite your surfacing efforts. You should try to use morph target surfacing whenever possible. You'll be pleased you did.

Well, that does it for our surfacing exploits. Now we're going to leap into designing industrial worlds. Before we get our hands dirty with the grease and grime of industry, let's take a few minutes to clear our heads and maybe do a little experimenting with morph target surfacing. Reach into your bag of organic objects and try doing some morph target surfacing on something you have already created. Then we'll move on to the industrial world.

Creating Industrial Environments

There are two main environments in reality, industrial and natural. Both have unique traits, and there are tricks to re-creating both in 3D. In this part we're going to take a look at developing industrial environments—city streets and buildings. Of course, we'll be focusing mainly on the streets since that is where the action takes place. While creating detailed buildings is essential for an industrial environment, the buildings themselves are actually quite easy to create since they are vertical and don't have a great deal of garbage hanging on them. On the other hand, city streets are chaotic. What makes a city street believable isn't the buildings but the small details we see on the streets, such as fire hydrants, chain-link fences, dumpsters, cigarette butts, bottle caps, and the weeds that grow in pavement cracks. Remember, it's the details that make a scene photorealistic. The more fine details we add, the more realistic the image becomes. Let's turn the page and take a look at what makes a city street realistic.

COLOR FIGURES ON THE CD-ROM

Chapter 8 deals with colors so you should refer to the color figures in the chapter8/figures folder on the companion CD-ROM before continuing with this part.

Designing City Streets

City streets are rather detailed and therefore complicated to replicate realistically in 3D. We all know what city streets look like, so we tend to be rather critical of them in 3D images. We expect to see certain details in a city street. If we don't see them, the image appears unrealistic. One of the major hurdles in creating city streets is the overwhelming amount of grungy chaos that exists in reality. City streets are typically rather worn, aged, and dirty, even in the cleanest parts of the city. That makes city streets even more challenging to re-create than most natural environments. While a natural environment presents challenges due to its organic details, the wilderness doesn't have an abundance of surfaces to get dirty and worn. We're not going to see a lot of grease, grime, rust, and oil in nature, nor will we see a great deal of garbage. Well, hopefully, we won't!

The first step in creating city streets is to observe the streets around us. We need to identify the key details that make a street believable. Certain details will make the industrial scenes we create appear startlingly realistic. It's really all about attention to detail and observation. Before you begin to create city streets, I recommend you explore the streets around you and take plenty of pictures. If you try to re-create the streets from memory, you're going to miss those critical little details that make the scene undeniably realistic.

To get a better idea of the details we need to concentrate on when developing photorealistic city streets, let's take a look at a 3D image of a city street. Figure 8.1 shows a cell from the *Platinum 3D* comic book.

Here we have a shot of a city street that captures a moment of frustration for the Platinum character, who is holding the Dumpster in the lower left corner.

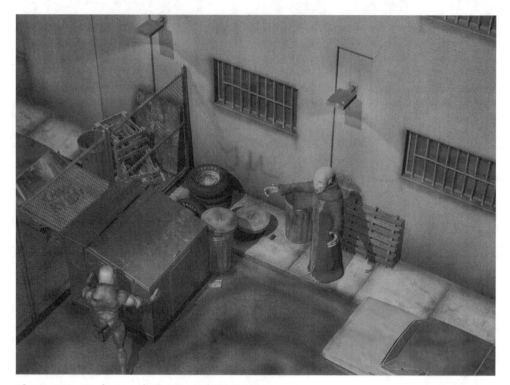

Figure 8.1 A photorealistic 3D city street.

Platinum is having a bit of spiritual turmoil coming to grips with his new-found cognitive state—he was a statue about five minutes earlier. The regal alien on the right side of the image is the Mystic who created Platinum. He's attempting to calm Platinum so he won't start wrecking the city. As you can see, the environment looks very realistic. It's riddled with the detail and chaos we expect to see in a real city street. Let's take a closer look at the details to get a better idea of their importance. We'll zoom in on the image one segment at a time, exploring the relevant details in depth. We'll start with the upper left corner of the image, shown in Figure 8.2.

This is the center of clutter in the image. It's always a good idea to have a strong point of clutter in your city streets. Rarely is the chaos evenly distributed on streets. It typically congregates around specific elements of the street, such as alleys, street corners, and anything that protrudes into the street, such as a portion of a building or the fence in this image.

CENTER YOUR CHAOS

Clutter tends to gather around specific regions in city streets such as alleys, building protrusions, and street corners. You don't want to evenly distribute the chaos because it will appear planned and therefore unrealistic.

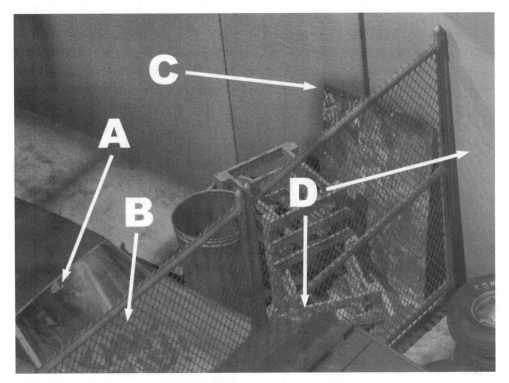

Figure 8.2 A closer look at the details.

The fence serves to divide the street. Since it's a point where movement stops, it's also where the clutter will gather. Even though the street is dirty and cluttered, the inhabitants will still organize the clutter so they can get around. A garbage dump may be complete chaos, but it still has a path dug for movement. In this image the clutter has been gathered around the fence on both sides, which is a logical place to center the chaos since it's where movement stops. Let's take a closer look at some of the specific details that make this segment of the image realistic.

A. **Garbage in the car.** Notice how there is garbage in the front seat of the car. This is a great detail since it's subtle yet convincing. This car obviously doesn't run so we can assume it's been sitting here for quite a while gathering rust and garbage. It's likely a homeless person was living in the car, which would explain the clutter inside. Even if nobody was living in the car, it's certainly a convenient place to put trash, particularly since the Dumpster is on the other side of the fence.

B. **Graffiti on the car.** Graffiti is a staple of nearly every city street. You can assume it will be on any large object that doesn't move, such as building walls and broken-down cars.

C. **Humidity stains.** This is a super detail to include in your city streets. When it rains, humidity collects around objects. While it does evaporate, if the object was dirty or rusty the humidity will stain the objects it reaches. Therefore, if we have a rusty metal sheet leaning against the wall, we'll need to stain the wall where it touches. That is, assuming the sheet has been there a while, which we can assume since it's behind a lot of other debris.

D. **Detail shadows.** While this isn't a required element of a city street, it most certainly helps add depth and realism. Notice the shadow created by the chain-link fence. This is an awesome detail in the scene. Detailed shadows add tremendous depth to an image, and as I've said many times before, the more depth, the greater the photorealism. Later in this chapter we'll be re-creating the chain link fence so you can use it in your city streets.

As you can see, even though we're only looking at one-sixth of the image, we have a number of details that add to the photorealism of this image. While individually these details have little impact on the scene, they combine to transform it into reality. Speaking of individual chaos, let's take a moment to zoom in on the broken-down car in this image to see how photorealistic chaos and detail was applied to the car. Take a look at Figure 8.3.

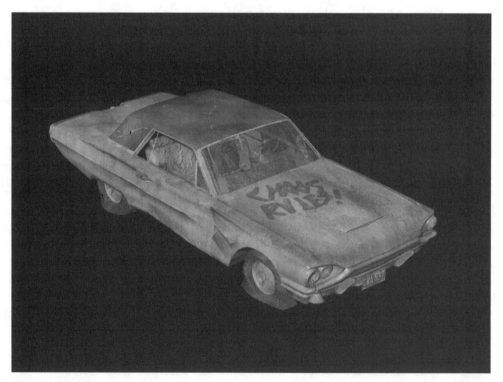

Figure 8.3 A close-up of the car.

This car represents the importance of individual chaos in a scene. While it's true that individual elements of chaos don't make the image, they are critical to the success of the image when combined. The same rule applies to objects in the scene. The individual elements of chaos on an object won't make or break its photorealism, but combined they can ensure it. Therefore we need to take the time to perfect the chaos of each object in the scene if we want the scene to appear photorealistic. In the case of this car, a great deal of chaos was added to make it appear like a realistic, aged car. One of the major elements of chaos was the use of different colored body panels, which is common on run-down cars. The owner probably couldn't afford to replace the parts with new ones, so he picked up body panels from cars in a junk yard to fix the damage caused by collisions or simply rust from aging. Of course, the body panels are all different ages, so they will probably rust differently since the protective coatings would fade at different rates.

While the body panels are a major element of chaos, many smaller elements are responsible for the photorealism of the car. Let's take a closer look at these details, shown in Figure 8.4.

A. **Worn and torn seats.** The seats in the car are extremely withered from exposure to the elements such as rain and sun. It's literally shriveled from the

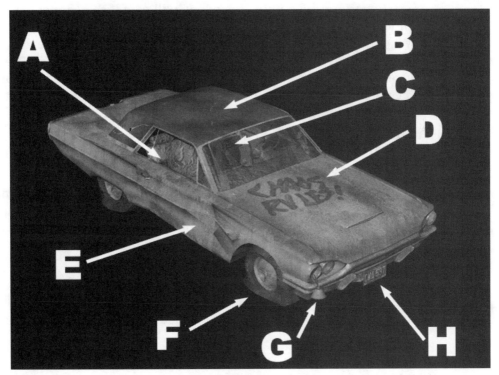

Figure 8.4 A closer look at the car's photorealistic details.

moisture and then baked crispy by the sun. In addition to the aging, there are also many holes torn in the seat cushion, showing the frame beneath. This seat by itself has a tremendous amount of detail and chaos, which makes it very realistic and an important contribution to the photorealism of the entire car.

B. **Sun-damaged canopy.** Notice the stains from rain and the cracks caused by the heat. The roof is faded from exposure to the elements, which definitely helps to make it appear aged.

C. **Missing seat cover.** The seat cover for the driver's seat is completely gone, no doubt borrowed by a homeless person looking for something to keep them warm in the harsh winter cold of the city. The exposed frame of the seat really adds a great deal of chaos and detail to the car. Remember, the more detail, the greater the likelihood it will appear realistic. The great thing is this seat frame is merely a collection of simple shapes. It only took a few minutes to model, yet it added a great detail to the car.

D. **Graffiti on the car.** Since the car is basically immobile we can assume it will be covered in graffiti. Graffiti is a staple of nearly every city street so you can assume it will be on any large object that doesn't move, such as this broken-down car.

E. **Dents and dings.** Broken-down cars often suffer from vandalism since they are stationary, and it's unlikely anyone will care if they are damaged. The dent in the passenger door of this car was probably caused by kids kicking it. Why can we assume this? Well, the paint isn't scraped off the door, which means it couldn't have been caused by another vehicle hitting it. The rubber sole of a shoe won't scratch the paint, so the dent was more likely caused by someone kicking the door. It's always a good idea to have a little fun vandalizing your broken-down cars to make them more believable.

F. **Flat tires.** This is an important detail for a broken-down car. It's very unlikely that we'll see inflated tires on a car that doesn't run. If old age didn't flatten them, vandals surely would have.

G. **Popped-out headlight.** This is a nice touch. Popping out a headlight makes it look like the car was vandalized or possibly a thief was trying to take the headlight but was spooked by something and ran off before finishing the job. Either way, this detail adds great depth to the image.

H. **Rusty, dented license plate.** One common detail on nearly every old car is a bent license plate. We can count on the drivers running into all kinds of things over the life of the car, particularly on a car as large as this one. The unfortunate license plate probably fell victim to the driver's poor vision or lack of depth perception.

As you can see, many details comprise the photorealism of a broken-down car. We didn't even discuss the broken glass of the passenger window, which was

vandalized by kids, or the missing interior panels of the car, which were likely snagged by someone who needed replacement parts for their car. While this car was one simple element of the entire image, the details of the car help to reinforce the photorealism of the image. Besides, if we take the time to perfect each element, we'll have something very detailed that we can use as the center of focus in another image. In fact, Figure 8.5 shows where this same car appeared in a parking garage in another cell of the same comic book.

The car in the back of the garage is the very same car, except the damage was reduced a bit to imply the car might actually run.

Okay, let's continue our exploration of the details in this image by looking to the left, as shown in Figure 8.6.

Notice how the clutter dissipates as we move farther away from the fence. This is an important photorealistic detail. When clutter gathers it will thin out as it reaches into the environment. It will be stacked highest in the center and taper down as it extends outward. It will also be very chaotic on the outer edge. The last thing we want is evenly distributed chaos and clutter. There aren't too many organized litterbugs—well, not where I live anyway.

Figure 8.5 Getting mileage out of photorealistic objects.

Figure 8.6 More photorealistic details.

Now let's examine the individual elements of this segment that help to make the overall image photorealistic.

A. **Running grime.** We can expect to see a great deal of running grime on the vertical surfaces in city scenes, particularly near rooftops and around windows and any object that might be attached to the building, like a water drain. In this image, the security bars on the windows are rusting, which means the rust will run off the bars and down the wall when it rains. We would also have dirt combined with the rust in the runoff since horizontal surfaces collect dirt, which then runs off when it rains. You can bet nobody has been by to clean this building in a long time.

B. **Chaotic organization.** There is order in chaos. While we are chaotic creatures, we do like to organize our chaos to some extent. For example, the tires are organized in a pile, but the pile is chaotically stacked. This is an example of ordered chaos. The garbage cans have a similar order and chaos. The lid is ordered because it sits upon the can, but it's also chaos because it's not properly placed on the can. This type of order and chaos combined is an important element of photorealism. While a totally chaotic pile of tires would look cool, it probably wouldn't make much sense in this image since humans

have a habit of at least trying to organize their chaos. Of course, if the tires were in a gorilla cage it would be an entirely different story.

C. **Random weeds and grass.** City sidewalks are littered with random growth of grass and small weeds, particularly those sidewalks that aren't traveled frequently. While you don't want to fill every crack with grass, you should distribute random clumps of grass to make the sidewalk appear more realistic.

D. **Aged trash can.** Naturally we had to add the obligatory dent to the trash can. One out of every three trash cans has a dent. Cans get dented when cars back into them, they get tossed around by brutish garbage collectors, or they're simply kicked by obnoxious kids. This simple dent adds some nice realism to the can.

E. **Rust runoff.** This is a very nice detail and something most people would miss. This is where the rust from the metal sheet has run off with rainwater. While it's a subtle element in the image, it would look odd if the sidewalk beneath the metal plate were perfectly clean, particularly since the wall around the sheet is stained. Remember, no detail is too small to include when creating photorealistic images.

Well, that was certainly plenty of detail for a small segment of the image. You can see how it requires a serious attention to detail to make realistic city streets. Yes, we could have skipped many of these fine details, but then the image would have suffered. Let's continue with our exploration of photorealistic details by looking upward at the building walls, as seen in Figure 8.7.

While buildings may be relatively light on clutter due to their vertical walls, they aren't light on details. We can expect to see a number of details on buildings:

A. **Graffiti on the wall.** This is a common detail found on most buildings in rundown parts of the city. Basically, if it doesn't move, it will be tagged with graffiti.

B. **Bird droppings.** Yes, bird droppings. Bird droppings are something we rarely see in 3D images, yet they litter our city streets. We can expect to see bird droppings on nearly every horizontal surface in a city, particularly those of higher altitude such as lampposts, building ledges, signs, and fire escapes. In this image we see bird droppings on the lamp and wall. We can assume the bird would drop his payload over the side of the lamp as well so there should be some evidence of bird droppings on the wall and the sidewalk below. Of course, the Mystic is standing on the sidewalk droppings. It's a good thing he wasn't standing there earlier.

C. **Cracks.** Here's a great element for photorealism. Cracks are common in industrial environments, particularly those that have been around for a while. They are a very simple detail to add, yet they add a great deal to the credibility of the scene.

Figure 8.7 Photorealistic details for walls.

D. Horizontal dirt. Horizontal surfaces will collect dirt, dust, and grime. Therefore we need to add this grunge to our horizontal surfaces for the image to appear photorealistic. We would also need to add the runoff down the front and sides of the horizontal surface where rainwater has pulled the dirt down the side of the building.

Well, that does it for the major elements of detail for this segment of the image. Just two more regions of the image to explore, and we'll be done. Are you getting the feeling detail is important to photorealism? I can't stress enough how important the details are when creating photorealistic images. You can see how industrial images require a serious dedication to the details. You'll find natural environments are actually easier on the details but more complicated on the modeling and surfacing because they're completely organic. We'll be exploring the natural environments in Part Five, "Creating Natural Environments." For now, let's continue with our study of photorealistic details by taking a look at the street details in Figure 8.8.

Here we have a close-up of the street. One of the common problems we see in most 3D streets is an absence of chaos. Streets are full of chaos. Even in the cleanest part of the city they are still covered in dirt, oil stains, grease, and lit-

ter. Since a street occupies a great deal of our industrial images we need to insure we incorporate enough chaos and detail to make the street believable. Let's take a look at the details of the street in this image.

A. Garbage and debris. We can count on garbage lining city streets. There aren't too many citizens who take the time to locate a trash receptacle. Most of them throw the garbage out their car window. In the case of this image, the garbage would be concentrated around the Dumpster since we can expect they'd aim for it, just not always hit it.

B. Cement runoff. While cement is a sturdy surface, it does experience wear from constant use and exposure to the elements. This wear results in a cement powder building up on the surface of the sidewalk. When it rains this powder runs off onto the pavement. Of course, cement is mixed with water originally so when it's mixed with rainwater the powder tends to create a white film on the streets when the water drains away. This is a subtle detail of city streets but one that really adds to the realism.

C. Water runoff dirt stains. The streets and sidewalk are covered in a thin layer of dirt. When the rains come they wash this dirt off the sidewalk and into the sewers. When the water evaporates on the streets it leaves a thin film of dirt

Figure 8.8 Photorealistic city street details.

on the very edge of the drainage flow and a much lighter film where the bulk of the drainage flowed. This is another subtle element that really adds credibility to the image. I have yet to see this detail in a 3D image, yet it's on every city street after rainfall.

D. **Grease and oil stains.** This is a staple of city streets. Cars are constantly dripping grease and oil on the streets. Therefore, for our 3D streets to appear realistic we need to incorporate the occasional grease and oil stain. Later in this chapter we'll take a look at some tricks for creating grease and oil stains.

E. **Skid marks.** Skid marks are very common on city streets, particularly around corners. They are created by a number of factors including accidents, drunk drivers, reckless drivers, and kids who are joy riding. Regardless of how they are created, we should include them on our city streets to reinforce the photorealism. In this image the skid marks are relatively old since they would have had to drive through the Dumpster to create them if they were recent. Why is this important? Well, we need to pay attention to how we layer the details so they are realistic. For example, if we had placed the skid marks over the water runoff dirt stains it would have implied they were recent, which means the car would have driven through the Dumpster. You can see how that would have undermined the credibility of this image. It's a good idea to think through all of the chaos you intend to add before you create it so you can layer it properly.

ITEMIZE YOUR SURFACING CHAOS

Surfacing chaos is created in layers in reality. For example, first there might be an oil stain on the pavement, then a skid mark is added, one day it rains and residue is created, then oil is dripped on the residue. If we were to create the street for this example we would need to make sure the residue was on top of the first oil stain and skid marks. If we didn't, we might undermine the photorealistic credibility of our image. Always itemize your surfacing details before you create them so you can plan how to layer the details.

It's easy to see how a few simple details can really add to the credibility of 3D city streets. I don't think you'll be able to find a city street in reality that comes even close to being black, or even a consistent tone, unless it has just been poured. To create realistic streets we need to add a plethora of chaos. Of course, this can be a bit tricky when working with large streets, but we'll take a look at some great techniques for adding grime to city streets later in this chapter. Right now, let's take a look at the details in the final segment of our city street image, shown in Figure 8.9.

A. **Skid mark.** Here's a great detail. Most sidewalks will have a skid mark on them, caused by parking errors or people turning too hard on a corner. In

Figure 8.9 One final look at city street details.

the case of our image the driver was doing a U-turn too quickly and rode up on the sidewalk, leaving a skid mark.

B. Dirt in the cracks. Dirt collects in the cracks of the pavement. When it rains this dirt is drawn up with the water. When the water evaporates it leaves dirt residue around the cracks. This is an important element of sidewalks. Obviously, the amount of dirt depends on the location of the sidewalk and the amount of precipitation. Let's face it, a rainy city is actually quite clean considering the rain washes away all the dirt.

C. Cracked and chipped pallet. Pallets are a great element for industrial street scenes. They are often left behind by deliveries of bulk material. If you plan on putting a pallet in your street scene you should take the time to damage the pallet. A perfectly clean pallet with no damage will be out of place in a city street. You should always take a few chunks out of your pallet.

D. Grime on walls. When it rains in the city, moisture collects at the base of the walls where the standing water resides. This water creates humidity that bleeds up the wall. This humidity collects dirt, creating a grungy spot at the base of the wall. This portion of the wall is also commonly damaged by the humidity, which tends to darken it.

E. **Consistent aging.** It's important to create consistent aging in your city scenes. For example, the car is aged to blend with the environment. It's unlikely a new car would be parked in this part of town. It's not out of the question, but if you did park a new car here you would need some form of justification since it would appear out of place in the image. Typically, run-down parts of a city have run-down cars, and everything else for that matter. You should try to maintain a consistency with your aging to make the image more believable.

Well, we're finally done exploring the photorealistic element of the image in Figure 8.1. Of course, there are actually far more than the 30 details we discussed, but you get the idea. You can never be too neurotic about details when creating photorealistic images. In fact, if you make an effort to include the elements we discussed in your city streets you'll be well on your way to achieving photorealism.

Now that we've covered some of the elements that make up a photorealistic city street, let's try our hand at creating one of them.

Creating City Street Elements

While most elements in a city street scene, such as the buildings, street, and sidewalk, are easy to create, some can be a little challenging, like a chain-link fence. Of course, it's the challenging objects that really catch our eyes when viewing an image. No matter how we may surface our street, the chain-link fence will be more captivating due to the intricate detail. While we could simply use a filter map on a flat plane to create the illusion of a chain-link fence, it really won't be photorealistic because it won't have depth. Instead, we should model the fence to insure we really wow the viewer. Okay, so how do we go about modeling a complex object like a chain-link fence? Well, let's take a look.

EXERCISE: MODELING A CHAIN-LINK FENCE

1. Open your modeling program. We're going to start by creating one vertical segment of the fence, and then we'll clone it. To start the vertical segment, you'll create a single bend in the segment and clone it. Basically, we'll be making liberal use of cloning to save ourselves a great deal of time. To start the bend, create a simple rectangle object with eight vertical segments as shown in Figure 8.10.

2. Now we need to move the segments to where they are needed. You're going to have to build concentrations of polygons in two areas so you can bend the mesh. Arrange the polygon segments so there are three at the top, two in the middle, and one at the bottom as shown in Figure 8.11.

Figure 8.10 Starting the fence.

Figure 8.11 Moving the segments.

3. Now we're ready to start shaping the segment. First, select the two polygons in the middle and pull them out to the left side from the z viewport. Then select the top row of points, or vertex, and rotate it inward a bit to create the top of a bend. Now repeat the same step for the lower vertex to create the bend shown in Figure 8.12.

4. The next step is to create the bend along the z-axis so this segment of the fence will link with another. To do this, select the two rows of points just above the bottom one in the bend, then select the lower row of points on the top of the segment and move them to the left in the x viewport as shown in Figure 8.13.

5. You now have a nice bend that allows the segments to link, but you have some hard corners that need to be smooth, so zoom in on the first bend you made and select the middle row of points. Then rotate them forward as shown in Figure 8.14.

6. Now we have a smooth bend in this joint. The next step is to smooth the bend at the top. Zoom in on the top of the segment and rotate the two rows of points just under the top to the right a bit and them move them down slightly to create the smooth bend shown in Figure 8.15.

Figure 8.12 Bending the segment.

Figure 8.13 Adding the bend.

Figure 8.14 Smoothing the bend.

Figure 8.15 Smoothing the bend at the top.

7. Great, you now have a completed segment for your fence. I know it doesn't look like much now but it will shortly. The next step is to clone this segment vertically to create half of the completed link. There are two ways we can clone it, automatically or manually. It really depends on the tools you have available. Before we start cloning it, select the polygon at the very top and bottom of the segment and delete them. You won't need them because they will be in the middle of your link when you create the clones. We're going to use the automatic cloning method to create our clones. If you don't have it, don't worry, I'll cover the manual method next. Before you clone the segment you need to measure the distance from the top to the bottom of the segment as shown in Figure 8.16.

8. In my case, the distance is 4 inches. Now select your clone tool and create 24 clones along the y-axis with an offset on the y equal to the height of your segment. I used an offset of 4 inches on the y-axis. When finished you should have something similar to Figure 8.17.

9. If you don't have access to automatic cloning you'll have to copy the segment and paste it on top of the original. Then repeat this process until you have 24 segments vertically. Either way you clone it, you'll need to merge the points where the clones meet. This can easily be done using a merge function. If you have an absolute value option, you may need to use this to

Figure 8.16 Measuring the segment.

Figure 8.17 Cloning the segment.

properly merge the points since they may not be directly over each other. An absolute value merges points within a spherical space around the points. The size of the sphere is determined by the absolute value. It will take some tweaking to find the right value, since one that is too high might weld your segments into a blob.

10. We now have part of our link completed. The next step is to clone this segment, rotate it 180 degrees, move it to the right and position it so it's lined up with the original segment as shown in Figure 8.18. The figure is zoomed in so you can see how your new clone should appear.

11. Now simply select the clone on the right and move it to the left so it bends in the middle overlap as shown in Figure 8.19.

12. Great, now we have a completed vertical link for our fence, which we can clone to create the fence segment. Of course, before we do this we need to tweak the top and bottom of the link. You want to leave one segment of polygons sticking out on either side at the bottom and top so zoom into the bottom of the links, select the excess polygons and delete them. You should now have something similar to Figure 8.20.

13. Now place a polygon at the bottom of the two extensions to cap them.

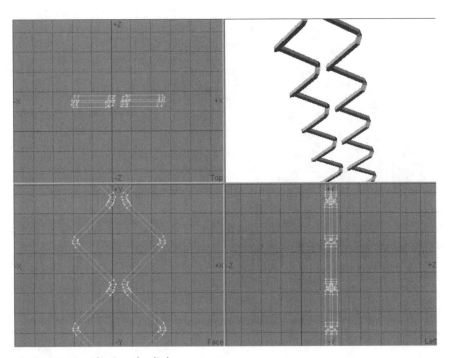

Figure 8.18 Cloning the link segment.

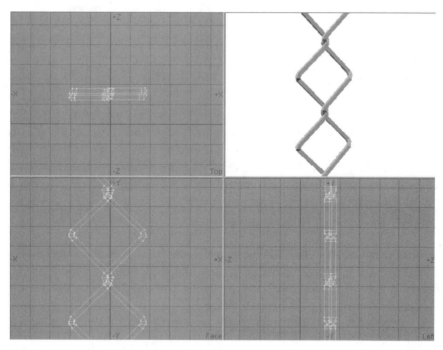

Figure 8.19 Overlapping the segments.

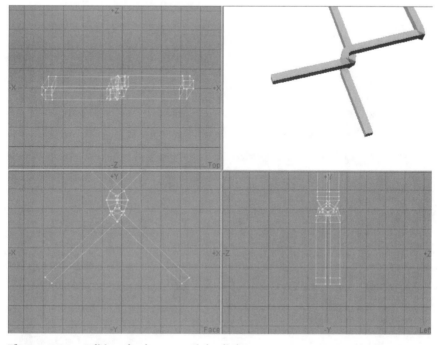

Figure 8.20 Editing the bottom of the links.

14. Next, zoom into the top of the links and repeat the last two steps.

15. The link is now complete, which means you're ready to clone it. You need to make 30 clones of the link to complete the segment of fence. To create the clones, measure the distance between the inside of the bends as shown in Figure 8.21.

16. My distance measured 3.3 inches. To make the clones, select the clone option and set the number of clones to 30, and then set the x offset to the distance you just measured. Be sure to set the y offset back to zero before you clone or your fence will climb vertically off the screen. When you are done with the cloning you should have something similar to Figure 8.22.

Excellent, we now have a very detailed chain-link fence. Figure 8.23 shows a close-up OpenGL preview of the links.

It looks great doesn't it? This mesh will now cast awesome shadows in a scene and will give you great depth in your images. Of course, the fence isn't quite finished yet since we don't have any poles to hold it in place, so let's complete this fence section by making our poles.

EXERCISE: CREATING THE FENCE POLES

1. Create a cylinder on the left side of the links that is about the diameter of one link and slightly taller than the links as shown in Figure 8.24.

Figure 8.21 Measuring the cloning distance.

Figure 8.22 The cloned links.

Figure 8.23 An OpenGL preview of the links.

Figure 8.24 Creating the first pole.

2. Now we need to top the pole so zoom in on the top, and then create a 32-point disc on the z-axis as shown in Figure 8.25.

3. Make sure the disc is lined up with the center of the pole on the x and z axes. We're going to edit this disc to create the pole topper. First, select all of the points on the left side of the disc and delete them. Then, using your drag tool, move the points on the right side to form a cylinder base as seen in Figure 8.26.

4. Be sure to create a bevel on the outer cylinder by placing points at a 45-degree angle next to the top and bottom of the cylinder. This will create a bevel when you lathe the object. Speaking of which, do a lathe on the y-axis with 36 segments. Make sure you are using the center of the topper as the reference point for your lathe. When finished, you should have a topper like the one in Figure 8.27.

5. Now we're ready to make the T-bars. Select the pole you created earlier and make a clone. Then scale the clone to be the diameter of the topper and reduce its size vertically so it's 1/12 the height of the original pole. Now move it to the top as shown in Figure 8.28.

6. To make the T-bar more realistic, you'll need to add a bevel to the top and bottom so you have specular highlights. Create a small bevel at the top and bottom of the T-bar as seen in Figure 8.29.

Figure 8.25 Starting the top.

Figure 8.26 Creating the bottom of the topper.

Figure 8.27 The completed topper.

Figure 8.28 Starting the T-bar.

7. To complete the T-bar, make a clone of this segment and rotate it 90 degrees clockwise as shown in Figure 8.30.

8. Now select the polygons on the left end and move them to the middle of the vertical bar, then delete them. We don't need to waste system resources on polygons we can't see. The completed T-bar should resemble Figure 8.31.

9. Of course, we need to have something to attach the T-bar to the pole, so you should add some rivets. Create a low-resolution primitive sphere and size it to be about one-quarter the diameter of the T-bar vertical pole. Now place the sphere near the top of the T-bar vertical pole so half the ball is penetrating the pole. Then make two copies and place them at the other two ends of the T-bar as shown in Figure 8.32.

10. Now mirror the rivets along the z-axis to create the rivets on the backside as seen in Figure 8.33.

11. Next, select the completed T-bar, with rivets, and make a clone. Then move the clone to the bottom of the pole as seen in Figure 8.34.

12. Now select the T-bars and pole and mirror them to the other side of the links as seen in Figure 8.35.

Figure 8.29 Beveling the T-bar.

Figure 8.30 Making the horizontal bar.

Figure 8.31 The completed T-bar.

Figure 8.32 Adding the rivets.

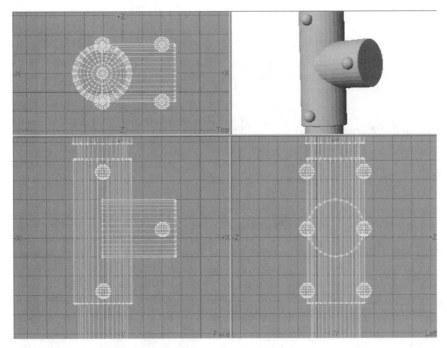

Figure 8.33 Completing the rivets.

Figure 8.34 Placement of the second T-bar.

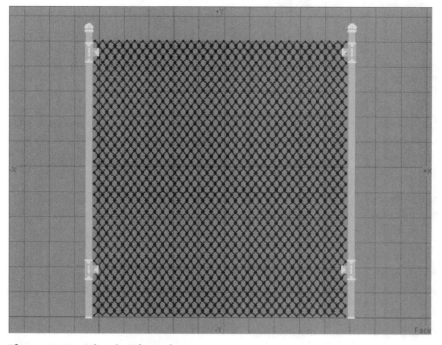

Figure 8.35 Mirroring the pole.

13. Then make a copy of the original pole, rotate it 90 degrees clockwise, and place it between the top T-bars. Use your stretch tool to shorten the pole so it fits between the T-bars. Now clone this bar and place it between the lower T-bars as shown in Figure 8.36.

14. Great, now the last step is to select the entire pole structure and move it so the links are flush against the back of the horizontal poles as seen in Figure 8.37.

15. Well, that wasn't too bad. Now save your object as fence. Creating photo-realistic models can take a bit of time but the results are well worth the effort as you can see by the OpenGL preview of the fence in Figure 8.38.

This image certainly has plenty of realistic detail and depth. This fence will now serve you well in your efforts to make photorealistic city streets. Of course, it was probably one of the most complicated objects you'll ever need to make—well, other than a car, which would be great to cover, but that is a healthy amount of effort and we just don't have that many pages. I think we'll wait until we have more room to cover such a tutorial, like possibly my next book on photorealism.

Okay, now that we've conquered one of the more complicated city street objects, let's take a look at how to tackle some of the problems associated with adding grunge to city streets.

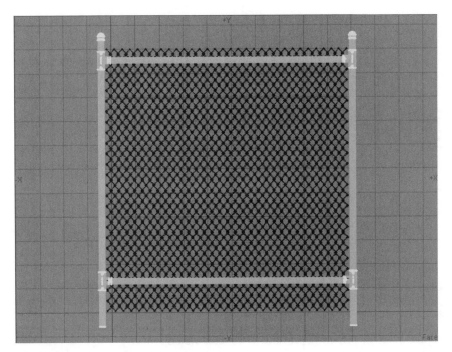

Figure 8.36 Completing the crossbars.

Figure 8.37 Positioning the poles.

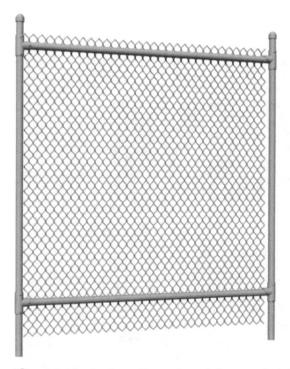

Figure 8.38 An OpenGL preview of the completed fence.

City Street Surfacing Tricks

City streets present a number of surfacing challenges, but the greatest challenge is adding dirt and grime globally without killing your computer with an outrageous volume of image maps in memory. Fortunately, there is an easy method for saving system resources by using an alpha image map for a dirt layer. Basically, you create an image map for the dirt and use an alpha image map to filter it, just as we did with the rusty can in Chapter 6, "Creating Detailed Image Maps."

There are two ways to use an alpha map for dirt. The first method is to create an alpha-mapped dirt image map that's the same size as the underlying color image map. The second is to apply alpha maps with specific grunge over a tiled image map, which is a great way to conserve system resources. Of course, only a few 3D programs can manage this, so we'll explore this method after we try our hand at the first. Let's take a look at how we create alpha-mapped dirt.

EXERCISE: CREATING ALPHA-MAPPED DIRT

1. In this exercise we'll be creating dirt for a segment of sidewalk. In the chapter8 folder on the companion CD-ROM you'll find a file called sidewalktemp.jpg. Load this file into your painting program. This is the template for a segment of sidewalk you'll be surfacing in a moment. It should look like Figure 8.39.

2. Now create a new layer called dirt. Then select the airbrush, set the pressure to 10 percent, and set the brush size to 65 pixels. Now set the color to RGB 86, 53, 13 and paint a few strokes around the perimeter of the image as shown in Figure 8.40.

3. This will create the base coat of dirt. This is the loose dirt that has been spread by the wind. The next step is to paint the hard dirt stain. To do this, select a brush size of 27 pixels and paint several strokes around the outside edge, making a darker band. Now apply some additional strokes to the places where the cement has been chipped away. These areas will hold more dirt, so we want to make them darker. You should now have something similar to Figure 8.41.

4. We're almost done with the dirt. It's actually quite easy to add dirt. The last step is to add some noise to break up the dirt so it doesn't look like we airbrushed it on the sidewalk. The airbrushed look is very common in 3D images because that's basically what we're doing. Unfortunately, that's not what happens in reality, so we need to add some chaos to eliminate the airbrushed look. To do this, select Filter/Noise/Add Noise and enter the following settings:

Figure 8.39 The sidewalk painting template.

Figure 8.40 Painting the first layer of dirt.

Figure 8.41 Adding the hard dirt.

Figure 8.42 Adding noise to the dirt.

Figure 8.43 The completed alpha map.

Figure 8.44 The final dirt image map.

- Amount: 13

- Distribution: Gaussian

- Monochromatic: Selected

This creates a scatter effect, which will make the final effect much more realistic. You should now have something similar to Figure 8.42.

5. Well, we're done with the dirt now. It's really that simple. The final step is to create an alpha map so you can filter the dirt. To do this, duplicate the dirt layer, rename it alpha, and then deselect the dirt layer. Now select the alpha layer and select Image/Adjust/Hue/Saturation and set the lightness to +100. This will convert the brown to white, which is what we need to filter the brown dirt. The last step you need is to add a black layer for the background of both the dirt and alpha layers. Create a new layer named black just above the background layer and fill it with black. You should now see the completed alpha map, which looks like Figure 8.43.

6. Save the file as sidewalk and then save a copy as sidewalkalpha.jpg. Deselect the alpha layer and activate the dirt layer. The dirt should now have a black background, which is your completed dirt map shown in Figure 8.44.

7. Now save a copy as sidewalkdirt.

8. Okay, we now have our completed image maps. Let's test them to see if they work. Open your rendering program and load the sidewalk.3ds file located in the chapter8 folder on the companion CD-ROM. Then load the cement.jpg image in the same folder. Now load your sidewalkdirt.jpg and sidewalkalpha.jpg image maps.

9. Select the cement surface color channel, and apply the cement.jpg as a planar map on the y-axis. Don't worry about the stretching down the sides of the sidewalk since it will be hidden by the other sidewalk tiles. Now add another channel to the color layer and apply the sidewalkdirt.jpg as a planar map on the y-axis. Then apply the sidewalkalpha.jpg image maps to the alpha channel as a planar map on the y-axis. Great, we have now added the dirt to the cement. Let's continue to surface the cement.

10. Select the bump channel and apply the cement.jpg as a planar map on the y-axis, then set the bump value to 100 percent. To create a truly realistic surface you should add a small fractal bump to rough up the cement.

11. Here's where a diffusion map becomes very useful. Diffusion allows us to make the dirt rich and natural. If you have diffusion, apply the cement.jpg as a planar map on the y-axis and set the opacity to 20 percent. Now add another channel to the diffusion layer and apply the sidewalkdirt.jpg as a planar map on the y-axis. Then apply the sidewalkalpha.jpg image maps to the alpha channel as a planar map on the y-axis and set the opacity to 50 percent.

12. Set the specularity to 15 percent and glossiness/hardness to 16 percent.

13. Now save the model and do a test render to check your results. You should end up with something similar to Figure 8.45.

Very nice, we now have a photorealistic dirty sidewalk tile, which we can use to create a city street scene by simply tiling the model as discussed in Chapter 3, "Adding Depth with Seamless, Tileable Models."

As you can see, using an alpha map is a great way to add dirt to your city street surfaces. Of course, the sidewalk tile was a relatively simple situation since it was tileable and didn't eat up much memory. On the other hand, the image map for a city street can be huge if you are using a single image map for the entire street. While you can tile an image map to save system resources you now run into the problem of creating specific details like oil stains, skid marks, grime, and water residue. You don't want to tile the details since they will be painfully obvious.

You could always create a huge image map for the street but that would be a major abuse of memory. Why don't we just use a smaller image map? Well, we need to use a higher-resolution image map so the surface doesn't break up when we render it. If the image map is too small, it will be pixelated when it renders because it's being resampled up to fit. Okay, so what do you do to solve the problem?

There is one solution that works very well: using alpha-mapped details. By using an alpha map, we can apply details to specific regions of the street with-

Figure 8.45 The surfaced sidewalk tile.

out having to create a giant image map. You apply the main color map as a tiled image map, and then create a planar map with the dirt using an alpha map. And the best thing is the alpha-mapped dirt doesn't have to be big, it can be small since dirt doesn't have any details that will be pixelated when resampled. It's really a very efficient way to add grunge to huge surfaces. Let's see how to use tiled textures with alpha-mapped dirt.

EXERCISE: USING ALPHA DIRT MAPS OVER TILED COLOR MAPS

1. In this exercise we'll be creating dirt for a large street object. In the chapter8 folder on the companion CD-ROM you'll find a file called streettemp.jpg. Load this file into your painting program. This is the template for the street you will be surfacing in a moment. It's only a simple white image because the street is void of any real detail.

2. To make your painting process a bit easier you should fill the background with your pavement texture. You won't be saving the dirt with this texture; you're just using it to make sure the details we paint work properly. Load the pavement.jpg image map located in the chapter8 folder on the companion CD-ROM. Then choose Select All and select Edit/Define Pattern.

3. Now select the streettemp.jpg image and fill the background with the pattern. You should now have a nice pavement background as shown in Figure 8.46.

Figure 8.46 Filling the background with pavement.

4. Now we can begin to create the grunge for our street. We'll start with some oil stains. Add a new layer named grease. Select the airbrush tool and set it to 6 percent pressure with a brush size of 65 pixels. Next set the color to RGB 86, 53, 13 and paint two spots in the middle of the image. This is the foundation of an oil stain. Oil stains are black in the middle and dark brown on the outside. These spots represent the brown area. Now set the color to RGB 80, 65, 57 and paint a spot right in the middle of the ones you just painted, as seen in Figure 8.47.

5. This is the black center. Yes, the black and brown are light, but that's because we haven't added the magic yet. Now it's time to add some grunginess to the oil stain, which is easily accomplished with the burn tool. Actually, the burn tool is your best friend when it comes to aging your surfaces. It's perfect for creating oil, grease, dirt, and general grime. In fact, let's use it now. Select the burn tool and set the exposure to 28 percent. Then select a 65-pixel brush and burn the oil stains until they are grungy like the ones in Figure 8.48.

6. You're off to a great start. The next step is to make some skid marks. You'll do it the same way as you did the oil stain. We'll paint a base color and then burn it for the effect. Select the airbrush tool with a 65-pixel brush, and then paint two broad strokes as shown in Figure 8.49.

7. Now select the burn tool and make some strokes over the skid marks to deepen their color as seen in Figure 8.50.

8. As you can see, adding grunge to the street is actually quite simple. It's a matter of painting a base color or two and burning it. Now we need to add some overall weathering of the street, which means we add random light and dark spots. To do this, select the airbrush tool and set the brush size to 100 pixels. The pressure should still be at 6 percent, which is what we want. Now set the color to white and drop down some random spots on the pavement. Then set the color to black and drop down some additional spots so you have something similar to Figure 8.51.

9. Well, we're just about done with the aging now. All you have to do now is add the dirt film where the water drainage would flow on the upper portion of the pavement. First, create a new layer named dirt, then select the lasso tool and select the top portion of the image, making the bottom part of the selection wavy. Now feather the selection with a feather radius of 5 pixels, and then fill it with RBG 86, 53, 13. Of course, this dirt is a bit dense. What we want to do is combine the dirt with the layers below so set the layer to soft light and the opacity to 33 percent. You should now have something similar to Figure 8.52.

Notice how natural the dirt appears on the pavement. Using soft light with layers is a great way to create natural aging.

Figure 8.47 Creating oil stains.

Figure 8.48 The completed oil stains.

Figure 8.49 Creating the skid mark foundation.

Figure 8.50 The completed skid marks.

CREATE NATURAL AGING

To create realistic aging you need to blend the grunge with the surface you are aging. Soft light does an excellent job of blending layers naturally. You should always blend your layers to create natural effects. Using normal layer settings will result in unnatural effects, since the colors won't be "blended," but rather simply layered. Use layers with soft light to create natural aging.

10. The last step in creating the dirt residue is to create a hard line of dirt where the water flow would stop on the outside edge. Add a new layer called dirt2 and make a narrow selection along the edge of the dirt you just created. Then fill it with the current color and the layer to soft light with an opacity of 33 percent. This will blend the dirt as shown in Figure 8.53.

Figure 8.51 Adding random aging to the pavement.

Figure 8.52 The dirt film.

Figure 8.53 The hard dirt.

Figure 8.54 Merging the layers.

Figure 8.55 Lightening the dirt film.

Figure 8.56 The completed grunge alpha map.

11. Okay, now we're ready to wrap up the dirt. Start by deselecting the background layer and then merging all of the foreground layers as shown in Figure 8.54.

12. Name the merged layer grunge and reselect the background layer so we can see it behind the grunge. Then select the grunge layer and pick the dodge tool. Now set the exposure to 16 percent, pick a 35-pixel brush, and dab some random strokes over the dirt film to lighten it in spots as seen in Figure 8.55.

13. We're almost done with the grunge. The last step is to add some noise to break up the grunge so it doesn't look like you airbrushed it. Select Filter/Noise/Add Noise and enter the following settings:

 - Amount: 13
 - Distribution: Gaussian
 - Monochromatic: Selected

14. Great, now you're done with the grunge! Next, we need to create an alpha map so we can filter the grunge. Duplicate the grunge layer, rename it alpha, and then deselect the grunge layer. Now select the alpha layer, select Image/Adjust/Hue/Saturation, and set the lightness to +100. This will convert the grunge to white, which is what you need to filter the grunge. Finally, we need to add a black layer for the background of both the grunge and alpha layers. Create a new layer named black just above the background layer, and then fill it with black. You should now see the completed alpha map, which looks like Figure 8.56.

15. Save the file as street and then save a copy as streetalpha.jpg. Next, deselect the alpha layer and activate the grunge layer. The dirt should now have a black background, which is our completed grunge map shown in Figure 8.57.

16. Now save a copy as streetgrunge.jpg.

17. Okay, we now have our completed image maps. Let's test them to see if they work. Open your rendering program and load the street.3ds file located in the chapter8 folder on the companion CD-ROM. Then load the asphalt.jpg image in the same folder. Now load your streetgrunge.jpg and streetalpha.jpg image maps.

18. Next select the street surface color channel and apply the asphalt.jpg as a planar map on the y-axis. Set it to repeat eight times horizontally and five times vertically. Now add another channel to the color layer and apply the streetgrunge.jpg as a planar map on the y-axis. Set it to fit to the entire size of the surface. Then apply the streetalpha.jpg image maps to the alpha channel as a planar map on the y-axis. Great, we have now added the grunge to the pavement. Let's continue to surface the street.

Figure 8.57 The final grunge image map.

19. Select the bump channel and apply the asphalt.jpg as a planar map on the y-axis, then set the bump value to 100 percent. Now set the image map to repeat eight times horizontally and five times vertically. Then to create a truly realistic surface you should add a small fractal bump to rough up the cement.

20. Now here's where a diffusion map becomes very useful. Diffusion allows us to make the grunge rich and natural. If you have diffusion, apply the asphalt.jpg as a planar map on the y-axis and set the opacity to 20 percent. Then set the image map to repeat eight times horizontally and five times vertically. Now add another channel to the diffusion layer and apply the streetgrunge.jpg as a planar map on the y-axis. Size the map to the full size of the surface. Then apply the streetalpha.jpg image maps to the alpha channel as a planar map on the y-axis and set the opacity to 50 percent.

21. Okay, the final step is to set the specularity to 15 percent and the glossiness/hardness to 16 percent.

22. Now save the model and do a test render to check your results. You should end up with something similar to Figure 8.58.

Figure 8.58 The surfaced street.

Very nice, we now have a photorealistic grungy street and we didn't have to kill our computer to do it. The grunge image maps are rather small in comparison to what they would normally need to be to surface the street. Typically they would be 3,000 pixels wide to do the job, but we can get away with an 800-pixel-wide grunge image since grunge can resample infinitely without losing its quality. After all, the image is simply a few blended colors, which won't cause pixelization when resampling. The 800-pixel image is only 33 KB, while the 3,000 pixel version is more than 250 KB, more than seven times as big. Now take into consideration the use of our tileable asphalt image. The asphalt tile is only 299 KB, while a single image map for the street would be 3.7MB, more than 12 times the file size.

You can see how the use of tileable image maps and alpha-mapped dirt can really save your system resources, not to mention your sanity. It also gives you a great deal of flexibility in changing the details since the grunge isn't combined with the asphalt image map. Now you can tweak the opacity of the grunge image maps to change the density of the grunge on the street. It's really a very useful technique, which you should use whenever the opportunity arises.

Wrap Up

Well, that was quite an adventure. We've covered a lot of ground this chapter. I'd say we now have a firm grasp of the details of a photorealistic city street. It's really all about attention to detail. Every little detail makes a difference when you are re-creating reality. Surfacing is one of the real tricks to creating photorealistic streets, and we explored the most powerful technique for aging industrial scenes, alpha-mapped dirt. You can't go wrong by using alpha maps to add dirt to your surfaces. It saves you both time and system resources, which you can never have too much of.

Before we jump into the next chapter and take a detailed look at creating natural environments, let's take a break and clear our heads. One of the most important tools you need to create photorealistic images is a clear head. We can't focus on the details when we can't focus our eyes, so take this opportunity to cool your jets with a break.

I'll see you in the next chapter.

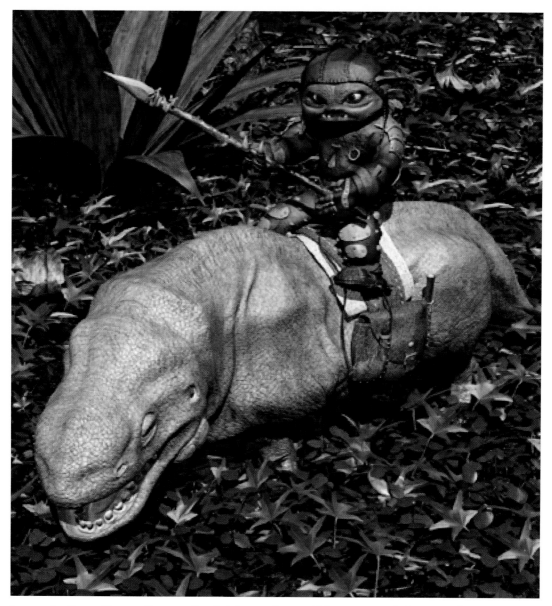

Image 1 **TROLL HUNT.** Grumpy, the Goblin warrior, and his trusty steed, the Komodosaur, are on a Troll hunt in the rain forest of the great Goblin Island in Lake Victoria, near Tanzania, Africa. Goblins are constantly at war with Trolls because Goblins capture baby Trolls, strap them to the ends of sticks, and use them as weapons. You see, baby Trolls aren't exactly the sweetest babies you'll meet. They bite everything in sight, which makes them a great weapon, particularly since they bite adult Trolls.

➢ **CREATING THE IMAGE:** The ground cover in this image was created using tileable models, which we discuss in Chapter 4, "Creating Tileable Ground Covers." We created a simple square of vines, then cloned it to complete the scene. The vines were manually moved away from the legs of the Komodosaur on each tile, as discussed in Chapter 5, "Displacement Map Effects."

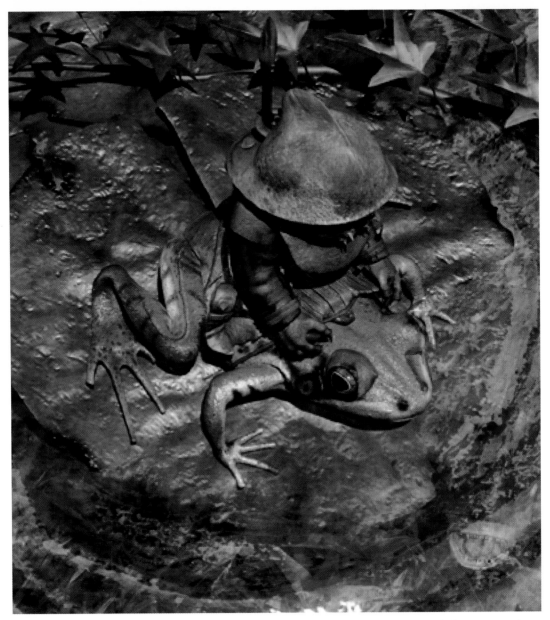

Image 2 GROIN THE SPY. Groin the "Goblin" is riding on *his* trusty steed, which happens to be a Wood Frog. Groin isn't actually a Goblin; he's a salamander posing as a Goblin to spy on the Goblins for Batra the Frog Czar. There is a long-standing feud between the Goblins and Batra. Goblins like to eat frogs, which of course doesn't appeal to a frog like Batra. Frogs and Goblins don't get along, so seeing a Goblin riding a frog is a dead giveaway that something is amiss, though the Goblins aren't bright enough to figure it out.

➢ **CREATING THE IMAGE:** The brown murky water in this image was created using a planar map on the surface of the water. The realistic water depth created in this pond was achieved using multiple transparent planes stacked vertically, and the wonderful chaos under the water was created using tileable vine models. All of these techniques are discussed in Chapter 10, "Exploring Ponds and Puddles."

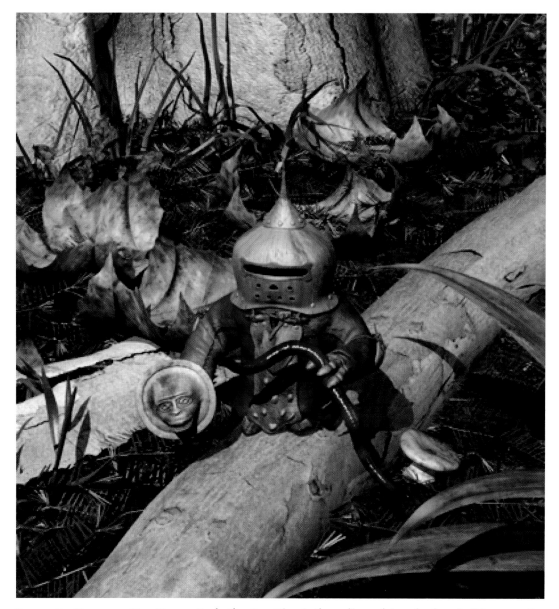

Image 3 DRALE THE BUG KING. Drale the Bug King is the self-proclaimed ruler of all bugs on the Goblin Island. He is on his way back from rescuing a worm that was about to be eaten by a salamander. The average Goblin is only five inches tall, making the prehistoric bugs giants in comparison. Goblins often find themselves appetizers for larger bugs, so they tend to avoid them. Drale, however, has befriended the bugs and has made it his personal mission to rescue them all from the perils of the other creatures on the Goblin Island, including the Frog Kingdom, which feeds mainly upon insects.

➢ **CREATING THE IMAGE:** The pine needle ground cover in this image was created using tileable models, which are discussed in Chapter 4, "Creating Tileable Ground Covers." We created a simple square of pine needles, then cloned it to complete the scene. The dead leaves were organically surfaced using morph target surface, which is covered in Chapter 7, "Morph Target Surfacing."

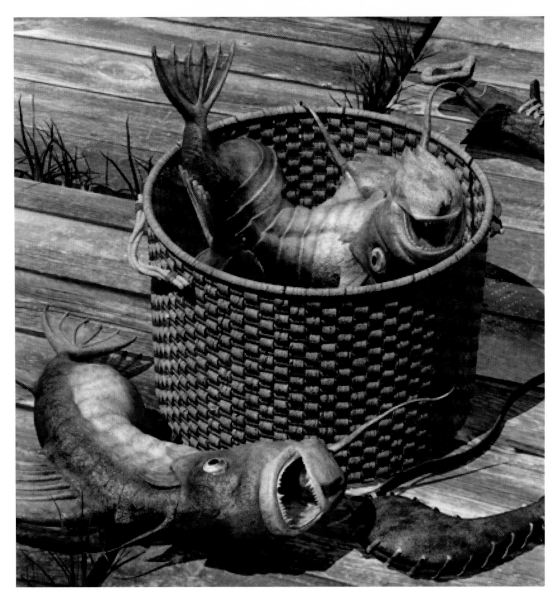

Image 4 Bladder Fish. A basket of Bladder Fish is a common sight on the Ruined Shore pier, owned by Grumpy the Goblin. In addition to being the greatest Goblin warrior, Grumpy is an avid fisherman. Grumpy sells the many types of fish he catches, including the freshwater Bladder Fish. The Bladder Fish is named for its unusually large belly, where it actually incubates the Goblin larvae of a species of Goblin called the Clonies. These little critters begin life as larvae. When they are eaten by a Bladder Fish, the larvae embed themselves in the walls of the belly where they incubate for two weeks until they are expelled by the fish as full grown Clonie Goblins.

➢ **Creating the Image:** The grass growing between the boards is one of the common elements seen in natural photorealism. We discuss the ten principles of natural photorealism in Chapter 1, "An Introduction to Photorealism." The leather bag in the upper right was surfaced using morph target surface, which is covered in Chapter 7, "Morph Target Surfacing."

Image 5 **MUNCH THE GOBLIN FISH.** Munch is a member of the only known Goblin fish species—*orblocaulus*. There are many large predators in Lake Victoria where this species originates, making survival for a friendly Goblin fish like Munch very difficult. To preserve their species, these chubby little fish evolved with large sacs that are used to capture swamp gasses. The gasses are lighter than air, making the fish float. Once they rise out of the water, they flap their fins like a hummingbird to move around. This is how they made it inland on the Goblin Island to the Great Goblin Lake, where they travel from pond to pond propagating their species.

➢ **CREATING THE IMAGE:** The leaves on the palm trees were surfaced using morph target surface, which is covered in Chapter 7, "Morph Target Surfacing." Morph target surfacing is the ideal method for surfacing complex organic shapes.

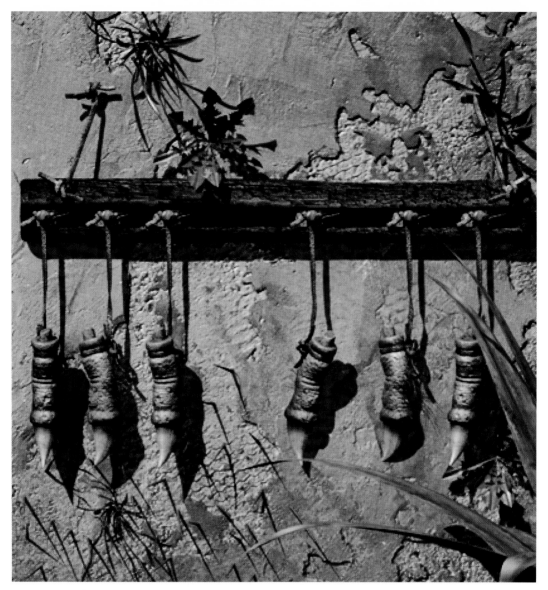

Image 6 GOBLIN ABACUS. Most Goblins are rather ignorant and quite goofy. There *are* a few Goblin geniuses, but even the most brilliant Goblins aren't terribly bright. Reckonin the Goblin mathematician is one of the more intelligent Goblins. He pioneered the first abacus to help him solve complex math problems. The only problem is he's used to counting on his fingers, so when he made the abacus he severed his fingers and hung them on the abacus to count. Of course, now he has trouble counting because he doesn't have any fingers to work the abacus.

➤ **CREATING THE IMAGE:** The clay wall was modeled using image map modeling, which we explore in Chapter 2, "Image Map Modeling." Image map modeling is an ideal method for rapidly modeling highly detailed objects. Instead of starting with a model and then creating the texture, we start with a texture and create the model to match. The wall was created from a photograph of packed clay, which was used as a modeling template.

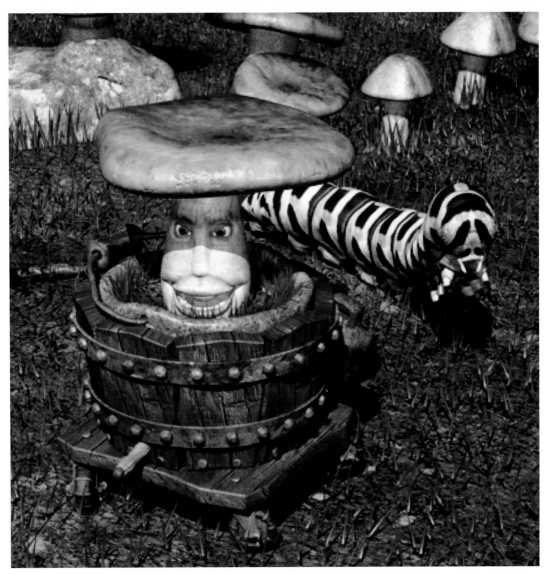

Image 7 BLEWIT THE UNFORTUNATE. The Great Mystics came to Earth in hopes of finding intelligent life to propagate their dying race. The Mystics had great powers. After thousands of years one of the Mystics died and was buried on the Goblin Island. Their bones are very magical, and enchant the dirt for miles when buried. Blewit is one of the unfortunate plants on the island that were brought to life by the enchanted dirt. He doesn't have legs, so he agreed to be Grumpy's chair in order to get around. He spends much of his day with a Goblin sitting on his head.

➢ **CREATING THE IMAGE:** The grass in the scene was created using object cloning, which is discussed in Chapter 5, "Displacement Map Effects." The depressions in the ground where the mushrooms are growing were created with displacement maps, also discussed in Chapter 5. Creating depressions in the ground for permanent objects is a must when creating photorealistic scenes. Fortunately it's rather simple to do.

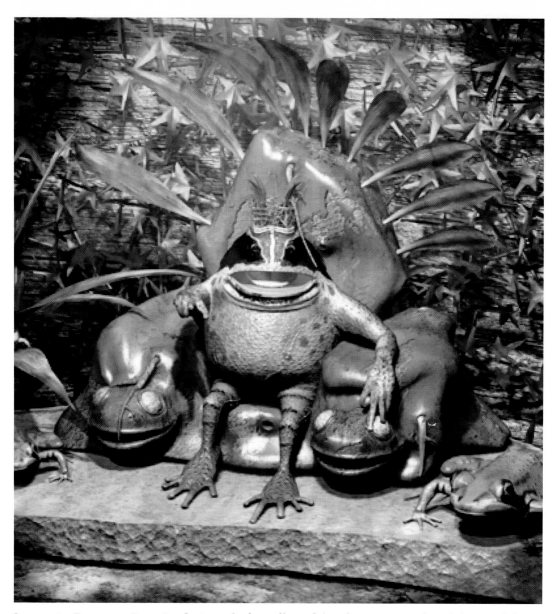

Image 8 BATRA THE FROG CZAR! Batra is the self-proclaimed Frog Czar, ruler of the amphibious kingdom, and one of the few Goblin frogs. In fact, he doesn't even know he's a Goblin. The humor lies in the fact that frogs aren't cognitive so they really don't pay any attention to Batra. While he does mobilize them for frequent wars, the frogs really don't do battle; they just jump around, inadvertently crushing everything. The Goblins are too ignorant to know the frogs aren't being malicious. Of course, Batra is too stupid to know the frogs are just being frogs, not warriors, so he thinks they actually worship him.

➢ **CREATING THE IMAGE:** The vines on the wall were created using tileable models, which are discussed in Chapter 4, "Creating Tileable Ground Covers." The yellow leaves on the throne were organically surfaced using morph target surfacing, covered in Chapter 7, "Morph Target Surfacing."

Creating Natural Environments

N atural environments are one of the most challenging scenes to create in 3D. It's not due to their complexity but actually the nature of their complexity (no pun intended). Nature is entirely organic, so there are no linear lines and flat edges—well, not many, anyway. This makes the task of modeling and surfacing natural objects significantly more complicated than industrial objects.

Of course, an industrial scene is actually far more complex to re-create than natural worlds. Industrial scenes are littered with chaos. There are countless small details on the streets, such as fire hydrants, chain-link fences, Dumpsters, cigarette butts, bottle caps, and the weeds that grow in the pavement cracks. This type of chaos doesn't exist in nature. Yes, there are plenty of plants, rocks, and trees in nature, but when you think about it, that's really all there is. We don't see the aging and corrosion of industrial worlds, nor do you see the litter—well, at least, you shouldn't.

Instead, we have organic chaos and plenty of it. Natural worlds are filled with plant life, which makes them challenging to re-create. You see we can get away with a scene that looks relatively planned in an industrial world because everything is manufactured, but in nature nothing can appear planned, or the image will be unrealistic. Therefore, to create photorealistic natural worlds we have to use complete chaos to ensure it doesn't look manufactured. This means we have to be very detailed in our staging and surfacing. Of course, we still need to apply some order to natural worlds to make them appear natural. While nature is chaotic, it's also ordered. Yes, it's a tricky line we walk when creating natural worlds, so let's turn the page and take a look at how we make a natural 3D world appear photorealistic.

COLOR FIGURES ON THE CD-ROM

Chapter 9 deals with color, so you should refer to the color figures in the chapter9/figures folder on the companion CD-ROM before continuing with this part.

Designing a Natural Scene

Natural worlds are very detailed, but their details are really limited to plants, trees, and rocks. Of course, there is also the dirt and water, but when you think about it, nature is really just a whole lot of a few objects. A forest is littered with trees. There may be several types of trees, but it's the volume that creates the chaos. Of course, the trees in a forest represent the buildings of an industrial scene. They support the scene, but they really don't carry the weight of the chaos and detail. It's the details on the ground level that create the chaos of natural settings, much the way it's the details of the city streets that make an industrial scene realistic. The weeds, rocks, twigs, and leaves of nature replace the garbage and clutter we see on city streets. The tree stumps replace the fire hydrants and the bushes replace the postal boxes and newspaper stands. Of course, natural scenes are much more cluttered than industrial scenes. We usually don't see city streets covered in trash, at least not in most cities. While the actual clutter details of city streets are more detailed, the volume of clutter in nature is much greater, making natural environments very resource abusive.

While creating natural environments presents challenges due to the volume of organic details, the wilderness doesn't have an abundance of surfaces to get dirty and worn. We're not going to see a lot of grease, grime, rust, and oil in nature, nor will we see a great deal of garbage—well, hopefully, we won't. Natural worlds are usually relatively clean. While they are covered in dirt, they don't have rusty, corroded, and grungy surfaces. We don't see bushes covered in dirt stains. The leaves may be dusty, but they aren't covered in grime. Of course, some places in nature are quite grimy, such as swamps and bogs, which are covered in fungus and other sticky things we prefer not to

experience, but these are usually isolated cases. For the most part, nature is free of grunge.

The first step in creating natural worlds is to observe the wilderness around us. We need to identify the key details that make a natural world believable. Certain details will make the natural scenes we create appear startlingly realistic. It's really all about attention to detail and observation. Before you begin to create your natural worlds, I recommend you explore the wilderness around you and take plenty of pictures. If you live in the city and don't have access to natural settings, I suggest you spend a great deal of time watching the Nature Channel on television or visiting the local library or parks. If you try to re-create natural settings from memory, you're going to miss those critical little details that make the scene undeniably realistic. We really need to immerse ourselves in the environment to capture the small details such as pebbles, ground covers, and twigs.

To get a better idea of the details we need to concentrate on when developing photorealistic natural worlds, let's take a look at an image of a natural 3D setting. Figure 9.1 shows the cover image from this book.

Here we have a shot of the Unfathomable Crag from the Great Goblin Gauntlet. Grumpy, the lead character of Goblin lore, is seen on a hunt for Shiny Things. Shiny Things are the currency of Goblins. Anything shiny has significant value, particularly metals, gems, and ores. This particular scene shows the fringe of the rain forest where it meets the Enchanted Desert. The Unfathomable Crag is a major icon in Goblin legend.

It's rumored that a young boy and girl Goblin were running though the forest when they fell into the crag. Goblins are very resilient creatures, so the fall didn't kill them, but the crag is miles deep and they couldn't climb out. They were forced to live out their lives in caves deep below the Earth's crust. The Goblin sweethearts eventually had children, and their community grew larger with each generation. There is now a whole community of Crag Dwellers that is said to feed upon the unfortunate Goblins who fall into the crag. It's said you can hear the screams of the Crag Goblins at night, which are meant to lure unsuspecting Goblins closer to the crag so they will fall in and feed the savage Crag Goblins.

Of course, the legend is only partially true. Yes, the sweetheart Goblins did fall into the crag, and they eventually expanded their family, but they don't eat the Goblins who fall into the crag. The new Goblins simply join the other unfortunate Goblins, who feed upon insects and crawfish from a freshwater spring. It's actually quite nice in the crag, a bit dark, but generally it's a pleasant place. The screams heard at night are actually sounds of celebration coming from the Goblins partying in the crag. Of course, the Crag Goblins don't

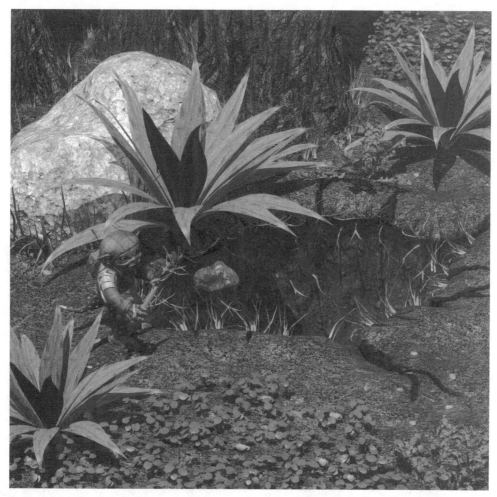

Figure 9.1 A photorealistic natural setting.

want this to be known because then there would be hoards of Goblins leaping into the crag to join the party, and there just isn't that much space, so they let the legend continue.

As you can see, the environment looks very realistic. It's riddled with the detail and chaos we expect to see in a natural world. We have random trees, scattered bushes and weeds, a chaotic ground cover, and dirt littered with rocks and twigs. It's actually a very detailed scene, yet there are really only a few types of objects in the scene. We have a tree, rock, clover ground cover, Guzloader (a prehistoric plant), and dirt. If this were a city street scene, we wouldn't have enough objects to make it appear realistic, but as a natural scene we have plenty of objects. The key is to have several of each object. Let's

take a closer look at the details to get a better idea of their importance. Take a look at Figure 9.2.

A. **Fringe grass.** One of the most common elements we see in natural settings is grass growing around the fringe of permanent objects. This is a very simple element to create—I'll show you how later in the chapter—but it adds a tremendous amount of chaos and detail to the scene. The simple grass has been wrapped around the rock, trees, and even the crag to make the image appear more natural and chaotic. Grass is one of the most important tools for creating natural realities. It's the most common element in natural settings. It comes in a wide variety of visual forms and is extremely easy to create.

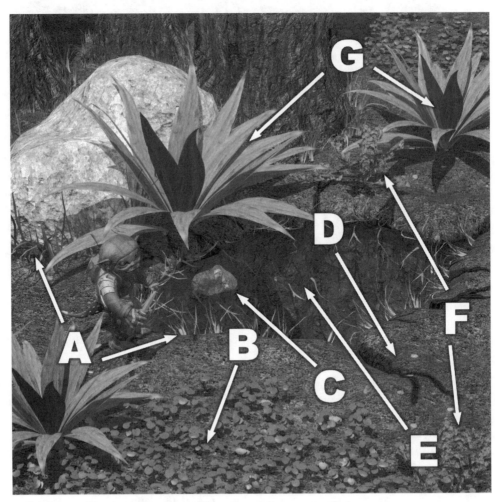

Figure 9.2 A closer look at the details.

USE GRASS TO ACCENT NATURAL SETTINGS

■■■■ **Grass is the most common weed found in nature. In fact, it can be considered nature's accessory. It's a very easy object to create, and it adds an amazing amount of chaos and detail to your images. Of course, when using grass, you have to be careful where you place it. Grass in nature typically grows around permanent objects such as large rocks and trees. You don't want to use too much of it in the open areas of your scenes since grass needs plenty of moisture to survive, and open ground doesn't retain much moisture. The grass grows around permanent objects because they trap moisture. Of course, random grass in the middle of a ground cover makes perfect sense because ground covers trap moisture.**

B. **Ground cover.** Ground cover is a staple in most natural settings. While it may not always be thick and abundant, there is most certainly some form of ground cover. It's a necessity for survival of surrounding plants. Ground cover traps the moisture of the soil so it won't evaporate, thereby retaining the precious water needed by the surrounding plants. About the only place where you won't find a ground cover is a desert, and even deserts have ground covers, just very stark ones since the soil is very dry. The ground cover in this image is a perfect example of how Mother Nature creates her ground covers. Notice how the coverage is uneven. Dense and barren spots occur randomly through the clover. This detail is important for making the ground cover believable. Let's face it, ground covers are only consistently dense in industrial worlds. The grass covering our front yards and parks is very dense because we engineered it that way. A grassy field in reality is very thin and not evenly distributed. The wind isn't terribly particular about where it blows the seeds. If you want to create convincing ground covers, they need to have spots where the density varies dramatically.

In addition to random density, you should also add plenty of random chaos to the size and rotation of the ground cover details. The clover in this image was made chaotic by applying a fractal noise displacement as we discussed in Chapter 5, "Displacement Map Effects." You should always add chaos to your ground covers so they don't look too perfect.

C. **Random rocks.** Nature is full of random rocks. They are perfect elements to accent your natural settings because they are easy to create in abundance. They are also easy to surface because they don't have too many specific details. Now, typically, a rock like the one illustrated would be dirty from being buried in dirt, but this rock is clean because it's exposed to the natural elements such as rain and wind. It's been washed clean over the years by the elements and will eventually fall below when the dirt is eroded away. Of course, this is likely to reduce the Goblin population below when it hits one of them on the head.

D. **Bare spots.** While the ground is covered in a short moss, it has numerous bare spots, which are critical for photorealism. Nothing grows consistently in nature. There will always be dense and light spots for ground covers or any other plant life, such as trees. There will always be a clearing in a forest since trees do not grow with an even distribution in nature. In this example, the moss texture is random, covering much of the ground but exposing random areas to make it more natural. To reinforce the natural chaos, small pebbles have been added to the bare spots to break up the dirt texture. We can assume that some pebbles will be visible in the bare areas where the dirt has eroded away from exposure to the elements.

INCLUDE BARE SPOTS IN GROUND COVERS

Ground covers are created by seeds blowing in the wind, which means they can't be evenly distributed as they are in our gardens and parks. When creating natural ground covers, you need to include bare spots and regions where the ground cover is very dense.

E. **Roots.** Roots aren't a staple of most natural settings, but they do add some nice detail and are fairly easy to create. While your scenes may not have a crag in them, you should experiment with placing surface roots in the scene to add some chaos.

F. **Random weeds.** Nature is littered with random weeds, and they are seen in every natural setting on the planet. Your natural settings should always include an abundance of weeds. You should also provide a variety of weeds in your natural worlds. The example image is a very tight shot with a major hole in the middle, so it has only one type of weed, a dandelion. If there were more surface area, it would probably have a variety of weeds, including ragweed, foxweed, and crabgrass.

G. **Plant placement.** The placement of plants is critical in a natural setting. While the placement in our gardens and parks has nothing to do with the available water, Mother Nature plants her major growth near the water supply. Plants need plenty of water, so they will grow where the supply is most abundant. While this doesn't mean they only grow near bodies of water, it does mean they will need to grow in fertile soil, which means the soil needs to retain moisture. Plants in nature will grow near permanent objects and ground covers where the soil is rich with moisture. In this image, the Guzloader plants are growing near the clover ground cover and the rock, which both help retail moisture in the soil.

DON'T PLACE PLANTS IN THE MIDDLE OF DENSE GROUND COVERS

Most ground covers have a dense root system, which can choke the roots of plants, so you typically don't see a lot of plants growing in the middle of dense ground covers. The denser the ground cover, the fewer plants in the middle of it.

As you can see, there really aren't too many details to photorealistic natural settings, there is just a large abundance of a few details. It's really all about where they are placed and their volume of distribution. If you want your natural settings to appear photorealistic you need to provide a few simple elements, a randomly dense ground cover, random weeds, and the occasional rock and twig. The formula is really that simple. The key is to provide a good variety of weeds and chaos, and if possible a number of different ground covers of varied height. The image in Figure 9.2 has two different ground covers, moss and clover. The moss is a very low bump-mapped ground cover, while the clover is a higher, physical mesh ground cover. The combination of these two ground covers fills out the scene nicely. You don't want a lot of dirt showing unless you are creating a desert like the one shown in Figure 9.3.

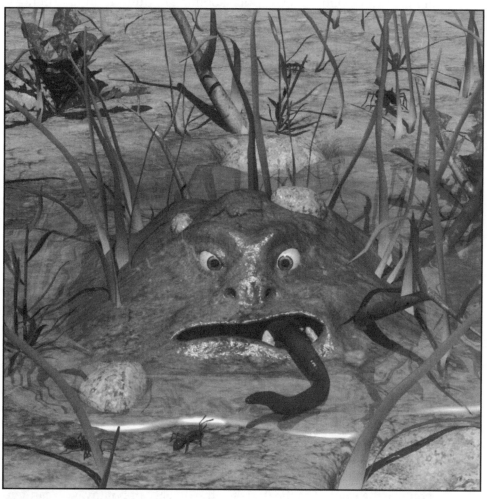

Figure 9.3 The sparse ground cover of a desert.

Here we have a shot of the Enchanted Goblin Desert after a Goblin has walked through it and dropped a bead of sweat on the ground. The dirt in the desert is enchanted by the bones of the Great Mystics who came to Earth in hopes of finding intelligent life to propagate their dying race. Of course, all they found was a civilization of dinosaurs and goofy Goblins. After thousands of years, one of the Mystics died, so the other Mystics buried him on the Goblin Island. The Mystics had great powers, and their bones are magical. When the bones are placed in the dirt, they enchant the dirt for miles. Since the Goblin Island is only 20 miles across, nearly half the island is enchanted by the Mystic's bones, which has brought many inanimate objects to life, including mushrooms, stones, and even tubers, all of which can be seen in the color insert of this book.

Well, when water is dropped on the Enchanted Desert it animates the dirt, creating Mud Goblins. These Mud Goblins are quite loud and obnoxious. The normal Goblins hate them because they are far too friendly, running around saying hello to everyone in sight. The Mud Goblins live only as long as they have moisture to keep the dirt wet, so when they are created they make a mad dash for the bordering rain forest. Of course, they rarely make it because they usually run in the wrong direction. The desert floor is littered with mounds of dirt that were former Mud Goblins. While they don't look like much from ground level, from the air they resemble mud corpses strewn about on a battlefield.

It takes quite a bit of water to create a Mud Goblin, typically several gallons. So what happens when only a bead of sweat hits the desert dirt? It creates a Desert Wart, which is a tiny Goblin like the one seen in Figure 9.3. It's basically just a bump on the desert floor that is only a quarter inch in diameter. When it sprinkles rain in the desert thousands of these little guys are created, which can be very annoying since they are quite loud. The rule of thumb is don't, at any cost, drop any water on the desert floor. It's a punishable crime in the Goblin kingdom.

Take a close look at Figure 9.3, and you'll notice the ground is clearly visible with a light dispersion of grass and the occasional weed. There isn't much precipitation in the desert, so it's very barren. On the other hand, a forest holds a great deal of moisture, so you want the ground to be thick with ground cover and weeds as shown in Figure 9.4.

Before you start developing your environment be sure to consider the amount of rainfall and the general climate of your world. These factors determine the density of foliage we expect to see in the scene. A rain forest has tremendous rainfall, so it's very thick with botany, while a desert has very little rainfall so it's relatively barren with only an occasional plant—and it's usually dead. If you use the rainfall as the basis for the density of botany, you can't go wrong.

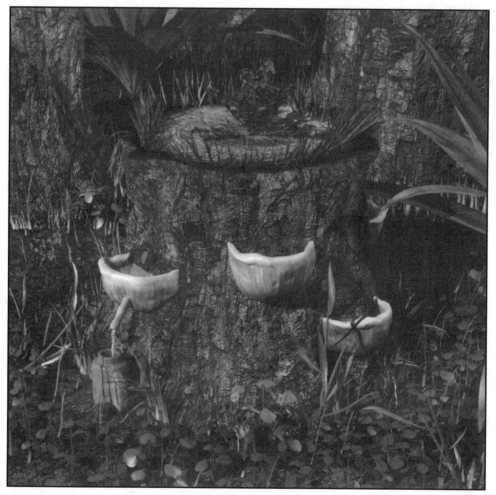

Figure 9.4 Dense ground cover of a forest.

USE RAINFALL TO DETERMINE THE DENSITY OF BOTANY

The amount of rainfall determines the density of foliage. A rain forest is dense with greenery because there is tremendous rainfall and the moisture is trapped by the tree canopy. On the other hand, a desert has very little rainfall and no trees to trap the moisture, so it's barren, with little to no foliage. You should always use rainfall to determine the amount of plants and ground cover you'll see in the environment.

Okay, now that we've covered some of the elements that make up a photorealistic natural scene, let's try our hand at creating an organic element.

Creating Natural Elements

Natural elements can be very complicated to manufacture because they are completely organic. While leaves and tree trunks aren't bad, it can be very challenging to create a dense tree or bush. This is why we typically see 3D trees and bushes that were created using digital botany programs such as Tree Druid. These programs create trees and plants very well, saving you countless hours. Of course, there's more to nature than trees and bushes. It's littered with weeds, rocks, twigs, and other chaotic details. Fortunately, these details are fairly easy to create as we did with the grass in Chapter 5, "Displacement Map Effects." Creating grass, leaves, and twigs is straightforward since they are simple shapes.

Of course, not everything in nature is a simple shape. While we could do a tutorial on manually creating a tree, which is a very complicated shape, it would probably eat up too many pages and surely give us a migraine headache. Instead, I think we'll do something more creative, like an object that's man-made from natural elements. Actually, we'll be doing a Goblin-made object, which is seen in Figure 9.5.

Remember this image from Chapter 1 "An Introduction to Photorealism"? Well, we're going to model the toilet monument from this image. This is a great object because it reflects a cognitive influence and is completely organic. One of the most difficult effects to create is natural seams. These are the points where two objects meet in nature, such as a hole in the ground for a rock or the mud packed around stones as seen on the Goblin toilet monument. While we can simply jam two objects together, they won't be natural because they will have a hard seam. We need to show where the ground or mud has built up around the rock if we want it to appear realistic. This requires some modeling tricks to create the effect. Let's take a look at how we can easily create the awesome effect of natural seams. We're going to create the rocks resting in the clay mortar of our toilet throne. To do this, we'll be using polygon modeling and subdivision for smoothing. The combination of polygons and subdivision is truly the most flexible method for creating awesome organic models. Of course, there are some tricks to creating details with subdivision modeling as we will explore in the following exercise.

EXERCISE: CREATING A GOBLIN TOILET MONUMENT

1. The first step is to create the clay mortar object. To make our lives easier, we'll create half the object, and then mirror it to complete the toilet monument. To start the clay mortar, create a box with six segments on the y-axis, five segments on the x-axis, and three segments on the z-axis. Then align the left side with the center axis as shown in Figure 9.6.

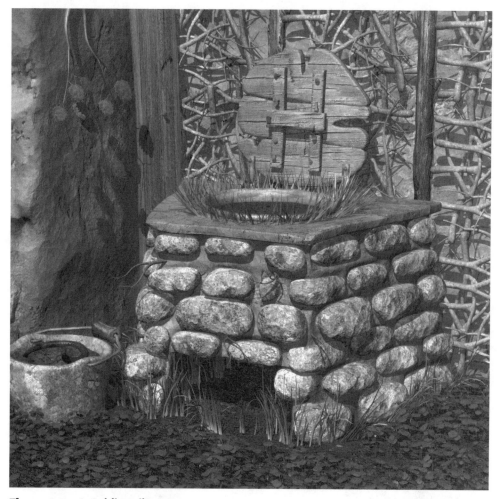

Figure 9.5 A Goblin toilet monument.

2. Now we need to shape this object to the general shape of our toilet. Start by tapering the top inward toward the center on the x-axis as shown in Figure 9.7.

3. Then taper the front inward on the z-axis as shown in Figure 9.8.

4. Finally, taper the top inward from both sides on the z-axis as shown in Figure 9.9.

5. Now select the middle point in the x viewport and stretch them inward as seen in Figure 9.10. This positions the points so we can begin to build the individual rocks.

6. Now let's make the first rock in the clay. Zoom into the upper right corner of the object in the x viewport. Then select the polygon in the corner,

Figure 9.6 Starting the clay mortar.

Figure 9.7 Tapering the top inward.

Figure 9.8 Tapering the front inward.

Figure 9.9 The last taper.

Figure 9.10 Stretching the points.

extrude it once, scale it down slightly, and move it back into the clay a bit as shown in Figure 9.11.

7. This is the beginning of your rock, so you need to rename the surface of this polygon to rock. Moving the polygon back into the clay will help create a smooth bulge around the rock when you smooth the mesh with subdivision. What we need to do now is create the actual rock. To do this, extrude the polygon, scale it up a bit larger than the original, and then move it forward slightly as seen in Figure 9.12.

8. To complete the rock, extrude the polygon one more time and move it forward a bit to add depth to the rock as seen in Figure 9.13.

9. Now, for the final touch, we need to add a bit of nonlinear chaos to the rock so it won't appear manufactured. Select the front polygon of the rock and skew it a bit as shown in Figure 9.14. You can either use a skew tool or simply drag the points or vertices to create the deformed face.

10. You now have a completed rock. Just 25 more to go! To complete the rocks, repeat the same process. Of course, there are some details we must consider first. We don't want the stones to be aligned perfectly; instead, we want them staggered like bricks, so you need to select two polygons for the next rock as seen in Figure 9.15.

Figure 9.11 Starting the rock.

Figure 9.12 Creating the rock.

Figure 9.13 Completing the rock.

Figure 9.14 Skewing the rock.

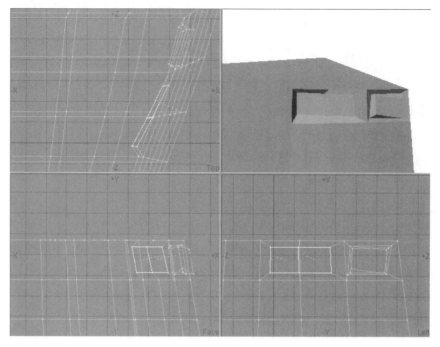

Figure 9.15 Creating the staggered rock.

11. These two polygons are edited the same way as the first rock. Now the next two polygons to the left are edited in the same fashion to create another wide rock as shown in Figure 9.16.

12. Next you can begin the second row, which requires a bit of trickery for depth. We want to stagger the rocks, which means we need to offset the rocks on the corners of the toilet. The corner is a bit tricky. Zoom in to the upper left corner just under the last rock on the top row, and then select the first polygon on the row and the connecting polygon on the front. Now extrude these and scale them down as shown in Figure 9.17.

13. Now complete this rock as you did the others by extruding it once, scaling it upward, and moving it out. Then extrude it again and move it out farther to create the corner rock seen in Figure 9.18.

14. Now complete the second row of rocks by creating two polygon rocks as shown in Figure 9.19.

15. Great! Now complete the rest of the rocks on this side of the toilet using the same techniques. The completed rocks should resemble Figure 9.20.

16. For the finishing touch, pull out your magnet tool and drag the rocks around a bit to add some realistic chaos as shown in Figure 9.21.

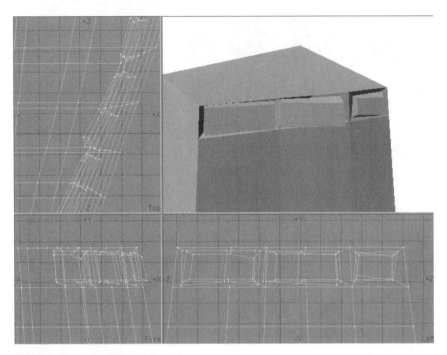

Figure 9.16 Another wide rock.

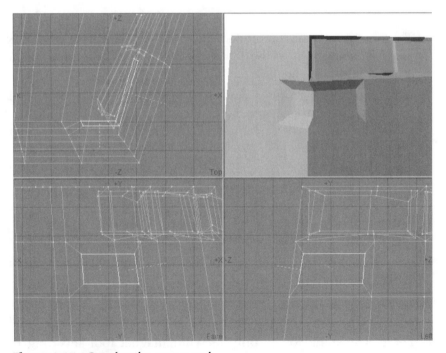

Figure 9.17 Creating the corner rock.

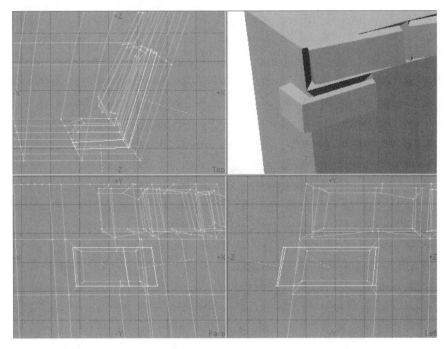

Figure 9.18 The completed corner rock.

Figure 9.19 Completing the second row of rocks.

Figure 9.20 The completed rocks.

Figure 9.21 The chaotic rocks.

17. Before we complete the rocks on the front of the toilet, we need to add a hole in the middle where the toilet drains and create the toilet interior. This is done using extrusions as you did with the rocks, but it's more complicated because we're working with an awkward shape. Let's take a stab at it and see how we do. Select the polygons along the center of the object and the four polygons on the lower front as shown in Figure 9.22.

18. Now give these polygons a surface named interior, so you can select it easier once you start to add the details. Next, extrude the polygons one time, and then scale them down and back as shown in Figure 9.23.

19. Be sure not to move the polygons along the x-axis. We want it lined up here so the seam is linear. Now we need to start pulling the polygons into the toilet, so extrude them again, scaling them down and moving them inward as shown in Figure 9.24.

20. To complete the interior we need to rotate the polygons outward to line up with the shape of the toilet. Hide the unselected polygons so we can complete the editing of our interior. Then use your drag tool to pull the angled polygons on the front edge around to conform to the shape of the toilet as shown in Figure 9.25.

21. Now unhide the toilet polygons, and select the polygons on the bottom of the toilet and delete them as shown in Figure 9.26.

Figure 9.22 Selecting the interior polygons.

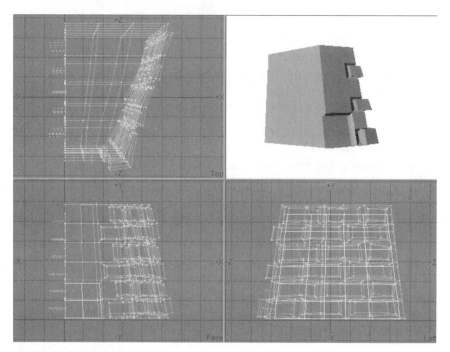

Figure 9.23 Starting to add depth to the interior.

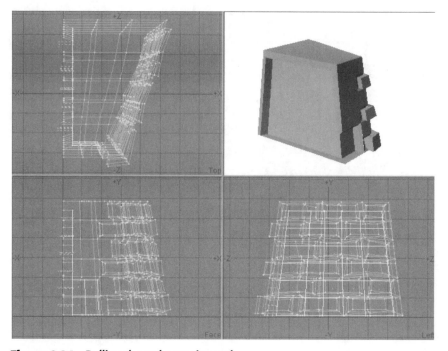

Figure 9.24 Pulling the polygons inward.

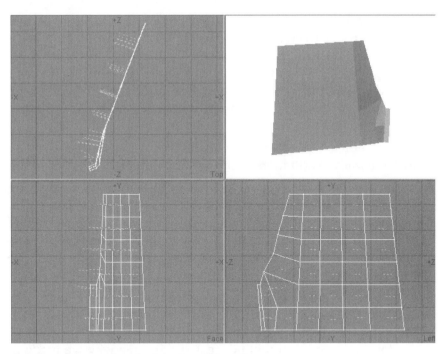

Figure 9.25 Forming the interior of the toilet.

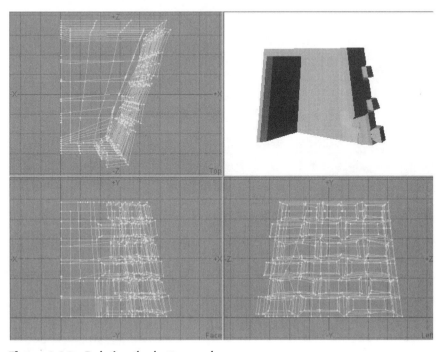

Figure 9.26 Deleting the bottom polygons.

22. Great, the interior of our toilet is now complete. It looks great doesn't it? It was a bit tricky to create, but it has tremendous depth. Now we just need to complete the front rocks, and we'll be done with our toilet base. Start by adding a rock just above the lower rock on the front. This rock needs to extend around the corner and into the interior to add realistic depth so you need to select the polygons on the front, side, and back, and extrude them inward as shown in Figure 9.27.

23. Now complete the rock just as you did for all the others. Be sure to pull the rock outward to add more depth as shown in Figure 9.28.

24. Okay, now you can complete the front of the toilet by adding some rocks using the same technique. On the center of the toilet where it meets the center axis, create some half rocks so when you mirror it they will complete a full rock. Just make sure you keep the left side of the half rocks parallel to the center axis. When finished, you should have something similar to Figure 9.29.

25. Now, for the final touch. Select the polygons along the center axis, set their value to zero on the center axis, and then delete them. Now we have half the toilet completed. Well, nearly complete anyway. We still need to add the top to the toilet. It will be created the same way we made the rocks. Select the polygons on the top of the toilet, apply a surface named top, and

Figure 9.27 Starting the corner rock.

Figure 9.28 Completing the corner rock.

Figure 9.29 Completing the front of the toilet.

then extrude it. Now scale it slightly larger and move it down a bit past the parallel point with the top, as seen in Figure 9.30.

26. Extrude the top again and move the polygons upward as shown in Figure 9.31 to add depth.

27. Next, we need to reinforce the top and add some edge detail. To make it easier to edit the top, hide everything but the top polygons. Now select the outer edge polygons and extrude them a bit as seen in Figure 9.32.

28. Now we want to add some edge chaos to make the top more organic and natural. To do this, select the two outer edge polygons on the back of the toilet and extrude them as shown in Figure 9.33.

29. To create some detail on the front corner of the edge, select all the remaining polygons except the one on the front inside edge, then extrude them as seen in Figure 9.34, dragging the occasional point to make the edge a bit more irregular.

30. Excellent, we're done with the top edge. Now unhide the toilet and you should have something similar to Figure 9.35.

31. The final step for the top is to create a hole. First, select the three polygons in the center of the top and drag their outer edges so they create a round edge as seen in Figure 9.36.

Figure 9.30 Starting the top.

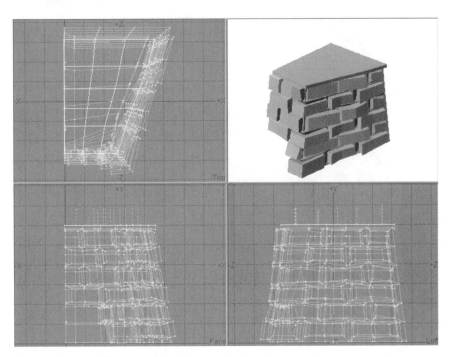

Figure 9.31 Adding depth to the top of the toilet.

Figure 9.32 Extruding the top edge.

Figure 9.33 Adding edge detail.

Figure 9.34 Adding the final edge chaos.

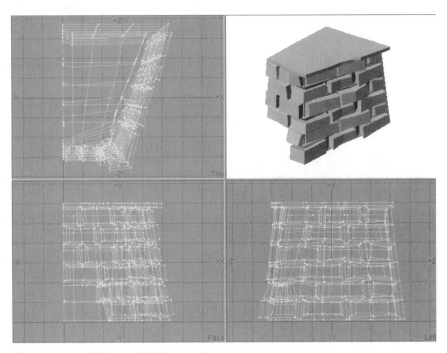

Figure 9.35 The completed top edge.

Figure 9.36 Creating the circle for the hole.

32. Now extrude these polygons and move them down parallel with the bottom edge of the toilet top as shown in Figure 9.37.

33. Next, extrude the polygons again and scale them somewhat larger than the hole as shown in Figure 9.38.

34. To complete the hole, select the polygons on the inner edge of the hole and extrude them outward to create the base of our metal rim as shown in Figure 9.39.

35. To create the toilet seat rim, extrude these polygons and drag the outer points outward a bit beyond their original position, then rename the surface to rim as shown in Figure 9.40.

36. Now extrude the polygons again and stretch them vertically to add depth to the rim as seen in Figure 9.41.

37. Finally, to strengthen the rim so it doesn't round too much when you apply the subdivision, extrude the polygons another time and stretch them vertically a bit as seen in Figure 9.42.

38. Okay, now unhide the toilet, and let's take a look at the completed toilet—well, half of it anyway. Figure 9.43 shows the completed half.

Figure 9.37 Creating the hole.

Figure 9.38 Extruding the bottom of the hole into the toilet.

Figure 9.39 Extruding the hole rim.

Figure 9.40 Starting the rim.

Figure 9.41 Adding depth to the rim.

Figure 9.42 Completing the rim.

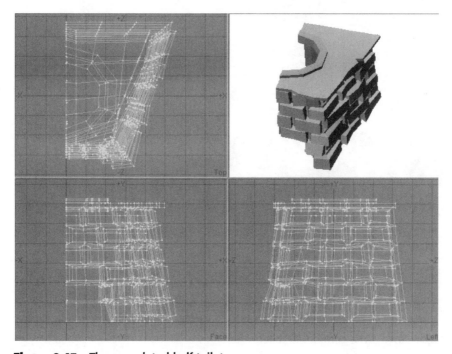

Figure 9.43 The completed half toilet.

39. All you need to do now is mirror the toilet along the center axis and merge the points in the middle to create the completed toilet seen in Figure 9.44.

40. Now save the object as toilet. Okay, you have a few choices now. One option is to subdivide the toilet to create the soft organic look shown in Figure 9.45.

41. The name for subdivision varies from one program to another. For example, in LightWave it is called Metaform, and in 3D Studio Max it is called Meshsmooth. In yet another program called trueSpace the subdivision function can be found in a plug-in called ThermoClay. Whatever the name, they all do the same thing. They divide the polygons in two segments and perform a smoothing function on them, which can be seen in our toilet. It looks very organic doesn't it? Notice how the clay folds around the rocks naturally. This toilet looks very realistic and naturally organic. In fact, it looks like a Flintstone toilet in this OpenGL preview. The default smoothing settings were used for the subdivision on this toilet. Let's save this completed toilet as toiletrocks.

This is only one option for the completed toilet. Another option would be to make the rocks look more like bricks, which can be done using a great subdivision trick. Let's do it now.

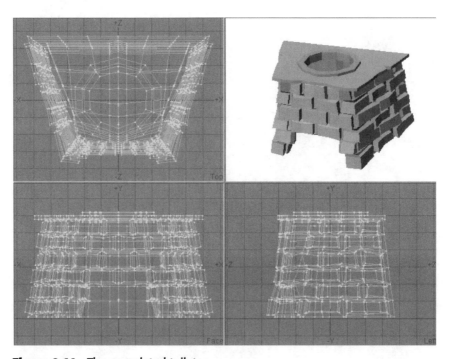

Figure 9.44 The completed toilet.

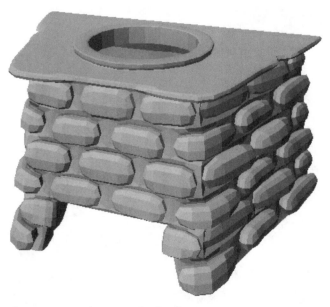

Figure 9.45 The smoothed toilet.

42. Delete the current object, and load the toilet object. Now apply subdivision with no smoothing. This will divide the polygons in two segments without smoothing them, as shown in Figure 9.46.

43. Why did we do this? Well, by dividing the polygons, you have made the mesh more rigid for subdivision. The higher volume of polygons will make the smoothing less prominent. Speaking of smoothing, apply another pass of subdivision with your default setting to create the smoothed bricks seen in Figure 9.47.

44. Notice how the rocks are more linear like bricks. By simply dividing the polygons before smoothing you have made the whole mesh more rigid, making the rocks look like bricks. Let's save this toilet as toiletbricks.

As you can see, creating organic objects can take a bit of time, but it's also very rewarding. Nothing is as stunning as a well-modeled organic object. They're fascinating even without surfacing. The next time you create an organic object, you should take a serious look at modeling with polygons and subdivision. It's truly amazing how much detail you can quickly add with polygons. The techniques we used to create the toilet can be used to create countless other objects. You are limited only by your creativity and imagination. Speaking of imagination, before we move on, let's take a look at how we can add some fine detail to our toilet. One of the main elements of photorealistic environments is fringe grass. Since the toilet has been around a while and is merely made of

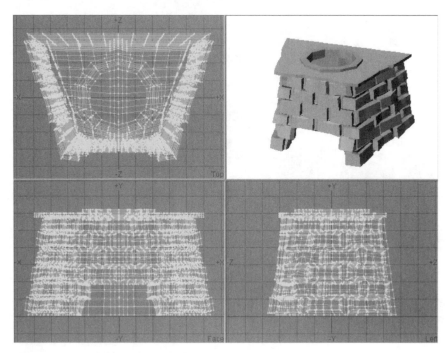

Figure 9.46 Dividing the polygons.

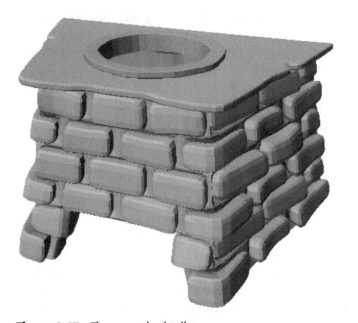

Figure 9.47 The smoothed toilet.

packed clay and stones, we can expect to see some fringe grass around the toilet rim. Let's take this opportunity to add some fringe grass to our toilet rim.

EXERCISE: ADDING FRINGE GRASS TO THE TOILET RIM

1. Load the grass.3ds object located in the chapter9 folder on the companion CD-ROM. This is the same blade of grass that you created in Chapter 5, "Displacement Map Effects." The blade of grass is shown in Figure 9.48.

2. Now load the toilet object you created a few minutes earlier. We're going to clone the blade around the rim of the toilet, but first we need to create a clump of grass to clone. If you simply cloned the blade, it would create an obvious repeating and far too linear pattern. To make sure that the grass looks natural, you'll be making two chaotic clumps that will be cloned to create an over nature look to the grass. Even with two clumps, you will still need to manually edit the grass to make it chaotic. To make the first clump, clone the blade five times and then arrange them in a cluster as shown in Figure 9.49.

3. To make the cluster more believable, use the bend tool to curl some of the blades. When you are done with the cluster, place it on the edge of the rim, in the middle as seen in Figure 9.49. We're going to clone this cluster around the rim using the center of the toilet hole as the point of rotation for the clones. Before you clone this cluster around the rim, you need to make

Figure 9.48 The blade of grass.

Figure 9.49 Creating the first cluster.

a single clone and add some chaos. Make a clone of the blade cluster and, using the center of the toilet hole as the axis for rotation, rotate the cluster clockwise until it's directly next to the first cluster. Then select each blade in the new cluster and rotate and bend them chaotically so they don't match the first cluster, as seen in Figure 9.50.

4. Okay, now it's time to clone the clusters around the rim. Select your clone tool and set the number of clones to 18, then set the y-axis rotation to 24 degrees. You should now have something similar to Figure 9.51.

5. It looks great doesn't it? Well, it does, but you need to break up the repeating pattern of the clusters. This is where we do a bit of tweaking. Simply select the blades at random and rotate and bend them to break up the repeating. Figure 9.52 shows how I added some chaos to the blades.

6. Combine the grass and the toilet to complete the toilet as shown in Figure 9.53.

7. Now subdivide the toilet. You should have a great looking Goblin toilet monument like the one seen in Figure 9.54.

8. Save the object as toiletgrass.

The grass was very easy to add, but it added a great deal of detail and chaos to the toilet, making it even more believable. Once again, the more detail, the

Figure 9.50 Creating the second cluster.

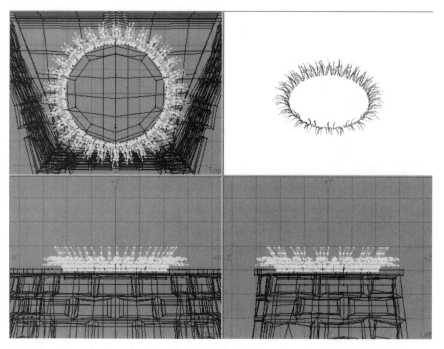

Figure 9.51 Cloning the grass around the rim.

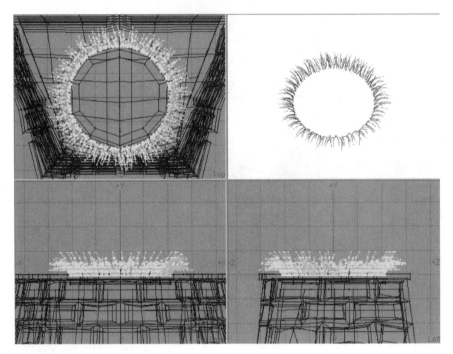

Figure 9.52 Adding chaos to the blades.

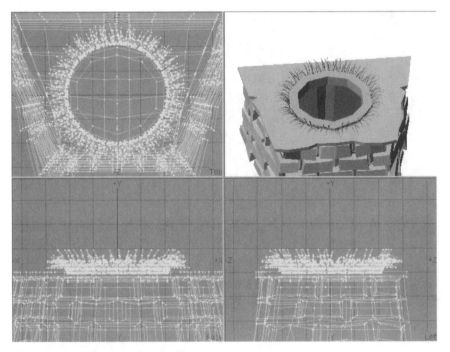

Figure 9.53 The completed toilet.

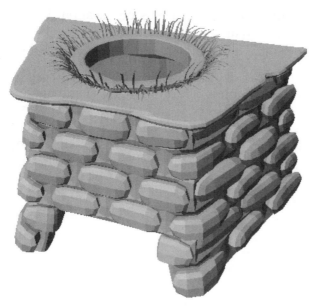

Figure 9.54 The subdivided toilet.

more realistic the model will appear. Don't stop modeling after you've created the basic object. That is what most 3D artists typically do. They would stop after modeling the toilet. It's the commitment to the fine details that make an object really come to life in a natural world. The small details such as grass, roots, and maybe the occasional pebble wedged in the cracks really bring a model to life. Don't skimp on the details because they will take your objects from 3D to photorealistic.

Wrap Up

The key to successful organic modeling is to focus on the small details, like the seam where the clay meets the rocks in the toilet and the grass around the rim. Another small detail seen in the toilet in the completed Goblin toilet monument image was roots protruding from the toilet. They were added by simply poking the roots into the clay. Since the roots grew out of the clay, we can get away with a fairly linear seam.

A good rule of thumb for object seams is when something grows up out of another object, the seam is usually fairly linear, like grass growing out of the ground. But if something is placed into another object, such as a rock in the mud, the seam is very organic. You would also expect an organic seam when erosion is a factor. A mushroom growing in fertile soil will probably have an organic seam because the ground would have eroded away due to rain and wind.

The real key to successful organic modeling is observation. It's a matter of exploring the natural world and mimicking the details you see. Besides, a walk in the wilderness can be a nice break from getting your eyes fried by monitor radiation.

Well, that does it for our exploration of natural world staging and modeling. We already covered a great deal of organic surfacing in Part Three, "Surfacing Complex Objects," so all that's left is to tackle one of the more complicated details of natural worlds: water effects. In the following chapter we'll explore several awesome techniques for creating very realistic water effects. Let's go to the next page and get started.

Exploring Ponds and Puddles

One of the more complicated effects to re-create in 3D is water. While water is a relatively simple element, it presents a number of problems when creating 3D images. Creating a realistic ocean is actually a snap. You merely create a blue plane, make it reflective, and add a crumple texture to simulate the choppy waves of an ocean. On the other hand, creating a puddle or a pond is much more challenging because we need to see past the surface of the water into the murky waters below. It requires great attention to detail to accurately simulate muddy and murky water. Since we can see into the water, we need to create water depth. What I mean is that there is a reduction in clarity as we look deeper into pond water. It becomes cloudy closer to the bottom because particles are being lifted from the floor. This cloudy effect is paramount to the success of our photorealism. Nothing is as artificial as perfectly clear pond water.

Of course, clean pond surfaces are also rare. They are typically covered in a thin film and quite often have an abundance of algae. If we look deeper into ponds, it's likely that we'll see a great deal of bottom detail—water plants, rocks, and a variety of debris that have made its way into the pond such as branches and dead leaves. Simply put, ponds are nothing but pure chaos and extreme detail, and much more complicated than ocean water since we can rarely see past the surface of ocean water and it's rarely clouded with particles because the floor is much deeper.

In this chapter we'll be re-creating the water seen in Figure 10.1. Here we have a shot of Groin the Goblin riding on his trusty steed, which happens to be a wood frog. Groin isn't actually a Goblin. He's a salamander posing as a Gob-

lin to spy on them for Batra the Frog Czar. There is a long-standing feud between the Goblins and Batra. Batra hates the Goblins because they like to eat frogs, which of course doesn't appeal to a frog like Batra. He's tired of the Goblins eating his subjects. Frogs and Goblins don't get along, so seeing a Goblin riding a frog is a dead giveaway that something is amiss.

Notice how the water in Figure 10.1 is a murky brown, but we can still see the objects just below the surface, such as the bladder fish that's just waiting for the Goblin to fall into the water so he can feed upon him. We can see there are vines under the water, but we can see the actual floor of the pond. This pond was created during a period of excess rainfall. It isn't a permanent body of water but rather a pond that formed in a low point of the Goblin rain

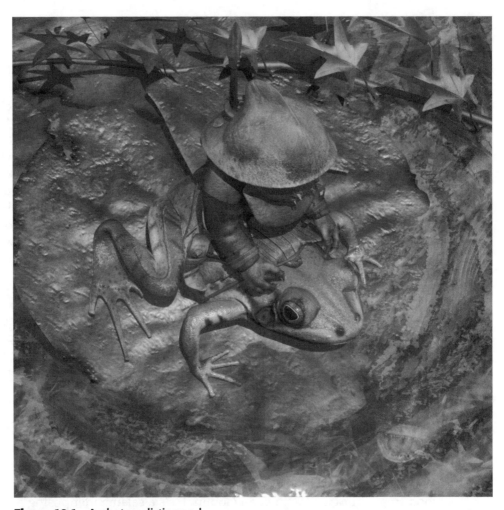

Figure 10.1 A photorealistic pond.

forest. That's why we see vines below the surface of the water. Normally we'd expect to see an abundance of water plants, but this pond is too new for them to have formed. Of course, the soil on the floor of the pond is not compressed the way we'd expect in a permanent body of water, so it floats up easily, creating a rather muddy bog. This is a great example of realistic water depth and detail because bogs are very muddy and full of details, particularly surface details.

Notice how the lily pad dipped just below the water is tinted brown. The water is clearly muddy, but as we look deeper into the mud the clarity of the water is reduced to the point where we lose sight of the details. This adds a great deal of depth and realism to the pond water. It's an awesome effect and very easy to create, as we will discover later in this chapter.

Okay, so how do we create realistic ponds? Well, we take it a step at a time. The first step is to create surface chaos, so let's take a look at how that is accomplished.

Creating Surface Chaos

The surface of pond water is riddled with chaos. I don't mean the lily pads, water weeds, or the water bugs. I'm referring to the water itself. Pond water is typically murky, particularly if the pond is small and shallow. Shallow ponds are cloudier because the muddy bottom is closer to the top, so the particles stirred up by the movement of the water are closer and therefore more visible. The environment also affects a shallow pond far more than a large pond, so the wind is more likely to churn the water, lifting particles off the floor. This means that if we want to simulate pond water properly we need to create the effect of a murky surface.

Creating a murky surface is more complicated than simply making the water a brown color. The distribution of particles in the water is dependent upon several factors including the water depth, current, environmental effects, and movement under the water from creatures. All of these factors serve to create a chaotic murkiness. To simulate this murky effect we need to create an image map for our water surface. Let's take a look at how we make a murky water surface.

EXERCISE: CREATING A MURKY WATER SURFACE

1. The first step is to create a water object. In your modeling program, create a flat plane on the y-axis with 20 segments on the x- and z-axes, like the one seen in Figure 10.2.

2. This will be our pond floor, so give it a surface named pondfloor.

Figure 10.2 Creating the pond floor.

3. Of course, a perfectly flat pond floor is impossible, so we need to add some chaos to it to be realistic. To do so, apply a small fractal noise or jitter to the mesh to create a lumpy surface like the one seen in Figure 10.3.

4. Now you're ready to create the actual water surface. Make a simple one-polygon plane just above the water as shown in Figure 10.4.

5. Now select this plane and give it a surface named pondwater. Then save the object as pond.

6. The next step is to surface the pond object. You'll be creating a water image map for the pond to make it appear murky brown, so load your painting program and create a new file that's 1024 by 1024 pixels. You don't need to make the file very large since it's only going to be blended colors, meaning it can resample up without getting pixelated.

FOR SEAMLESS TEXTURES USE INCREMENTS OF 256

When using Photoshop filters to paint your textures, increments of 256 pixels will create a seamless tile automatically. For example, an image that is 1024 by 1024 pixels will result in seamless filter effects. This can be very useful and time-saving when creating seamless textures.

Figure 10.3 Creating a chaotic surface.

Figure 10.4 Creating the water plane.

7. Now set the foreground color to RGB 165, 122, 42. Then set the background color to RGB 106, 76, 23. We're going to use these colors to create a fractal cloud texture, which will provide us with varying shades of brown-yellow. To do so, apply Filter/Render/Clouds. You should now have something similar to Figure 10.5.

8. The next step is to add some yellow-orange spots to the water surface to break up the browns a bit. Set the foreground color to RGB 165, 108, 19 and select the airbrush tool. Set the brush size to 100 pixels and the pressure to 20 percent. Now paint some random spots on the image as shown in Figure 10.6.

9. Now you have a nice chaotic muddy surface. The reason we used yellow-brown colors was due to the color of the surrounding mud in the forest. This region has a great deal of minerals in the soil, which tends to tint the color yellow-orange.

10. The last step is to soften the colors. Rendering the clouds filter creates some hard fractal noise, which is fine for rust, but we want the colors to blend smoothly since we're talking water here. Apply a gaussian blur with a radius of 10 pixels. You should now have a soft cloudy texture like the one shown in Figure 10.7.

Figure 10.5 A cloudy brown-yellow water texture.

Figure 10.6 Adding yellow-orange spots.

Figure 10.7 The completed cloudy water texture.

11. Now save this file as bogwater, then save a copy as bogwater.jpg.

12. Now you're ready to surface the water. Open your rendering program and load the pond object. Then load the bogwater.jpg file and the clouds.jpg and moss.jpg images found in the chapter10 folder on the companion CD-ROM. We'll be using the clouds.jpg file as our reflection map and the moss.jpg file to surface the pond floor.

13. Select the pondfloor surface and apply the moss.jpg file to the color channel as a planar map on the y-axis. Also apply the texture map to the bump channel as a planar map on the y-axis. Then set the bump value to 100 percent.

14. Now set the diffusion to 70 percent, specularity to 20 percent, and glossiness/hardness to 50 percent.

15. The pond floor is now surfaced. The next step is to surface the water so apply the bogwater.jpg file as a planar map on the y-axis to the color channel of the pondwater surface.

16. Now set the transparency to 35 percent. This allow us to see through the water, but the clarity will be skewed by the bogwater.jpg texture.

17. Next, set the diffusion to 70 percent, specularity to 90 percent, and glossiness/hardness to 50 percent.

18. Now set the reflectivity to 35 percent and apply the clouds.jpg file as a reflection map. This will cast a nice blue sky and white clouds on the surface of the water. It's very important to have the sky reflecting on your water to make it realistic.

19. Great, we're now done surfacing the water. Save the scene as pond, then save the pond object. Now let's do a test render to see the results of our labor. Figure 10.8 shows the rendered pond.

While this is a very simple scene, you can clearly see the water is a murky brown with varying shades. This is much better than if we had rendered the water with a simple monotone color. The varied colors are more natural. Of course, the pond is a long way from being photorealistic. While we have a great pond floor and nice water, we're seriously lacking in depth. To really see the effects of the cloudy water we should add some chaos to the pond floor. Let's take a look at how that is accomplished.

Creating Underwater Detail

Creating a detailed pond floor isn't terribly difficult. It's basically the same as creating a ground cover, but under the water. To make truly realistic ponds we simply need to add some chaos to the ground. While there aren't many weeds under water, there are plenty of water plants, sticks, twigs, and leaves. In the

Figure 10.8 The pond test.

case of our example pond in the Goblin rain forest we mainly see a patch of vines under the water. These vines are created the same way we made the tileable clover patch in Chapter 4, "Creating Tileable Ground Covers." Let's add the vine ground cover to our pond scene.

EXERCISE: CREATING UNDERWATER DETAIL

1. With your pond scene open, load the vines.3ds files located in the chapter10 folder on the companion CD-ROM. Then load the clover.jpg file located in the same folder. We'll be using this image map to surface the vines.

2. Select the vine surface and set the color to RGB 255, 255, 0, then apply clover.jpg file to the color channel as a planar map on the y-axis. Size the texture to the surface, and then set the opacity to 75 percent.

 Setting the color to yellow with an opacity of 75 percent on the image map will give the vine a yellow tint. Using base colors with transparent image maps is a great way to make use of a single image map. We can surface three different surfaces on the vine with a single image map and make them look different by using unique base colors with transparent image maps.

USE TEXTURE OPACITY WITH BASE COLORS
TO CREATE UNIQUE SURFACES

■■■■■ **When creating ground covers you'll find you need to make several unique surfaces to create realistic detail, but these surfaces may still appear very similar, just different shades of a color. For example, the stalk of a vine is a yellow-green, while the leaves are green. They have the same texture, just different colors. We could create several different image maps to surface them but why waste the resources. The best move is to use a different base color and make the image map we apply less than 100 percent opaque so the base color tints it.**

3. Now apply the texture map to the bump channel as a planar map on the y-axis. Then set the bump value to 100 percent. Now set the diffusion to 70 percent, specularity to 35 percent, and glossiness/hardness to 25 percent.

4. Now copy this surface to the vineleafvein surface.

5. Next, select the vineleaf surface and set the color to RGB 47, 121, 0, then apply clover.jpg file to the color channel as a planar map on the y-axis. Size the texture to the surface. Then set the opacity to 80 percent. This adds a yellow-green hue to the leaf.

6. Then apply the texture map to the bump channel as a planar map on the y-axis. Then set the bump value to 100 percent. Now set the diffusion to 70 percent, specularity to 35 percent, and glossiness/hardness to 25 percent.

7. The vine is now surfaced. The next step is to size it and clone it. We want to create a grid of four vine patches under the water. Scale the vine patch so it's one-fourth the size of the pond object, move it to the upper left corner, and place it just above the pond floor. Now clone the vine object, rotate it 90 degrees clockwise, and place it next to the original, overlapping it slightly, as shown in Figure 10.9.

8. Clone the original vines object again, rotate it 90 degrees counterclockwise and place it below the original, overlapping it a bit.

9. Create one last clone, rotate it 180 degrees clockwise, and place it in the lower right corner to complete the vine grid shown in Figure 10.10.

10. Great, now save the scene and do a test render. You should have something similar to Figure 10.11.

Now that looks better. We have some chaos under the water's surface. Notice the high level of detail the ground cover provides. It adds a great deal of depth to the scene, of course, but for cloudy water we can see the vines too clearly, which means we need to make the water more cloudy the farther down we go.

Figure 10.9 Cloning the vines.

Figure 10.10 The completed vine grid.

This may seem like a daunting task, but it's really not that bad. You might consider using volumetric shaders to add a fog to the water, but that is very resource intense and requires a great deal of tweaking to perfect. Fortunately, there is an extraordinarily simple technique for adding water depth. Let's take a look at how it's done.

Figure 10.11 Testing the pond floor detail.

Creating Water Depth

Water depth is the most critical detail of photorealistic ponds. Water gets cloudier the deeper you go. Clear water is very artificial. While some mountain springs may be clear, standing water is rarely clear because there is no current to move the dirt away. It simply hovers near the bottom of the pond making it difficult to see the bottom of the pond. Adding this cloudy effect will make your 3D ponds incredibly realistic. It will also limit the amount of detail you need to create on the bottom of the pond since it will be obscured by the cloudy water.

Okay, so what's the best way to create cloudy water? Well, we've already surmised that particle systems and fog aren't the best choice, so what's left? Polygon planes. We can create amazing photorealistic cloudy water by merely cloning our water object and stacking the clones vertically under the original. While it's an incredibly simple technique, the effect is very realistic. The layers of transparent water objects will gradually obscure your vision as the light passes through them. To get a better idea of how this works, let's add some cloudy water to our pond.

EXERCISE: CREATING CLOUDY WATER DEPTH

1. Load the pond object into your modeling program. Then select the water object and create eleven clones under it as shown in Figure 10.12.

2. To surface the water properly you'll need to give each water layer its own surface so you can edit them individually. Select the first clone under the original water object and name it lily water 1.

3. Now rename the rest of the water layers, numbering them sequentially.

4. Next, save the object as pondcloudy and replace the pond object in your rendering program with this object.

5. Now change the transparency of the lily water surface to 80 percent. You want the water to be more transparent since you'll be using layers to make the water cloudy.

6. Next, copy the lily water surface to the lily water 1 surface. Then set the transparency to 70 percent.

7. Then set the specularity to 0 and the glossiness/hardness to 0. You don't want the water below the surface to be specular since only the surface is specular. A specular highlight going into the water would be very strange and unrealistic.

Figure 10.12 Cloning the water object.

8. You also need to set the reflectivity to 0 since only the surface of the water is reflective.

9. Copy the lily water surface to all the other lily water surfaces. The layers of water will be additive with their opacity, each layer making the water cloudier. Of course, the cloudiness isn't a gradual fade, it's actually much cloudier near the floor of the pond, so set the transperance of the lily water surfaces 10 and 11 to 50 percent, then 8 and 9 to 60 percent. This will make the water around the floor very murky.

10. Now save the pondcloudy object and then save the scene.

11. Finally, do a test render to see the results of our water layers. You should have a cloudy pond like the one seen in Figure 10.13.

Well, that's more like it. The water gets cloudier the farther down we look. Notice how the vines are clear at the top and become obscured by the cloudy water the closer to the pond ground we get. The water truly looks cloudy. This was a very simple solution to a rather complex problem. Creating 3D photorealism isn't really complicated. It about finding creative ways to solve seemingly insurmountable problems. The last thing we want is to make our lives more complicated.

Figure 10.13 The cloudy water layers.

Speaking of complications, we can now add even more detail to the water to make it more photorealistic. We can add strands of grass to the water, which is a great effect because the grass grows vertically because of the water pressure, but then lies flat on the top just under the water's surface. This helps to obscure our vision of the water floor detail, adding more depth to the scene. Let's add some grass to our pond.

EXERCISE: ADDING GRASS TO THE POND

1. Load the pond object into your modeling program. Then load the grass.3ds object in the chapter10 folder on the companion CD-ROM.

2. We're going to clone this blade of grass to create some chaotic grass under the water. First, you need to size the grass so it just penetrates the pond floor and stops just below the surface of the water as seen in Figure 10.14.

3. Now clone the blade. Using your clone tool, set the number of clones to 360, then set the y rotation to a minimum of –35 degrees and a maximum of 180 degrees. You should now have a chaotic patch of grass like the one shown in Figure 10.15.

4. Now save the object as watergrass and then load it into your rendering program.

5. You need to surface the grass now, which can be quickly done by copying the vine leaf surface to the grass surface. Of course, you need to change the

Figure 10.14 Scaling the grass.

Figure 10.15 The grass patch.

color of the grass to be a little more yellow. Set the base color to RGB 107, 255,9. This will make the grass a lighter green-yellow.

6. Save the watergrass object and do a test render. You should have something similar to Figure 10.16.

It looks great doesn't it? The grass has added even more depth to the pond. Notice how the grass closest to the surface is clearly visible while the base of the grass is completely obscured by the cloudy water below. The combination of the low ground cover, and the tall grass really adds great depth to the pond. About the only thing we need now is a fish swimming around in the pond. We probably could go on adding detail all day long, but you get the idea. When creating a pond you want to create a lower level detail and then something on the upper level closer to the surface, and of course, something on the surface is good, too. Something like a lily pad, some fallen leaves, a water bug, or even algae would be great surface detail.

It's important to consider the type of pond carefully before you start adding the details. The good news is the details really aren't that difficult to add. The real key is to take it a step at a time. Don't try dropping everything in at once. First, test the water surface, then add the bottom detail, and finally create the murky water. As a finishing touch, you can add the top surface details like lily pads and leaves. You don't want to add the surface details until you have perfected the water. Otherwise, it can make it very difficult to test the water.

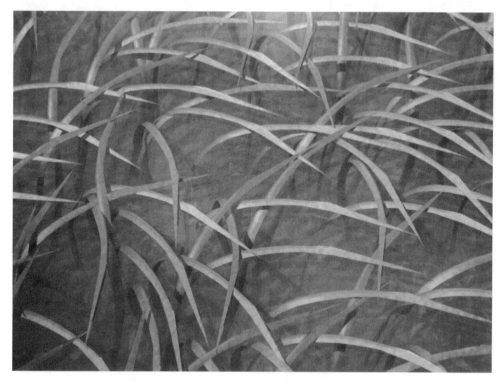

Figure 10.16 Water grass.

Wrap Up

Well, that about does it for creating photorealistic ponds. As you can see, it's really not that complicated to re-create the murky waters of real ponds, it's simply a matter of using a few simple tricks such as image mapping the water and using layers of water to add depth.

It would appear we've run out of pages. It looks like this will do it for our exploration of advanced photorealism. Naturally, there is a great deal more we could cover, but unfortunately we can only squeeze so many pages in a book. Of course, the techniques we covered in this book can be used to create countless photorealistic effects. Don't limit yourself to simply the examples we explored in this book.

Well, until we meet in the next book on photorealism, keep it real! Be sure to send me samples of what you've done using the techniques we've covered in this book. You can reach me at komodo@home.com. I'd love to see what you're doing with 3D photorealism.

CD-ROM Image Map Libraries

- **Image Map Modeling Textures CD-ROM**

 Marlin Studios
 www.marlinstudios.com/

 More than 300 textures created specifically for image map modeling by renowned author and artist Bill Fleming. This CD contains images of many industrial elements including windows, doors, water mains, walls, manhole covers, sidewalks, steam vents, and countless others. These are the only 3D textures in the world that are edited specifically for image map modeling. All shadows, reflections and other undesirable details have been edited out of the images. Resolution: 3 sizes each—Large avg. 1280 × 1024. Some as large as 2000 × 2000.

- **Seamless Textures You Can Really Use CD-ROM**

 Marlin Studios
 www.marlinstudios.com/

 More than 250 seamless, tileable textures, all hand-created from photos of real-world objects. Great all-inclusive, general-purpose-use collection. Includes 193 matching bump maps. Average resolution: 640 × 480 pixels

- **Seamless Textures2—Rustic Exterior Surfaces CD-ROM**

 Marlin Studios
 www.marlinstudios.com/

 Includes 310 seamless and tileable textures, all created from photos shot in remote, rural areas. Includes plenty of aged doors, windows, concrete, rust,

woods, and much more. Also includes 310 matching bump maps. Resolution: 3 sizes each—Large avg. 1280 × 1024.

- **Seamless Textures3—Ultimate Interior Surfaces CD-ROM**

Marlin Studios
www.marlinstudios.com/

More than 300 never-before-released textures and an extensive interior color guide, all created by renowned author and artist Bill Fleming. The product is the third in a series of photorealistic, seamless textures collections created for use by 2D and 3D graphics artists. Resolution: 3 sizes each—Large avg. 1280 × 1024. Some as large as 2000 × 2000.

- **City Surfaces (CD-ROM)**

Artbeats
www.artbeats.com/

City Surfaces is a collection of high-resolution building, street, storefront, and building material textures. Accessories include signs and manhole covers. There are also sky textures for "pasting into" reflecting from high rise windows. Images also have corresponding bump and reflection maps when applicable. Taken from drum scans of medium format transparencies. For PC, MacOS, and UNIX rendering applications. This professional collection will give designers and game developers the extra realism needed for creating striking virtual environments.

- **Photoreality Texture Collection (CD-ROM)**

3D Cafe

www.3dcafestore.com/3dcafe/phottexcol.html

Photoreality is a collection of seamlessly tileable, royalty-free 24-bit textures in Targa format designed for use in 3D modeling and as a base for your own textures. They can be used in games, art, Web pages, and other such works, but they may not be redistributed as part of another collection.

What's on the CD-ROM?

The companion CD-ROM contains a variety of support materials for the tutorials in this book. There are ten folders on the CD-ROM, one for each chapter of the book. In these folders you will find support files, models, and image maps for the exercises you will perform. You will also find a folder named figures that features all of the figures for that chapter in color JPG format. I highly recommend you take advantage of these figures when reading the chapters.

The support materials for the exercises discussed in this book are provided in a common format that can be used by any program on any platform. The models are provided in ten file formats:

- LWO
- 3DS
- DXF
- COB
- MAX
- IMA
- OBJ
- HRC
- VIS
- 3DMF

The images are provided in JPG format as well as Photoshop PSD files.

Software Requirements

You will, of course, need a 3D program to take advantage of the exercise models found on the CD-ROM. Any 3D program is fine since the models are provided in LWO, 3DS, DXF, COB, MAX, IMA, OBJ, HRC, VIS, and 3DMF formats.

You will also need a painting program such as Photoshop to open the image files, which are in JPG format. There are also a few Photoshop files found on the CD-ROM for use with the exercises. If you don't have Photoshop, you can use Fractal Design Painter, Corel's Photopaint, or even Paintshop Pro.

User Assistance and Information

The software accompanying this book is being provided as is without warranty or support of any kind. Should you require basic installation assistance, or if your media is defective, please call our product support number at (212) 850-6194 weekdays between 9 A.M. and 4 P.M. Eastern Standard Time. Or, we can be reached via e-mail at: wprtusw@wiley.com.

To place additional orders or to request information about other Wiley products, please call (800) 879-4539.

A

Aging, 15–17
 consistent, 274
 natural, 299
Alpha-mapped dirt, 293–297
 over tiled color maps, 297–303
Animation:
 displacement maps, 176–178
 fractal-displacement, 177–178

B

Bare spots, 312
Believability, 10–12
Beveling, manual, 94
Bird droppings, 33, 36, 269
Bones, creating surfacing morph target,
 243–247
Boolean modifier object, 48–50
Botany image maps, 203–221
Bricks, modeling, 61–68
Bucket fungus, 257–258
Bump map:
 convert to grayscale, 195
 painting, 206

C

Canopy, sun-damaged, 266
Car, worn and torn seats, 265
Caulking, 32–33
CD-ROM, contents, 369–370
Cement runoff, 271
Chain-link fence, modeling, 274–283
Chaos, 5–6
 adding to ground covers, 160–176
 adding with displacement maps,
 166–171

centering, 262
grungy, 261
major, creating with displacement
 maps, 170–171
surface, pond, 351–356
surfacing, itemizing, 272
Chaotic organization, 268–269
City streets, 261–306
 alpha dirt maps over tiled color maps,
 297–303
 alpha-mapped dirt, 293–297
 creating fence poles, 282, 284–292
 grungy chaos, 261
 modeling chain-link fence, 274–283
Clay, 16
Cloning tool, 30
Cloudy water depth, 361–362
Clover:
 clusters, automatically cloning,
 137–140
 creating bed, 130–136
 creating field, 129–143
Clover patch:
 creating, 136–143
 manually, 140–143
 tiling, 143
Clutter, 5–6
Cobblestones:
 modeling, 90–94
 source image, editing, 90–91
 tile, surfacing, 98–101
Color shifting, extreme, 176
Contours, custom, image map displace-
 ment, 171–176
Corrosion bump texture, 191
Cracks, 17–19, 269, 273

Creature head, 225–227
Custom model, creating from seamless
 tileable model, 105

D
Debris, 271
Dents, 266
Depth:
 adding, 102
 image map modeling, 60–68
Desert, 313–315
Desert Wart, 314
Details:
 increasing contrast, 90
 repeating, removing, 89
Difference Clouds filter, 185–187
Diffusion, 99
Dings, 266
Dirt, 15–17
 alpha-mapped, 293–297
 in cracks, 273
 horizontal, 270
Displacement maps, 159–182
 animation, 176–178
 creating major chaos, 170–171
 image map, custom contours,
 171–176
 using to create chaos, 166–171
Dust, 15–17

E
Edges, rounded, 19–21
Expectations, 7–10
 viewer's, 9–10
Extruding, manually beveling objects,
 94

F
Familiar objects, 12
Fence poles, creating, 282, 284–292
Find Edges filter, 190
Flat object, never create in nature,
 161
Flaws, 17–19
Flecks, adding, 186–190

Foliage, density, 315
Fractal-noise displacement, animating
 grass with, 177–178

G
Garbage, 271
 in car, 263
Glass, modeling, 47–50
Goblin toilet monument, 4–24
 adding fringe grass, 343–347
 creating, 316–343
Goblin tree, 223–225
 editing for morph target surfacing,
 228–236
 folded for surfacing, 227–228
 morph target surfacing, 236–240
Graffiti:
 on car, 263, 266
 on wall, 269
Grass, 8, 269
 to accent natural settings, 311
 adding chaos with displacement
 maps, 166–170
 animating with fractal-noise displace-
 ment, 177–178
 creating depression in, 173–176
 fringe, 310
 adding to toilet rim, 343–347
 in pond, 363–365
 pummeled, 170–171
 tileable object, creating, 160–166
Grayscale, converting bump maps to,
 195
Grease stains, 272
Grime:
 running, 268
 on walls, 273
Ground cover, 311
 adding chaos, 160–176
 bare spots, 312
 placing objects in, 146–157
 tileable, 125–158
 grass object, 160–166
 staging, 143–157
Grunge, image map, 302

H

Headlight, popped-out, 266
Hot Spots, 33
Humidity stains, 264

I

Image map:
 alpha, 200–202
 dirt, 293–297
 dirt maps over tiled color maps,
 297–303
 botany, 203–221
 CD-ROM libraries, 367–368
 detailed, 183–221
 displacement, custom contours,
 171–176
 grunge, 302
 unhealthy leaf, 206–221
 water line, 249–251
Image map modeling, 27–86
 with depth, 60–68
 editing a source image map, 31–41
 modeling glass, 47–50
 modeling window, 41–47
 organic, 69–86
 process, 29–30
 security bars, modeling, 51–53
 source, editing, 31–41
 surfacing the window, 53–60
Image resolution, 29
Industrial window, 30

L

Leaf:
 cluster, 254–257
 healthy, details, 204
 modeling, 71–77
 morph target surfacing, 251–257
 surfacing, 83–86
 unhealthy
 details, 205
 image map, 206–221
License plate, 266
Light, reflected, 22–24
Lunch ball, 126–128

M

Material depth, 21–22
Mesh template, unwrapped, 225–227
Morph objects, new surface name,
 240–242
Morph targets, using instead of bones,
 243
Morph target surfacing, 223–258
 editing Goblin tree for, 228–236
 Goblin tree, 236–240
 leaves, 251–257
 saving resources, 247–250
 simple objects, 242–247
 using bones to create, 243–247
Mud Goblins, 314
Murky water surface, 351–356

N

Natural scene, 307–348
 creating goblin toilet monument,
 316–343
 key details, 308
 using grass to accent, 311
 using rainfall to determine botany
 density, 315
Noise bump, 193, 220
Nurnies, 100–101

O

Object:
 depth, 21–22, 102
 flat, 161
 placing in ground cover, 146–157
Oil can, 198–203
Oil stains, 272
Organic image map modeling, 69–86
 leaf, 71–77, 341
 stalk, 77–82
 surfacing leaf, 83–86

P

Painting template, 173–174
 unwrapped, 225–226
Pallets, 273
Personality, 7–9

Plants, placement, 312
Platinum, city streets, 261–264
Polygons, using in image map modeling, 42
Ponds, 349–351
 grass in, 363–365
 surface chaos, 351–356
Puddles, 349

R

Radiosity, 22–24
Reference plane, 163
Reflections, 32
Repeating details, removing, 89
Resolution models, multiple, 130
Rock, 317, 320–323
 placing in ground covers, 147–154
 random, 311
Room, tileable, creating, 114–123
Roots, 312
Rot, 15–17
Rotation points, multiple, 131
Rounded edges, 19–21
Rust, 183–184
 creating patches, 198–203
 painting, 184–198
 runoff, 269

S

Saving steps, 134
Scaling, manually beveling objects, 94
Scanners, 29–30
Scan patterns, 30
Seamless textures, increments of 256 pixels, 352
Seamless tileable model, 87–124
 adding depth, 102
 complex, 113–123
 custom shapes from, 104–113
 detail contrast, increasing, 90
 flipped surface normals, 105
 manually beveling objects, 94
 repeating details, removing, 89
Seat cover, missing, 266
Security bars, modeling, 51–53

Shadows, 31, 33
 detail, 264
 problem of, 30
Shapes, custom, 104–113
Sidewalk, 120, 122–123
Skid marks, 272–273
Smoothing function, 340
Source image map, editing, 31–41
Specularity, 14–15, 32, 99–100
Staging, natural tileable models, 143–157
Stalk, modeling, 77–82
Subdivision, 163–164
Surface normals, flipped, 105
Surface texture, 12–14
Surfacing:
 chaos, itemizing, 272
 cobblestone tile, 98–101
 leaf, 83–86
 window, 53–60

T

Tears, 17–19
Template, primitive, shaping objects, 239
Texture:
 definition, 12
 opacity, using base colors to create unique surfaces, 358
 seamless, increments of 256, 184
Tileable models, seamless, *see* Seamless tileable model
Tileable room, creating, 114–123
Tires, flat, 266
Trash can, aged, 269
Tree, Goblin, 223–225

U

Underwater detail, 356–360

V

Viewer's expectations, 9–10
Viewing angle, 29
Vines, 358–360
 tileable model, 156–157

W

Water, 349–365
 creating depth, 360–363
 creating murky surface, 351–356
 runoff dirt stains, 271–272
 texture opacity with base colors, 358
 underwater detail, 356–360
Water line, image map, 249–251
Water weed, cubic-mapped, 249–250

Weeds, 269
 random, 312
Window:
 modeling, 41–47
 modeling glass, 47–50
 surfacing, 53–60
Wood
 cracks, 18
 surface, 13

REGISTER YOUR BOOK TODAY
AND GET A FREE BONUS!

Register "Advanced 3D Photorealism Techniques" and receive a collection of free image map modeling textures created by the author, Bill Fleming. This collection includes 25 of Bill's favorite image map modeling textures, many of which he used in the production of the newly released P-XG1 graphic novel.

To register your book simply visit www.komodostudio.com/adv_photorealism and fill out the registration form provided. Once you submit the form you will be able to download the image map modeling texture collection. You will also be added to Bill's personal email newsletter, which he sends out biweekly to inform his friends and colleagues of his latest books, magazines, and Komodo Studio projects.

www.komodostudio.com/adv_photorealism

To use this CD-ROM, your system must meet the following requirements:

Platform/Processor/Operating System. 100% IBM compatible running Windows 3.1 or higher; Macintosh running System 7.0 or higher

Hard Drive Space. 220 MB required for support files

Peripherals. CD-ROM drive; browser installed

3 5282 00487 7885

3 5282 00487 7893